Fabulosity

kimora lee simmons

Fabulosity

What It Is & How to Get It

ReganBooks

An Imprint of HarperCollinsPublishers

FIRST EDITION

Designed by Judith Stagnitto Abbate and Richard Ljoenes
Printed on acid-free paper

Library of Congress Cataloging-in-Publication Data has been applied for.

ISBN 13: 978-0-06-084339-7
ISBN 10: 0-06-084339-X

06 07 08 09 10 RRD 10 9 8 7 6 5 4 3 2 1

This is for Ming Lee, Aoki Lee, and women everywhere. Smile, be uplifted, and be happy. I love and feel you. You inspire me.

Fabulosity (n) 1. a state of everything that is fabulous. 2. a quality ascribed to that which expresses glamour, style, charisma, power, and heart.

Contents

Introduction

WITH THE FIRST checking account I opened, I wrote myself a check for a million dollars. I remember the moment clearly. One day, after getting home from a fashion shoot, I sat down at my desk in a very businesslike manner, opened my purse, and filled in a seven-figure check to myself. I left an open date on the top—so I could cash it at any point in the future—and signed it with a flourish of purple ball-point pen at the bottom. Then I tore it out of the checkbook and put it in my treasure box with all my other important papers and letters, where it sat, maturing like a bottle of fine red wine.

I'd been modeling for several years at that point and was earning nice money—though certainly not a million dollars kind of money. But I guess you could say I was inspired to dream big. Fashion was a glamorous industry full of very successful people; I'd glimpsed the opportunities that awaited anyone with vision and determination. And I thought, quite naturally, "I want that success for myself."

I never told anyone about my purple-lettered check because they would've thought it was silly, a teenage version of those games we all used to play as kids where we pretended to be travel agents and schoolteachers with fake forms and toy stamps. But I wasn't goofing around! To me, that check stood for something big. I wrote it as a kind of promise to myself, a statement of intent about what I wanted to manifest in my future. I don't think I'd read any books about "creative visualization" or "how to make dreams become real" back then. For me, it was just this intuitive thing. By writing down my outlandish-seeming goal and by doing it on an official

bank document with my signature on it, I was telling myself, "This is going to happen, and it's just a matter of time!" And so it was. I still have that check. The difference is that today I could cash it any time I want.

Now, don't worry, this isn't going to be some new agey motivational book. I *am* hoping to encourage you to dream big and live large, but I'm a practical girl at heart—there's nothing hokey in here about doing trust falls with your friends or fire walking through your fears. Officially, I have zero degrees in the art of telling anyone else how to live. I'm not a life coach or a self-help guru; I don't claim to be an expert! What I *do* claim to be is a girl from Missouri who was once a total misfit, but who imagined herself to be a million-dollar woman. A girl who worked hard toward a big goal in an unconventional way, made something of the challenges and opportunities that crossed her path, and ultimately *became* a million-dollar woman with a full and meaningful life.

I truly believe in the idea "Everything you can imagine is real" because it seems like that's what happened to me. That motto means that all the possibilities are already out there waiting to be claimed by each person; if you can let yourself dream enough to visualize them and see that they exist, you'll figure out a way to start connecting the dots and realize them.

So listen up people! This book is my handbook to happiness—let's call it my "philosophy of fabulosity." It's about self-empowerment and self-reliance as much as it is about glitz, glamour, flamboyance, and fun. It's *my* guide to the modern girl's life, which I think should mean carving out your own path to success, no matter where you come from and what you want to achieve: creating an image that is stylish and powerful and figuring out how to use your power to get where you need to be in public and personal realms. In the sixteen laws that follow, I won't be telling you how to turn your pillowcases into shirts or whip up dinner for four in ten minutes. I want to share some ideas on how I got where I am today and give you my thoughts on creating a fulfilling and successful life for yourself; I call it "fabulosity," and I think every woman deserves it.

In a way, this is just a new version of the age-old American

Dream. It speaks to a new generation—and scares the old guard, who call it "too much" because they don't understand it! I'll warn you right off the bat that my way of doing things has never been understated. My style is over-the-top: it's hip-hop; it's bling-bling; it's Elizabeth Taylor and Donatella Versace! It's baroque; it's yards of pearls; it's Coco Chanel back in the day. It's flamboyant, and it's outrageous. My home is grand. I drive a Bentley and a Rolls Royce (one at a time, of course!), and as everyone knows by now, I love diamonds. I do! I am outspoken, extravagant, and larger than life, and I take responsibility for doing things my way, even if it flaunts convention. So to paraphrase what I have been known to say, so cheerfully and oh-so-directly, *Welcome to my life. Please come on in*. But for all you haters who are reading this to judge me when we're done—do us all a favor, and put the damn thing down!

First things first. Why did I write this? Because in the six years that I've been President and Creative Director of Baby Phat, I've gotten countless questions from girls and women asking me how I got where I am today and how they can get there too. They might say, "I want to be a designer, a model, a businesswoman." Or, "I've got young kids too, and I want to feel sexy again." Sometimes it's just the obvious wish: "I want to marry rich and famous like you!" That's okay, because if it's the bling that brings you in—the big old house or the big rocks—now I've got your attention for what I *really* want to say: aspire to greatness, walk tall, and define your identity the way you want, no matter what other people say. And if you want to wear huge diamond rocks on every finger, great! Just don't think you have to wait for someone else to buy them. (And never mind whether they're real or fake!)

I've traveled a lot, and to my surprise, the chorus continues even halfway around the world. On a trip to Southeast Asia, I met scores of women thirsty for knowledge. They'd say, "Your story inspires me—it makes me feel better about my own possibilities!" Actually, what some of them most wanted to know was, "Damn, how'd you get to be so tall?" Apparently they'd never seen a half-Asian woman who stands six-foot-four in her stilettos. But I welcome those questions because what I think they really want to know is, *Kimora, how can I be fabulous too?*

I connect with women like them because I'm young, I'm pop, and most of all, I'm *not boring*! I don't look like a typical company president, and I don't talk like one either: I'm a mix of business, celebrity, and urban chic. I guess you could say my whole approach comes from a mash-up of high fashion and hip-hop: When you throw those things in the pot, you end up with a big gumbo of excess and extravagance. Fashion is glamour incarnate, but it's hip-hop that pushes things over the edge. The hip-hop lifestyle means being on full blast, 24/7; it's always luxurious, fun, and sexy. Some people say it's ostentatious, but what they don't get is that it's all one big celebration, a way of telling the world, "I'm here! I made it!" It's supposed to be fun! I think 50 Cent pretty much summed up the attitude: "Hate it or love it, the underdog's on top, and I'm gonna shine until my heart stops."

I hope that when girls see my clothes, my shoes, or my outrageous jewelry collection, they feel the thrill of wanting more for themselves too. I love what my friend André Leon Talley, *Vogue* magazine's editor-at-large, said: "If you are successful, people want to see it. They want to share in the dream." Amen to that! I want to share my dream with you. Growing up in the Midwest, there weren't many rich, famous, foxy female role models who sparked my imagination. I, like most young women, turned to the fabulousness of Diana Ross, Tina Turner, and Sophia Loren. Inspired by their glamour, beauty, and strength, at thirteen, I set sail on my own unconventional career path and just kind of navigated by my gut, learning as I went. Seventeen years later, my dream has become my living reality.

Let me explain my title, *Fabulosity*. It came to me in the middle of the night a while back. It's not just an expression of this new American Dream in which anyone with a vision and application can claim the prize, no matter who they are and where they're from. It's also a reference to what I did to find happiness: I pushed myself off the comfortable, but ultimately unsatisfying, path that lay before me in life and forced myself to pick the more challenging trail instead.

When I married my husband, Russell Simmons, eight years ago, he was an extremely successful man. One of the founders of

rap and its most important record label, he was, and still is, known as the "Godfather of Hip-Hop." I was a model almost twenty years his junior. I'd traveled the world, managed my own career and money, and worked with many of the top names in fashion carving out an independent life, while most girls my age were getting Slurpees at 7-Eleven. I ran my own show, and I did it pretty well: I built up a nice little nest-egg and had a foundation for my future. But suddenly at twenty-two, I was offered the chance to renounce all that responsibility and coast along easy street. I was married to a mogul! Now, I could be a glamorous *dependent*: I could put away my modeling portfolio, put up my tired feet, and relax (while having as many French pedicures as I wanted!) No more castings, commission fees, and cut-throat competition to worry about—I could busy myself with maintaining my hair and my house and devote my thoughts to how to be the most fabulous arm-candy a wealthy man could have. The job of trophy wife was up for grabs, and it was a made-in-the-shade, pampered-lady fantasy like the ones we used to watch on *Dallas* and *Falcon Crest* growing up, only this time featuring much flyer clothes and cars.

I admit, there was a brief moment when I thought, "This is it; I have arrived!" I was young, madly in love, and the golden land glimmered seductively for a second: a place where your hair colorist always makes time for you because you're his best customer, and there's not a personal shopper for a hundred miles that hasn't run your credit card through the register.

But it wasn't long before the reality set in. A trophy wife has the most boring, spirit-deadening existence ever! I was used to hustling around different cities on jobs, using my street-smarts and sharpening my professional skills, not spending hours swaddled in plush bathrobes or having tennis lessons. In fact, once I quit working and started setting up my husband's and my new home, I got an up-close view of the kept-woman lifestyle. It made me feel sick! To sit on your ass doing nothing but taking French classes all day, or to ride on someone else's magic carpet free, or to cash in on someone else's fame and fortune—that's just not fulfilling! I'd get mad even looking at the women we met who'd married well and given up applying themselves. I'd think, *Girl, be charita-*

ble! Don't sit around doing nothing; at least throw a dinner and raise some money for charity!

And I could see the way the rest of society looked at newly wealthy young wives. Their sharp glances seemed to ask, "What's she possibly got to offer beyond her legs and her looks?" I wasn't having it. The same itch that made me strike out alone in the workplace at thirteen hit me again in my early twenties: I had a hunger to do more and be more than the status quo suggested. The role of acquiesent accessory just didn't fit my personality—there's too much I want to say on my own terms to be known simply as someone's wife. That whole "hook a rich man" paradigm is actually *disempowering* to women! To me, security and success has always aligned with working to *make myself successful* so that I'd never be dependent on anyone—rather than crossing my fingers; hoping someone else makes all the decisions. Don't get me wrong, I'm all for high-maintenance grooming and looking fabulous (and yes, I do have my fair share of plush bathrobes), but a woman should be doing it for herself. It's common sense, isn't it? What girl with half a brain in her head puts in the time and effort to have fabulous hair and perfect nails for the good of someone *else's* reputation?

So I turned to business. The fact is that being around my husband didn't make me want to defer to him or be his designer-dress-wearing Chia Pet. It was the exact opposite—his success made me hypercompetitive. He had his own investments, so I wanted my own as well. To this day, almost thirteen years after we met, part of what drives me every single day is to whup my husband's ass in business. The other part, of course, is whupping my own ass; I've always been most competitive with myself.

It wasn't an easy path to take. In my position as the president and CEO of Baby Phat, I've had to roll over—and I mean really crush—every stereotype you can imagine. The "ex-model" cliché: *What does she know about fashion? She's just a clotheshorse.* The "rich man's wife" cliché: *Why's she trying to meddle with business? She should just shut up and go shopping.* The "socialite" cliché: *She's all about parties and paparazzi—does she even get up before noon?* Even after developing a company that's close to matching my husband's in value, I've been called a trophy wife.

But I've kept going anyway and blown by the critics. By discovering what I love to do and am good at, I have discovered much more of myself. And I have made my own title, my own way of seeing things—Fabulosity, not trophy wife.

How does this apply to you? I want to share with you that you can do anything, no matter what other peoples' preconceptions may be and no matter what fences seem to surround you. You might not be called a "trophy wife," but you might know the feeling of being stuck in a rut, standing in another's shadow, or not getting the credit you're due. It doesn't have anything to do with being married or having money or not—you could be a stay-at-home mom who's working like crazy to look after the kids or a student who's got no idea how to get her start in the world. What I'm talking about is recognizing the urge to bust outside of situations that appear to be limiting and taking responsibility for your own happiness.

When I began working on this book, I thought it was going to be a guide to great style. A kind of primer in glam—*Ghetto Fabulous 101*. But when I started thinking about style, I realized that talking about that stuff—the clothes, the shoes, the cars—is like starting halfway through the movie. Style is an expression of your confident, fabulous self; it's a useful tool and helps you create your persona. But how do you get the self-assurance to be fabulous in the first place? When other women ask "How do you do it?", it's more than asking how to acquire a killer wardrobe and runway walk. What they're really asking is "How do I live out my dreams? How do I create the satisfying life I want for myself when I can't see any way to start? How do I project the image of the person I want to be when nobody is showing me how?" As an answer to those questions, I drafted sixteen laws, one for each chapter that follows.

"There are only two types of women—goddesses and doormats," Pablo Picasso once said. Although I think it's a pretty sexist thing to say, some part of me can't help but agree. I think all women are goddesses, and it's just a matter of letting that goddess-power shine—and if you don't try to be the biggest and baddest damn goddess you can be, you are selling yourself short. Even in

our society today, girls are conditioned to be demure, modest, and bashful about their achievements. I say: *Enough!* It's the twenty-first century, and it's time we defined a new model of the powerful, self-defined, sexy, and successful woman. The following are the five key components to my fabulosity philosophy, which I'll return to again and again:

Confidence: I want you to dream in wide-screen format and to take the steps to put those dreams into motion. To feel sophisticated, independent, and glamorous! To love yourself enough to grab for better things. I want you to speak up, speak out, and add your voice to the cultural mix.

Uniqueness: Believe that you should stand out *because* you're different, and don't ever worry about trying to blend in. Be true to yourself and stick with who you are, through thick and thin, without letting anyone dilute your essence. Take unconventional routes, and don't fear if you don't have the "right" education, background, or connections.

Independence: Make self-reliance your foundation. Open your own doors, grab your own opportunities, work as hard as you can, and manage your own money. Carve out the high-profile persona you want, and be high maintenance on your own dime! Find satisfaction in yourself first before you ever start seeking it from anyone else.

Luxury: Know that every woman deserves to indulge in moments of luxury, never mind how large or small. Use fashion and beauty to indulge in fabulous, sexy, and feminine power, and be free to express it however you want.

Generosity: To be a good leader, you have to be a good servant. No amount of cool "lifestyle" things will truly satisfy you until you know that you are contributing to the world and giving other people happiness. Do not hoard your good fortune. To whom much is given, much is expected.

I'm not telling people to want my life. Because lives are like fingerprints, we all have different ones. The point is to live the best life you can live and make a difference in the world while you're at it! I've found a formula that's worked for me—and most of it is simple common sense. You know, the stuff your mother always told you, and you told her to shut up and let you grow! Whether I'm perfect at living with Fabulosity 100 percent of the time or not, I'm going to preach it, and I'm going to practice it. I'm going to talk the talk and try my best to walk the walk. And when I get down, I remember that this is just a journey of growing and learning, and I think of the Maya Angelou quote, "You did then what you knew how to do. When you knew better, you did better!"

I do feel like I've come a long way in a short time. The kids used to talk about me and do me so wrong and pull my hair, but look at me now—not that I want to toot my own horn because I'm trying to be a graceful woman, but toot toot! Look at me now! The way I've done things I feel like all of you are on the journey with me. Other fashion designers start by producing expensive lines and then work downward to reach larger audiences with cheaper lines. I'm moving in the opposite direction—upward. First I created Baby Phat; then we did a contemporary, more expensive line, KLS; and finally, at the top-level, the Kimora Lee Simmons collection. In other words, I am on the ups! And I want to take my girls with me, all of you who've been with me for the whole ride supporting our vision at Baby Phat. That's why I wanted to write this book—for the women who buy my jeans, my shoes, my jewelry, my cosmetics, and my "Goddess" fragrance and who came up to me in the street and at in-store promotions. I can't help but want to give you some of my advice, too. No matter what I've achieved, deep inside I'm still that girl who goes against convention and rocks the status quo. There's a lot farther to go; I want you to come with me.

Always Aspire!

"He who is not courageous enough to take risks will accomplish nothing in life."

—MUHAMMAD ALI

"If I'd observed all the rules, I'd never have gotten anywhere."

—MARILYN MONROE

"You must act as if it is impossible to fail."

—GHANIAN PROVERB

"Although there may be tragedy in your life, there's always a possibility to triumph. It doesn't matter who you are, where you come from. The ability to triumph begins with you. Always."

—OPRAH WINFREY

"It's a risk, but I believe the best investment you can make in anything is yourself. Invest in yourself, and then back it up. Back it up with what you do."

—IMAN

Self-belief
&
Confidence

P Powerful

R Responsible

I Independent

D Determined

E Entitled

If you're gonna buy caviar, make it beluga

SO THIS IS THE JUMP OFF. I'm gonna start with the fundamentals: my ground zero for success. I call it the "Grand Aspiration Theory"—the G.A.T.—and it's pretty simple. It goes like this.

1. High aspirations breed frustration.
2. Frustration breeds motivation.
3. Motivation pushes you to action—whether you take tiny baby steps or huge strides.
4. Action breeds confidence; you start to feel in control.
5. Confidence is cumulative: Once you start acquiring it, you get more and more of it.
6. *Soon enough, you prove to yourself that you're a star who can surmount any obstacle and achieve whatever you decide you want to achieve with your life. You're on a roll!*

And all this because at one point, you let yourself wish you had something that other people told you was way out of reach.

I've always had high aspirations. Even as a small kid, I was never satisfied with the status quo and was deeply competitive with myself: I always wanted to enhance things and make them

better, and I pretty much always believed I could. Where this strong opinion of myself came from is hard to say. Partly it was due to my mom. She brought me up on her own in St. Louis, Missouri, and being a first-generation Asian immigrant, she had high expectations for her only child. Partly it came from my absentee dad. Since I didn't see much of my father, I subconsciously turned my insecurity into action and thought, "If I don't take charge of my life, nobody else will." I know all the statistics and what the numbers say about the benefits of a two-parent family, but it's not always the reality—and I think it's fine either way. Since I was raised by my mother alone, I came out more empowered, not less. From what I saw, women were the center of the world! We are the center of the universe! I had the proof in my mother that a woman can do anything, even though the time, the situation, and everything else may be against her.

I'm a Taurus, which means I am acquisitive and pretty stubborn about doing things my way. So it's not surprising that the clues to my ambition started popping up pretty young in the one arena I had some control over—style. When I was eight, my mom decided I should attend a Girl Scout summer camp outside St. Louis so that I'd keep busy during the day. She worked for the government as a social security administrator in charge of thirty people, and I normally went to babysitters after school, but summertime required more planning. The Girl Scout set-up was nothing fancy—just a place where regular kids from town would go by school bus to scamper around the woods and learn how to tie things in knots. But when I heard the words "summer camp," I figured, "I'll do summer camp *times ten*." Where most kids were outfitted in sensible neutrals and navy-blue shorts, I insisted on a perfect, white-on-white sporting ensemble: a crisp Izod polo shirt, Jordache shorts with stripes on the side, and squeaky clean K-Swiss sneakers. The fact that white clothes require major upkeep when your daily activities include dodgeball and Twister in the grass didn't faze me one bit. If I had to use a toothbrush to keep those sneakers box fresh, so be it. Such was the price for style.

Some would call it picky; I'd call it a natural penchant for Fabulosity and a desire to rise above the rest. Why blend in with the

ordinary? Why be happy with the same-old, same-old? If everyone else is rocking beige, it'd be just plain silly not to rock magenta.

My insistence on style at all costs was also a small act of rebellion. Although our house was long on female self-empowerment—my mom was a self-made woman who always told me, "You can do anything"—it was short on glamour. There wasn't much cash to throw around on frivolous things like fashion, so naturally that's what I wanted most. It drove my mom nuts because she hated to shop. She'd compromise by taking me to the one-stop shop where they had everything—from shoelaces to hair bows. Once there, I had to unleash my own meticulous vision and go to major creative extremes to get the most bang for the buck. Since I was pre-pubescent, most of my fashion sense revolved around color, usually purple. (It was a Prince thing, I'm sure). I spent hours picking out the elements to make a complete mono-chrome ensemble: purple shirt, purple sweater, purple pants; purple socks, purple sneakers, and purple laces. I'd also carefully watch the way my older sister (from my father's previous marriage) put outfits together and use the funky pieces she passed down to me to create my own looks.

As I got more advanced, I developed a two-tone thing. Red and black perfectly alternated from head to toe: red shirt, black vest, red skirt, black tights. I had to match everything to the T, and the distribution of color had to be even. Mom would despair, "Kimora, you don't have to coordinate the exact same shades of red. You can wear a purse that's a different tone of the same shade." But I knew better. To be polished and pulled together, I had to be hooked up. I always remember it because everybody would talk about me—I guess that's when I made the connection between style and power. (Maybe those rigid dress codes offer a glimpse of my psychology as well: Even today, I need order in all aspects of my life to keep chaos at bay. I'm all about lists, charts, polaroiding my outfits, and doing the numbers three times over.)

One of my biggest pleasures back then was to fly through the streets of St. Louis on my banana-seat bike—probably wearing color-coordinated bike shorts under my miniskirt and trailing matching ribbons from the handlebars—and look at the biggest

houses on each block, imagining that one day I would live in them. Which one would I pick? What lawn ornaments would I have out front? Would I build a swimming pool or a tennis court? Kids do that all the time; they have elaborate fantasies and don't question whether they are worthy of them. They start off life with a simple assumption: I deserve something special simply for being me. My three-year-old, Aoki Lee, maintains that she's a different princess, mermaid, or fairy every day of the week, and she never questions whether it's possible or not! She announces who she is today and acts accordingly. It's just that as adults, we lose the skill of imagining better things and skulk around half the time as if we're not entitled to want. I didn't really know what I wanted the future to bring as I pedaled around those leafy streets, but looking at those houses, I started sketching colorful fantasies for myself and imagined that what was coming would involve money, power, and respect.

There's another reason I couldn't help but think that I could do anything or be anything I wanted as an eight-year-old. Hello—I'm a child of the late 1970s! By the time I became a consumer of pop culture, media was bombarding me with the kind of candyland have-it-all images of what a woman's life could be. The 1980s was an era of Wall Street superwomen in padded-shoulder power-suits, *Dynasty* glamazons in Bob Mackie sequins and sapphires, and Janet Jackson telling every little girl like me to take *Control*. It was Jennifer Beal in *Flashdance*, sweating in those legwarmers to prove she was way more than just a welder, and it was *Fame! What-a-feeling!* inspiring me that kids with dreams could make it to the top. And of course there was Madonna, blowing the lid off everything grandma ever said a woman should be. I guess you could say I had a healthy dose of *bronze* ambition from an early age.

Factor in that it was the decade of "conspicuous consumption," full of shiny *Miami Vice* Ferraris and turbo-charged speed boats, and you can pretty much see my daydreams take shape: Everything in them was big, fast, colorful, and luxurious! The daydreaming worked—twenty years later, I've achieved as much as I could've hoped for and more.

YOUR HOMEWORK: VISUALIZATION

There's a famous female opera singer who takes a few moments before performances to visualize herself giving an incredible performance, complete with standing ovations. She runs through the whole scenario quickly in her head to direct herself in the right direction, as if imagining the only possible outcome is success, and then she takes the stage with confidence. The same thing goes in any realm of life: Letting the mind see clearly what the heart really wants often prompts the right choices and manifests the right outcome. Take some time and play a few scenes in your head of the life you want—the details are what gives it shape. Maybe in your vision you're a businesswoman striding down Fifth Avenue on your way to a power meeting. What are you wearing? What shoes have you picked out? What is the reaction of people when you walk in the room? What fantastic trip are you on after this meeting? I'm not saying indulge in these as escapisms: It's sketching out a picture of what you want to achieve so that you can make a grab for it.

So why does having high aspirations get such a bad rap these days, at least in mainstream culture? If a woman is seen to be wanting too much and aiming too high, she'll get taken down in a hail of snippy comments: "She's got delusions of grandeur! Who does she think she is? What a social climber!" As if it's a negative thing to want to play with different cards from the ones you were dealt.

I don't get it. Without aspirations for a better existence, you're stuck in the mud and going nowhere. To me, if a person never wishes for more rewards and a better quality of life, she's being complacent. And she's selling herself short because she never even gets close to stretching her potential. In my opinion, *not* having aspirations is cause for alarm. When I hear someone's suffering from apathy and has lost that itch to achieve more, do more, or be more, I want to run out and give her mouth-to-mouth resuscitation and wake her up with a real Kimora Lee Simmons bang! The whole neighborhood would hear me yelling: "*What?* Are you con-

KNOW YOUR VALUE

Hey, Miss Fabulous with a college degree and a decent job. Did you know that in this country a full-time working woman currently receives only seventy-three cents to every dollar received by a man? That African-American women are paid only sixty-five cents for every dollar received by white men, while Hispanic women are paid only fifty-three cents to the dollar? Why aren't you asking for more, demanding a pay raise and a promotion?

And you, Ms. Hard-Working-Homemaker, dealing with the kids, the pets, your aging parents, all on your own? Did you ever add up the time you spent cooking and cleaning at home and find out what the going rate is for a maid and a chef just so you know what you're worth? Not to mention a food-shopper, babysitter, and elderly-parent caretaker too? This is not cheap labor you're performing! Push for your rewards and your rights. My point is that you can never afford to get complacent about your value. Whether you're juggling three part-time jobs or working at home, don't just float through life taking the cards that you are dealt. Maybe you need to rent the movie *Waiting to Exhale*.

tent to be scraping by week to week, getting paid less than you deserve?" Or, "You're okay with dating that loser guy who's already got three kids by three other women?" Or, "You're happy to be that man's mail-opener for twenty years when by now you could be head of the department? Wake up! Stop sleepwalking through your life!" Then if that didn't work, she'd have to go, honey! Life is too short for that.

I'm not trying to dump on any of my sisters. It's the opposite. I think women are all-powerful, all-mighty goddesses who can do any- and everything they want. It makes me mad when I see girls who are too accepting of what they have when what they've ended up with is not at all close to what they always wanted. It makes me so frustrated to see women who don't feel the fire burning up inside them that makes them say, "Screw you, I'm worth more than this!" So you got pregnant at a young age, and people told you your

life was over? You failed all your tests, and teachers said you wouldn't amount to much? You picked the wrong job, wrong man, or wrong town and feel the walls closing in? Get it together and get started with the next chapter of your story! Keep the momentum moving forward and know that it's easier to make adjustments once you're in motion than if you're frozen on the spot.

If you look up the word "aspire" in the dictionary, there are two definitions. One, to seek to attain a particular goal. And two, to soar to a great height. Now I ask you, who hasn't wanted to fly at some point in their lives? Who doesn't dream of gliding over treetops when they're in their beds at night? You probably thought it was possible when you were five years old and stood three-feet tall in your Mary Janes. So what happened between then and now that you stopped wanting to soar—when did you start being so irresponsible to yourself?

I'm big on aspiration mainly because I don't fully believe in lucky breaks, fairy godmothers, or men on white horses coming to save the day. I think you have to want things for yourself, make them happen for yourself, and take risks to put your own dreams into motion. Once you do that, it's amazing how the doors start opening—but they don't swing wide when you're hanging out at home reading your old *Cosmo* magazines for the fourth time in a row. Don't get me wrong: I'm not saying you should simply aspire to make a ton of cash or get famous. Instead, I think that first and foremost, you should aspire to a level of personal excellence—to be the best you can be. You should aspire to have the richest life you can get in terms of fulfillment, happiness, and peace. And then, hell, when it comes to material things, sign up for the best there is as well because this should be your default attitude about everything in life: You want caviar, so you reach for the top shelf and snatch the Beluga—it's the best!

That's what I mean when I say, *I want to inspire you to aspire.* I want to be your own personal Lynda Carter, aka Wonder Woman—the larger-than-life fox in a satin bustier who makes you want to throw a lasso around your dreams. I'm like the 2005 version of Jane Fonda in 1985: "Come on ladies, you can do it, feel the burn!" Only I do it in jeans and stilettos. I'm not flaunting a fancy

lifestyle to tease you. I'm not trying to make you crazy by dangling a diamond ring in your face like a carrot on a stick. I just want to light a fire under your ass. Because in my opinion, actively wanting the best you can get is like switching on the AC volt. It empowers you to get your butt off the damn couch, turn off the TV, and make something of your life.

The key is to cultivate a sense of entitlement. I know, I know—entitlement is another one of those words that are frowned upon. It means to act like you think you're "too good," right? It means you're a snooty bitch with her nose in the air, right? Double wrong. What entitlement means is to have a right, a privilege, a claim to something. Entitlement means giving yourself permission to reach, and I believe every single person needs a healthy dose of it to get anywhere in life. Do you think Serena Williams ever wins a trophy by muttering as she walks on court, "Maybe if I'm lucky and the other girl's got cramps . . ." No! She walks on with 300 percent entitlement, thinking, "I have sweated my ass off for months, and I am going to take that trophy home if it's the last thing I do because I deserve it!" Game on!

If you can't picture ever winning some kind of glittering gold cup and holding it above your head while the cameras pop, I think you're suffering from a lack of imagination that's rooted in fear. Fear of change, fear of trying and not succeeding, or fear that you won't even know what to ask for because the exact trophy you want isn't clear to you yet or perhaps the path isn't obvious. But here's a revelation that might help: *It's not a weakness if you don't know what to do with your life—that's the state most of us are in most of the time. The weakness is if you don't want anything at all and settle for just the minimum of what you can get.*

I always tell people that if you don't know what to do with your life, go to school or college. Don't sit at home doing nothing and not know! You don't have to know what you want to be when you graduate. Get active. Take the classes, meet the people, and a clearer path will emerge than if you were just sitting at home. Because you can't generate something from nothing—no matter how hard you sit and think it over. And this applies to anything in life. If you don't know what to do, just do something.

fabulous: Amazingly or almost unbelievably great or wonderful. Existing only in, described in, or typical of myths and legends.

DO IT YOURSELF #1:
START A JOURNAL.

Saying your intentions out loud and writing them down on paper confirms things and makes them happen. It's a way of stating your intention to the universe. Keeping a journal that only you have access to is a very healthy way of downloading your hopes, dreams, and wishes and giving them concrete form.

To me, fear and frustration are useful things. When you're in a swirl of frustration because you can't see the way out or you hate your life, that energy fires up the cylinders. It's like cranking the motor that drives change. Frustration is what made me get on a plane to go work in Paris as a thirteen year old, not knowing a soul there or speaking a lick of French. Frustration is what made me want to develop a fashion brand as a young woman when a rational person would've thought they didn't have the know-how. As for fear? Let's just say that fear of failure is the best motivator there is—at least until you're enlightened enough to be completely fearless, which is the ultimate goal for all of us, isn't it? 'Til we all get there, I say, appreciate how fears of failure and of wasted opportunity can drive a person forward!

Here's my truth: I never had a concrete picture of what I wanted. I never knew I wanted to become X, Y, or Z in terms of jobs or career. But I did know I wanted to be someone that people talked about for being excellent. I figured life would show me how and where to make the turns along the way. And meanwhile I set for myself the best goals I could—even if they were very broad ones like "make a million dollars." I had intentions of the *kind of life* I wanted—a big life, a trophy life full of stimulation, rewards, luxury, and love. That was enough to make me think positively about my own potential.

What I've discovered since that time is that almost every successful person I've met has come up with their own unique way of

creatively visualizing success. They declare their intentions to themselves and to the world by writing them down, saying them each morning as affirmations, or drawing a picture of what they want rather than holding their hopes close to their chests like a guilty secret. I read that Tiger Woods put his goals on index cards and stared at them every day! It doesn't have to get more artistic than that. By stating something you truly want, you show yourself that you believe in your goal, even if you don't know exactly how you'll get from A to Z. Get started, hold yourself to a high standard of self-worth, and let life take care of the rest.

At the time of writing that million-dollar check, I really believed I was a million-dollar woman. I believed that I would make that money myself—I've always been of the school of thought that you should do everything yourself because you can. Fourteen years later, I'm starting to understand that money is just a way to quantify success and see if you've hit certain goals. What really drives all of us is the need to prove ourselves and make something of our lives: It's a need for self-respect. But I recognize that money has made many a person, including myself, get the brick out of their ass. So I won't ever tell you not to write yourself a check like that— just remember to factor in inflation. A billion is the new one million!

By now it's probably clear that I think the starting point to absolutely everything good in life is not your background or your social situation. It's self-confidence. Luckily, confidence is one of the few things in life that's free, and it accumulates quickly. You can start with really simple things, like pulling yourself together and taking pride in whatever you have, even if it's one pair of jeans and a couple of T-shirts that you iron and accessorize differently each day or writing one good paper or report at work that you know is your best work. That's the first nugget; then you acquire more scraps of confidence along the way because in my experience life puts the obstacles and challenges on that path where a person needs to grow.

Kimora's guaranteed top five confidence tips

1. *Never say never.* Banish certain words from the brain: "can't," "won't," and "don't." Any time you think you can't, you can't. All of us need to retrain our brains because negative thoughts do become true if we believe them: I'm a loser; I'll never amount to much. Believe and know that you are everything you'll ever want. Whatever you believe and know about yourself is what it's going to be.

2. *Fake it 'til you make it.* I don't mean to fake being somebody you're not or being a phony. I mean tell yourself that you're great even when some part of you is doubting it. It's a trick-start, just like when your car dies and you push it down the hill to start because it catches from the momentum. You don't even have to believe everything's going to turn out or that you can achieve it all right now—fake that you do, and it will get you moving forward.

3. *Trust there's a reason that you are there, not someone else.* This is a trick I used any time I got nervous as a model, up there on the catwalk in front of hundreds of people. I figured, "I am up here; you are down there in your seat. If you think you can do it better, you get up here and do it, and I'll go take your chair. But for now, I'm the one here, so even if I fall flat on my face, it's still more than what you're doing in your chair!" Once I acquired that attitude, my steps got stronger, and my head got higher. I've continued to use that throughout my life, whether I have to give a speech or attend a big red-carpet event. I tell myself, "I'm here because I deserve to be here, not because of some mistake."

4. *Believe other people's confidence in you, even when you don't believe it yourself.* I learned this early on thanks to an older model—let's call her Jennifer. She was another part-Asian runway model who was in her thirties when I was thirteen, and she hated

me for being on her turf. So when we got paired up to walk the runway—back in the day, fashion shows were a little more choreographed—she would "forget" to do the turn at the top of the catwalk and just keep on walking, leaving me in the dust out there alone. I was mortified, but I chose to believe the people who consoled me: "No, she's the fool; it's obvious she did it on purpose. It only made *her* look bad, not you." I chose to go with their words instead of my own thoughts. Reveling in self-pity and going, "Oh my god, I looked so bad; everyone hates me!" would have made me want to run and hide.

5. *Choose your company wisely.* Confidence is contagious: We can each pick it up by hanging out with people who have a lot of it. To girls and women of any age, I say put yourself in proximity to successful women who've got it together, and it will rub off on you. Whether it's an internship, mentorship, or befriending the latest fly girl. At the end of the day, we're all in it together, and we should stick together! Society makes it tough enough by degrading women, putting us down, sometimes treating us like we're nothing. In urban culture, in hip-hop videos, everyone's naked and shaking their booties, barely this side of porn! I admit I dance along and shake my booty to the music too—but I still want to counter that with alternative messages because women should be applauded and up-lifted, and I don't think it happens enough. So have the confidence to tell another sister, "You are a total goddess, and I want to be like you!" The rule is the more the merrier. It's not a one-woman show.

To this day, the one critique people like to throw at me is that I am "too much." Too loud, too flamboyant, too self-confident, too bling. *What!* How can you be too self-confident? Do they say that to Elton John; do they say that to Donald Trump? I think not. Maybe it's true that a confident woman is threatening. Maybe they know we really are the masters of the universe. Whatever the case, I say, "Shoot for the moon, and even if you fail, you'll be somewhere amongst the stars."

"The thing women have yet to learn is nobody gives you power. You just take it"

—ROSEANNE BARR

"It's the repetition of affirmations that leads to belief. And once that belief becomes a deep conviction, things begin to happen."

—MUHAMMAD ALI

"Some people say that I have an attitude. Maybe I do. But I think that you have to. You have to believe in yourself when no one else does—that makes you a winner right there."

—VENUS WILLIAMS

"The question isn't who is going to let me; it's who is going to stop me."

—AYN RAND

"Strivers achieve what dreamers believe."

—USHER

Le freak, c'est chic!

HERE'S MY BIG SECRET. I'm the misfit that made it big. I'm the too-tall, too-weird, not-black-enough but not-Asian-enough, too-ethnic, too kooky-haired, too-dark, *and* too-light . . . girl most un-likely. And I have a message for anyone out there who's sitting there hating on herself—anybody who at this minute is picking apart her looks, her body, her hair, or her one-of-a-kind accent, her bizarre family, or her crappy neighborhood that's not like the ones on TV: *Thank God you're not average.*

Average is safe. Average is comfortable. But average is boring and totally not fabulous!

This is not obvious when you are young, unhappy, and living anywhere outside a funky, fashion-forward city. But by the time you are a Gucci-sandal-wearing, paparazzi-attracting, multi-company-owning grown woman—or whatever traffic-stopping female you fantasize about becoming—I promise that your differences will be your strengths, and your underdog past will be the key to your suc-cessful present. Look around! The most incredible artists, innova-tors, and entrepreneurs have always had the most awkward and uncomfortable beginnings. What they did was turn adversity into power and spin perceived negatives into brilliant positives—and

then got the satisfaction of raising their middle finger at the establishment at the end.

I know this from experience because I've never blended into anything in my life. Whether I liked it or not, from an early age, I stood out from the crowd—literally. I was super-tall and super-skinny by age eleven: five-foot-ten in my bare feet. I was a mutt mix of chocolate and cream: part Japanese-Korean thanks to my mom and part African American thanks to my dad. In the late seventies and early eighties in the heart of the Midwest, where skin was usually no darker than suntan and hair was, ideally, blonde and feather-cut, my ethnic combination was totally not cool. Oh yeah—then there was my name. Kimora. The kids had fun with that one, too. Creamora. Kimchee. "Can I have some-mora, Kimora?" as they stole my lunch from my Cabbage Patch lunchbox.

There was always a different flavor in our house, somewhere between three cultures without really landing permanently in one. Mom would make rice noodles, and I'd make mac and cheese on the side and then flick through *Vogue* and *Elle* magazines in my bedroom, wondering—is this me? My mom is very *Joy Luck Club* about things. It's the Asian way, where you don't know stuff about your own parents. Sometimes she'd go by the name Joanne and other times by Kyoko. (To this day, I don't know how old she is because she would never say). I guess in a way it was just as hard for her to be in Midwestern limbo. There weren't a whole lot of Asians in St. Louis, just a small community—but it was its own self-contained group, where people were fully Asian in their language, food, and customs. She created something looser than that. Sometimes she'd get Asian friends and their kids to come over and play with me so that I was exposed to more people "like me." But I never really saw myself reflected back in any of their faces because I was darker than them.

What I saw in pop culture was confusing, too. If I was black, then wasn't I supposed to have a *Cosby Show* life, with my own Dr. Huxtable in a Z. Cavaricci sweater to take care of me? And if I was the typical American kid—a spelling-bee champ with a collection of Strawberry Shortcake dolls in my room—then why didn't I have

a chirpy household like the one in *Family Ties*? It didn't quite add up. It's funny. Today, marketing gurus make a big deal about things that are "out of the box." Out of the box means something special, original, unexpected, not the same old seen-it, done-it paradigm. When you hit on that incredible, O.O.T.B. idea, that's when you have the huge hit product on your hands. Well, I've been out of the box since I was about four years old—but it took me a while to realize what a gift that would turn out to be.

It was when pre-puberty struck that things started getting tough. One day when I was ten, my back started hurting. In the morning when I got out of bed, I'd feel my lower lumbar region just ache. "Mom, what's wrong with me?" I'd complain. "Oh, baby," she'd say, "you're just growing!" The problem was that it had started too soon. Some kind of Jack and the Beanstalk thing took over me as I inched up the chart. It was horrible. Clothes I'd wear one month would be totally outgrown by the next. Five foot six, five foot seven, and up. . . . While all the other kids in class were still bungalow-sized, I was becoming a lofty skyscraper. Combine my skin, my eyes, my lips, my hair, and my height, and I couldn't hide if I tried.

I didn't tell my Mom how I felt, though she probably guessed how unhappy I was. Maybe I inherited more of her *Joy Luck* spirit than I knew—I kept all my confusion inside. Nothing seemed to fit me: neither my clothes nor the private, Lutheran grade-school I'd been attending, which had no Asian students and hardly any black ones. I got it into my head that if I transferred to public school for seventh grade, I might find a place that felt more like home, where everything was more mixed up and diverse and not so perfectly Midwestern. My mom agreed that a new environment might help, and I left the safe ground of private school for regular junior high.

That's when I discovered what it *really* means to be different. In a school that mixed kids of all races and from multiple neighborhoods, the social boundaries are suddenly life-or-death. I thought it'd be so much cooler—that the black kids would high-five me and the Asian kids would trade slap bracelets with me, and I'd get to sit at whatever lunch table I wanted and share my New Coke and Cheetos. Instead I soon discovered that junior high was

all about strength and survival: I had to walk the minefield and try to avoid the bombs. Kids like to create a clear boundary between who's in and who's out because when someone else is the outsider, it makes them more secure about themselves. As the most visibly different person around and a new addition to the class, I didn't fit in any of the cliques. Plus I towered over the boys as well as the girls, which meant few friends and even fewer dates.

Maybe they knew I'd been to private school beforehand—that probably didn't help. Midway into the first month, I started to hear the whispers and giggles from this one particular posse of tough girls who didn't take kindly to my unorthodox looks or my well-accessorized dress sense. "Chinky Giraffe," they'd say and laugh hysterically at how funny they were and so smart, too, for coming up with a nickname that covered all the bases—"giraffe" because I was way too tall and skinny, with long, loping legs. And since I definitely had some Asian in me too—horror of horrors—they added the "Chinky" in a surefire stroke of genius. Pretty soon the name caught on, and if those kids or their friends were hanging out in the street, they'd yell after me, "Chinky Giraffe!" It really hurt, especially since "chink" was like a slap in the face to my Mom and all the values she believed in. The neighborhood boys who yelled after me weren't really the problem. They were just goofballs who didn't even know how to talk normally to females; their comments weren't sharp enough to sting. It was the girls I had to watch out for.

What I learned pretty quickly is that if a group of chicks sniffs out your weakness, they'll come at you like hyenas thirsty for blood. In public junior high in Missouri, the mean girls were real bitches, and they played hard. They tried to break me down—pulled my hair, stuck out their feet to trip me, and at one point, chased me down the hall with a can of hairspray and a lighter, threatening to torch me with a *woosh!* I mean, come on!

I refused to sit back and be bullied and instead sought other people who could give me better support. The St. Louis boys who hung out around the mall liked me because all of them seemed to think I was older and sophisticated due to my height. That helped me think better of myself, but since thirteen-year-old boys aren't

the most picky bunch when it comes to socializing, it didn't fill my needs. I wanted the *girls* to like me. Young or old, girls are the ones whose opinion seems to matter the most—they judge you most harshly but compliment you most truthfully too.

Ultimately, what it all came down to was hair. My hair was super-long and crazy curly, exactly like my daughters, Ming Lee and Aoki Lee, today. It was the damning evidence that made the black girls say, *"She's not really black!"* But since it was the mid-eighties and the ultimate era of big hair, when every white girl in the Midwest was teasing, perming, and crimping their locks to new heights, I had an automatic "in" with their clique. The white girls loved my hair! I could do huge side ponytails, major standup bangs, and I never needed a crimping machine to get waves. They thought I was the bomb. The result was that the white girls accepted me, and the black girls ostracized me, saying, "She's so stuck up; she thinks she's white. She thinks she's better than us—look at her over there." It's stupid how all of us let those prejudices bubble up in ourselves. But I had to believe I was above it all, or I would've sunk like a stone. The stronger I got in the face of their taunting, the more it made them mad. When you learn to become unfazed by your critics and don't burst into tears, it confuses the hell out of them—I see that even now.

Then one day I got a reprieve from my seventh-grade hell. My mom sensed that under my cool surface I was becoming a pre-teen mess of self-conscious self-doubt. She enrolled me in a local modeling school so that I could be around other tall, awkward teens and learn to carry myself with confidence. Her intention was never for me to become a model, but for me to stop slouching, pull my shoulders back, and find the confidence and poise I needed to carry off my height.

As a rule I don't recommend modeling schools. I believe the majority of them are designed to take girls' money and give them false promises of modeling stardom. But for an eleven-year-old misfit, learning how to walk with a book on my head, how to go to castings, and what to pack in a model bag offered me a chance to finally let my guard down. Instead of being slammed, my giraffe proportions were celebrated. One of the women who ran the

school was a six-foot-tall goddess named Meg, who instantly took stock of my strange mix of features and my huge, crazy hair and told me, "Girl, you've got something special." Her positive words started to replace all the negative ones I'd heard so far. And for the first time, I understood that it just takes one person to see something in you to turn everything around. If you take their praise and plant it, nurture it, and let it grow, one small seed becomes a strong root of self-belief. Meg's words made me let my true personality out and from that minute on, the stupid kids at school didn't have such a hold on me.

Soon enough, the classes morphed into real casting sessions and meetings with prospective clients. There was no big whoop to modeling at first. It was something for me to do with my time and get paid; where other kids did ballet or gymnastics, I did modeling on the weekends. Nor was it extremely glamorous. My mom would rush me to castings during the week, oftentimes getting chewed out by her coworkers and risking her job to get me to appointments before five. Although I didn't know much about anything, I started booking work; one of my first gigs was as a living mannequin for a local St. Louis mall. This "freeze modeling" meant I got paid by the hour to sit still as a rock and look into the distance. It was boring as hell and gave me a very sore behind, but the fact that I was hired for a professional job was like a shot of vitamins in the arm— I felt like I had the power to pull myself up to my full height, look my tormentors in the eyes, and say, "I *dare* you fools to call me Chinky Giraffe one more time; I'm making $250 an hour on the weekend, while you girls don't even know what a job is!"

The turning point was when my teacher sent me over to a big modeling convention in Kansas City. A convention is a little like an NBA talent camp, where scouts come to pick up players and hopefully find a few diamonds in the rough. For one weekend, model agents from around the world come to scrutinize thousands of teenage girls and hope to discover the next Cindy, Linda, or Naomi—and if not them, then a few bankable faces who will work steadily in catalogs and ads around the world. The goal as a fledgling model is to do the rounds and introduce yourself to all kinds of professionals, from agents to photographers to acting coaches,

WALKING THE WALK

When I was 14, I got interviewed by Mary Hart on *Entertainment Tonight* for a "true-to-life Cinderella story." My mom was so excited! She still has the tape, on which I say, "I know I am different because I don't see anyone else who looks like me out there. But I like it. Being one of a kind is better than being one of a hundred people who all look the same." So it's proof that I'm not just saying all this stuff with the benefit of age. I walked the walk back then as well. (And today I am one of the regulars for *ET* and *The Insider* on air!)

and compete in various categories to get recognition, such as Best Runway Walk and Best Portfolio. I made the rounds, and everyone said, "Wow, who knew this girl was here under a rock?"

Attending the convention scored me one of the biggest agents in Paris. Although I was as young as they come, the French agents told us, "Kimora must come to Paris. She can't achieve anything just working in St. Louis." That was it! My ticket out. I begged and begged my mother to let me go. Since she was a working mom and couldn't afford to just ditch her career for me, she had major reservations. But she had grown up living in different countries where she was exposed to foreign peoples and cultures—she lived in Asia before coming to the United States—and she knew that the benefits of sending me to a place where I might finally feel accepted and observe new lifestyles would outweigh the risks. I had never, ever been abroad, but to the challenge of living in a city where I didn't know a soul and didn't speak the language, I said, "Bring it on!" My new agent promised to provide me with a place to live and to watch over me like a hawk. The summer before high school started, in 1989, I was on a plane to France. Bye, ladies!

Paris was a different story altogether. Parisians just *love* the exotic, and they've always had a thing for black Americans. It's where Josephine Baker—also from Missouri—found her fame, where James Baldwin found his peace, and fashion designer Patrick Kelly got his big break in the 1980s. (Not to mention they

got Grace Jones long before the rest of the world did.) It's as if they give you credit just for being ethnic—like somehow we're jazzier and cooler than the norm.

Being a mix of skin tones and features, I played even more into the exotica fantasy. I got all kinds of nationalities and cultural stories projected onto me. In fact Valentino used to tell people that I looked like a Gauguin painting. A Polynesian Queen! I barely knew where the South Sea Islands were on a map, let alone ever claiming to come from there, but it was funny how many people picked up on that and assumed I must be some kind of Tahitian girl with a closetful of grass skirts and flower leis.

The thing is, that's fashion. It's a fantasy world where everyone recreates himself or herself over and over again—designers reinvent their entire look several times a year—and you can adopt any persona you want, through clothes, hair, and makeup. Being different is what the whole industry of fashion is about! If they couldn't persuade women to go from short skirts to long in the blink of an eye, they'd all be out of business. So I started to explore this place I'd come to, figuring out what my place in it might be. I actually went to the Louvre one afternoon and stared at the Gauguin paintings. I did look like those girls, and they were beautiful!

Yes, there was something kind of screwed up about the ethnic reinvention, especially when people in the business would say, as they did from time to time, "Oh don't worry, you're not *black*— you're exotic!" as if under the admiration of "cool" black folk was the reality that we still never got booked for the elite jobs or commissioned the top fees. But at the same time, it was totally liberating to be rid of America and its tedious census-bureau labels on identity. I had arrived on the scene at exactly the right moment in time, as a new wave of multiethnic models started to shake things up. Girls like Helena Christensen, who was half-Danish and half-Peruvian; pixie-haired Nadège, with her mix of French and island blood; and the dark-eyed Yasmeen, who was a Pakistani-German girl from Montreal. It was the time of the whole United Colors of Benetton cultural explosion—before long, I got featured in their ads. Fashion was totally enamored of girls who looked like they represented the world. It's all an illusion; I mean, most of the

world isn't five-eleven and 115 pounds, but it was a powerful illusion to be part of because it felt so new and exciting. So if a designer wanted to claim he'd discovered you as a tribal goat-herder—like they did with Iman when she first broke onto the scene, even though she was a diplomat's daughter who spoke five languages—you just let them. It was better than being called Chinky Giraffe.

As soon as I arrived in Paris, I was sent to work and had to find my way around town on go-sees and castings. The first big job I landed was at Chanel. It was weird: I went to the casting, met with Karl, and booked the couture show just like that. The kind of thing most models have to work toward for years, I got in days. I kind of knew about the prestige of Chanel, but I didn't really understand what a big deal it was at first. Not only was I going to be in the show, but I was also one of the few "cabine girls," which meant I had to report to work every day at No. 31 rue Cambon, the Chanel ateliers, and they made the clothes on my body. The "cabine girl" is basically the fit model, which in the rest of the fashion industry is kind of a bad thing to be because you always stay behind the scenes. Normally runway models laugh at the fit models! But not when you're the fit model for Chanel. Not when you're the fit model for Karl Lagerfeld. That's fabulous! Not only was I in the show, but I was also the finale. I got to be the very last model, which in couture is always the bride, and it's significant because it means you're the chosen one who represents the whole house that season.

Doing that work set my career in motion. I got a lot of work from being the one who Karl Lagerfeld had hand-picked form the crowd. Because he was German and he said I was the greatest, naturally all the German fashion magazines thought I was the greatest, too. I worked with magazines such as German *Vogue* and *Elle*, and German *Bazaar* was one of my first covers. It wasn't long before I was getting booked for all of the major shows—Christian Dior, Yves Saint Laurent, Christian Lacroix, and Valentino. It was a long way from posing in the St. Louis shopping mall, that's for sure.

Fashion was my salvation. For an awkward girl who'd felt like a freak of nature all her life—believe me when I say those pre-teen

YOUR HOMEWORK:
BROADEN THE PARAMETERS.

I think most women are hampered by the beauty standard in our cul-ture. For me, traveling and seeing stunning women all around the world broadened my definition of beauty and gave me new ways to see myself. If you can't get on a plane, find images of women you relate to from much more diverse sources than BET and American fashion magazines. I'm talking the voluptuous women in paintings from 200 years ago! African women in tribal jewelry in *National Geographic*! Frida Kahlo! Cut out the pictures and make your own inspiration board. Feed your eyes with a richer diet than models and actors.

years had felt long indeed—the fashion world was a fabulous refuge, a safe haven from all the kids who ever pointed at me and pulled my hair. All of a sudden, my "freakiness" was the hottest thing in Paris! As the song says, "Le freak, c'est chic." Because fashion is so over-the-top, it attracts people of extremes. "Average" might keep you protected in junior high, but it doesn't play well in the realm of high-fashion. There, if you're cute and petite and cheerleader-princess-looking, you'll get booed off the stage—*quickly!* Actually it's more like they'd throw you to the lions for having the audacity to show up with your shoulder-length bob and eager smile. It's a cruel world, and it can switch on you in a heartbeat—you're in, then you're out—but what redeems fashion forever in my book is this: It embraces outsiders. In fact it's almost entirely populated with underdogs—the people who are too out-there style-wise, too dreamy, or sometimes, too flamboyantly gay, to fit in anywhere more conventional.

Where I'd once gotten knocked for being too big, now I found that fashion was a melting pot of the biggest personalities from around the world—divas, drama queens, and all kinds of beautiful genetic freaks. Especially in the late 1980s! Fashion in Paris and Milan was a circus, a dream. It was giants and midgets—Naomi

Campbell in heels hugging the diminutive designer Azzedine Alaïa, her body wrapped in bands of tight black lycra. It was Las Vegas in outer space—Diana Ross modeling Thierry Mugler's molded plastic corsets in an explosion of paparazzi flashes. Amidst all these women who were part goddess and part alien, with their super-wide eyes, elongated arms, and spindly fingers, I felt like E.T.—I'd finally come home!

And not only that, I'd truly *arrived*. To land at one of the biggest, most historic names in fashion, Chanel, was like getting a graduate degree in fashion, taken at warp speed. It was my entry into the high echelons of the business because I was involved in everything: shooting the ads, modeling ready-to-wear, as well as the couture for two seasons each year. Haute Couture is the absolute top of the top—the made-to-measure clothes that the ultra-rich order so that they can ensure they are completely unique and that nobody else will be wearing what they have. Often I met the clients, figures from high society and foreign royalty for whom a typical dress could cost $20,000. It was eye-opening—and tiring. Recently, Karl told me, "What we were doing then was probably totally illegal—there must be laws against making a thirteen year old work like that!" But I would've paid him if I could; it was utterly inspiring for a girl from Missouri to be let inside that fairy tale.

And it was just about the most affirming experience a teenage girl could ever have. Karl loved me *because* I was so weird-looking. He told people I was "The Face of the Twenty-first Century." For the first time ever, I thought, "Maybe it's not so bad to look like this, to have lips like this, or skin color like this." Karl thought the next generation of women would look closer to me and my mixed-up genes as our world got smaller and ethnicities got blended together. And boy, was he right.

I was a living paper-doll, and ironically, that taught me a lot! As runway models, we girls would get turned into new women every single day. Sometimes we were made to look weirder, sometimes to look less pretty, and other times, more glamorous. All the experimentation freed me up from even thinking too hard about how I looked—it was a job! When we were done each night during collection, I'd come home to the little apartment I shared, take off my

DO-IT-YOURSELF #2:
INVENT YOUR OWN IDENTITY.

To boost my self-esteem in the early days, I would actively think of and write down the words that I felt defined me. Now that I market my clothes and products around the world, I see exactly what I was doing then: I was creating the "brand of Kimora," and it was a brand that was so fabulous and so solid, its import couldn't be denied. To build any successful brand, you need a "brand vocabulary." In my beauty-brand vocabulary, I wasn't "unconventional-looking;" I was "exotic." I wasn't "too tall;" I was "regal." I wasn't "too outspoken;" I was "influential." I wasn't too "flashy;" I was "show-stopping." I keep adding to this list throughout my life, turning negatives into positives. I might not be all those things—but because I think them, I am them. What's in your brand vocabulary?

makeup, and fall into bed. I didn't have a social life at all! My face and body were something I had to look after and be responsible for, but in a way, beauty was no longer the be-all, end-all thing it would be for a regular teenage girl. Beauty was the product that I possessed and could trade for money! Beauty was my business.

I had to get hardened to comments that hurt, such as, "We were expecting a black girl; she's not black!" or "We asked for an Asian girl; who is this?" But it made me realize that the surface-level things—my ethnicity, my looks, even my gender—were actually different from who I was inside. It helped me get some distance because none of those people knew jack about my real self. It was an early age to learn it, but that kind of distance is pretty healthy. To this day, I can be surprisingly low-key about style and fashion—despite what you may have heard. If we have five minutes to do makeup, we have five minutes. And if there's nothing good to wear, give me whatever you have, and I'll make it work, so let's go!

Better than all that was the fact that I had an impact. Girls in Asia would write letters to me because they hadn't seen a face up

on the catwalk that looked anything like theirs before. I'd get fan mail from around the world, in fact, and it made me realize that while I was feeling like a misfit in Missouri, there were girls all over the place who were feeling the exact same way. Had I not been exposed to a new culture with different standards of beauty, I probably would've never flourished or felt good about myself. Which goes to show that when things look bad, you need to shift perspective because things look different depending on the angle—or in this case the country—that you look at them from.

And I began to find power in my difference, to use it to my advantage instead of running from it like I used to. When I'd come back to St. Louis for the school semesters, all the local companies and magazines wanted to work with me. I was a big runway girl from Europe now! I'd bring back my little silk Chanel ballerina flats and tweed jackets, a few Fendi coats that I'd received as gifts from Karl, and some random designer this and designer that, all mixed in with my jeans and white T-shirts. Then I'd rock that look to school or down to McDonald's, finishing the look with a Chanel belt on my waist, Chanel sunglasses, and a watch. Did the other kids get my style? I doubt it. But I loved it, and I was going to stand out as much as I wanted now because I'd worked for it. I understood fashion, and it was truly in my blood.

Kimora's top five freak-chic tips

Conformity is safe and cozy: but it doesn't always give you the inner strength to be a true survivor. I not only think being different from the norm is a blessing, but also I think each woman should try *to find a quality that makes her unique and project it* in life, work, style, love, relationships, and everything she does. Make your difference your trademark—think like Cindy Crawford when she turned her mole into her most recognizable asset instead of having it removed. Whether you're a different-looking model, an unconventional student, or the quirkiest character in the work-

place, don't compromise the very things that make you tick. Accepting your differences demands strength of character, but it builds it too. Here's what to keep in mind.

1. *Don't try to change yourself to fit a stifling status quo.* Change your circumstances, so you find other groups who appreciate you. There was nothing about me that said it could be done, but I did it. And all it took was one person outside of my rote environment to believe in me and show me a new door.

2. *Never compare yourself with others.* Don't let yourself look at other women and say, "I wish I was like her . . ." or "I wish I had her hair/nose/boobs . . ." Don't wish! That puts your head in the future-clouds. You *are*, and you're here in the present—and you're fabulous.

3. *Act like you are the product and its promoter.* You have to have integrity about who you are and how you are. Embrace the things that make you most defiantly you and don't let people water you down. Being wishy washy means you get walked over. Know when to block out twisted "advice" that tries to steer you the wrong way.

4. *When in doubt, move further away from center.* Exaggerate your difference and try to stand out more! Blending in is so boring! If you're tall, put on heels. If you have eight million freckles, show them off instead of covering them up with foundation. If you have a big curly afro—I say, yeah!

5. *If you really want to change your looks and are considering surgery, please wait until you're out of your teens.* For one thing, your body is still developing. For another, with age comes the grace to carry off unconventional beauty—and you might regret looking like everyone else a few years down the road. If you go ahead, make sure you know what problems you're really expecting to solve and keep your expectations in check. Are you trying to fix your ears or your entire sense of self?

IF YOU'RE BRAVE: Highlight your distinctive features with makeup and make them more pronounced, not less. It adds to your drama. I like to play up my Asian eyes and my full lips at once; if I could make my eyes look more Asian, I would. What's your most unique feature?

To this day I still find strength in difference. I support the underdog, and I always will. When you're conventional, it's easy for you to get in the door. You're not struggling; you're not the fish swimming upstream—you're in! I was never that girl. And so I speak to those women that are not that girl. I try to project my own image in the Baby Phat ads because I think I *am* that face of the future—only the future is now, the twenty-first century, and I want to show people that you can be a mulatta, Asian, Latina, or a mix of all of three and be an American Beauty. You don't have to look like Brooke Shields. I want to expand the notions of what's beautiful to be even more inclusive. One of the first models we used in the Baby Phat ads was my friend Devon Aoki, who also got her big break with Karl Lagerfeld. The mainstream person might find her wide face and freckles too weird, but I think she's one of the most beautiful women in the world.

These days the beauty standard is mixed. It's so funny; I meet people and ask, "Where are you from?" and they go, "Oh, I'm mixed." "Mix of what?" I say. "Eastern European, Western European, you know, Polish, German. . . ." Years ago, someone like that would just consider themselves "white." It shows that our whole planet is full of hybrid people nowadays and kids without hyphens in their identity get jealous. There was an article in the newspaper recently about how students of different races did DNA tests to discover their true genetic make-up. All the students who thought they were 100 percent one race or another wanted to discover a glitch, like they're part Asian way back down the line or a quarter-Cherokee Indian. It's a badge in this multicultural world. It's still a little like being a monkey in a cage—the article also said that suburban kids wanted to find out they were partly black to piss off their parents. But it's undeniable that the whole world is shifting in that direction.

And I try to buck the system and be different in all kinds of areas of business today. To me, the strength of the Kimora Lee Simmons brand is that it's all about showing America's "other truth." We say, "Wait a minute; not everyone looks like the whippet-thin women in *Vanity Fair* magazine!" We piss off "proper" fashion people all the time because we don't "know our place." We have huge

DON'T EVER LET SOMEONE tell you that your idea for a new business or your vision of a new form of creativity is too out-there. If you think of it, almost certainly, someone else out there will respond to it.

fashion shows when we're not supposed to because we're "urban;" we bring fashion to girls who are supposed to be left out by the elite. And moreover we have plus size clothes in the same stores as smaller sizes, which is like a betrayal to an industry that makes larger women go shop in Siberia or in a "plus size" department on their own. You'd be surprised how controversial all that stuff is. Being different, no matter how successful you are, will always be unpopular because it threatens the status quo.

I predict that some time in the future being different will have more and more cultural currency. It will be so valuable. The more ethnically mixed-up you are, the more you stand out, the better you'll be. I hope so because in some ways as we get more culturally diverse as people, we're also getting homogenized in media—every new star falls into the same perky category. Maybe it's just the extreme before a correction happens. I already teach my daughters that it's better to be different. I teach them about their Asian heritage, and they love the fabrics, colors, and foods. They are totally tapped into their black roots, too, not only from their genetic heritage but also from the cultural impact of their dad's work. I tell them they're beautiful *because* they're unusual. It's definitely about consciousness and cultural awareness. If you don't know where you're from, you don't know where you're going, honey.

When I was modeling, there weren't that many Asian icons. And there still aren't many today. It's weird because to this day my looks are still considered unorthodox by a lot of people—girls like me just don't get those same big bucks the white models do. We've got a few major girls who are ethnic and black, the Liya Kebedes, the Alek Weks, and the Omahyras, but there's still a lot farther to go.

"I have no problem with whatever the next big look is. Just don't try to tell me that only one look is beautiful."

—ALEK WEK

"So much has changed in the fashion industry. We don't have to be the stereotypical button-nosed, blue-eyed blonde beauty; we don't all have to be five foot nine. And you can be whatever age now, and I think that's wonderful."

—LINDA EVANGELISTA

"Don't let anyone tell you that you have to be a certain way. Be unique. Be what you feel."

—MELISSA ETHRIDGE

"Conformity is the jailer of freedom and the enemy of growth."

—JOHN F. KENNEDY

Grab the mic

I AM NOT A WAIFY GIRL. I am six-foot tall in my flat feet, six-four in my stilettos. I am outspoken; I am funny; I am opinionated—and no, I will not keep my voice down! I'm the opposite of everything the etiquette books always said about little girls being seen but not heard, and it's a key to my success. In fashion, in entertainment, in hip-hop, following that kind of b.s. advice will make you only one thing: completely forgotten.

Does being precocious make you come off as a brat sometimes? Sure. I know I got on peoples' nerves all day long when I first started out because I'm not the type of person to be a blank canvas as a model. Even now, when someone does my makeup, I'll say, "This doesn't look good on me; why don't you do it like this?" It's just being smart because my image is my business. But it used to get me in so much trouble when I was young! If Yves Saint Laurent or Christian Lacroix said a certain red lipstick is the one all the girls in the lineup should wear, I was the one who challenged it, saying, "This tone of red doesn't look right on every girl's skin tone! I understand that you as a designer want your signature red, but did you know that you need to give ethnic girls a different tone so all of us end up looking the same?" I didn't say it to the designer

himself, of course; he didn't give a damn about what I was saying, but after the makeup artists worked on me, I'd run to the bathroom and change it to the red I wanted. They'd get so mad at me! "That's not the red I put on you; why did you touch my makeup? How dare you!"

It's a thin line between respecting the integrity of an artist's vision and making yourself look good. But I had to do it; it was self-protection. A lot of those makeup artists didn't even know how to make up the black girls, and there were no Asian girls, so being a black-Asian girl was a lost cause. I'm Asian: I don't have the same eyelid creases as the other girls, and I can't let someone just draw the same old line on, or fill in my eyebrows the wrong color, or use a foundation that makes me look ashy green! If I didn't speak up for myself, they'd have made me look like a damned fool!

Modeling was a crash course in standing up for myself—or maybe it's more like diving into shark-infested waters and quickly learning how to swim. But I draw on that teenage experience every single day in my business. If I don't feel comfortable with the way I'm being portrayed or with the direction my company is going, I speak up immediately and put a halt to things. If I wait 'til later to say "But it wasn't fair. . . ." or "They didn't tell me it was going to be like that. . . .", then that's already far too late. I will stop a photo shoot if the tiniest thing is not right, and I would rather say what's on my mind upfront than lose control of my image.

I learned that lesson from Karl Lagerfeld. He would always say, "Speak loudly, speak quickly, and be concise! Nobody has time for long-windedness." He wasn't being mean, just honest. In an industry full of outsized egos, everybody would much rather be thinking about themselves. So he knew how to communicate in a way that arrested everyone's attention at once. Torrents of words would roll off his tongue in three languages simultaneously: German, French, and English. He talked so fast that everyone in earshot would have to stop for a second, watch his face behind the fluttering of his fan, and really concentrate on his speech. It was amazing.

I took that lesson to heart. If you're meek, you will be bulldozed—or worse—ignored. Even if it scares the crap out of

DO IT YOURSELF #3:
MODELING TIPS

During a shoot, the key is to flirt with the camera as if the lens is a guy you've got the hots for. The way I see it, the relationship between the photographer and the model is very predatorial—one of us is the tiger and the other is the tamer, though I'm not sure who's who. You kind of stalk each other, switching direction, teasing and taunting, and you keep it moving. There are tons of distractions in every direction, editors jumping in the frame to the dress, hair and makeup people sticking their hands in your face, and the assistants buzzing all around you with equipment. But as the model, your job is to be 100 percent focused on the photographer. You have to hone in on your dialogue and literally cut out any other input. It means you have to be pretty cool in the eye of the storm.

you at first, you have to throw your voice into the mix. It's one of my first criteria for hiring somebody or doing a partnership deal: Will they state their mind honestly, get to the point, and win over a crowd? In my experience, if you wait for someone to ask your opinion, you're going to be waiting a long time because, honey, no one's going to ask you what you think! Things move fast in my line of work, and there's not a lot of hand-holding going on. I have to tell people all the time "Interrupt me! Interject!" because at first they'll just be paralyzed like a deer in headlights: Everyone in my office is talking, hollering, laughing, and handling about seven situations at once.

Speaking out is a way of grabbing a piece of the action and declaring, "I deserve to be here." You don't have to always believe you deserve it—you're at a job interview, a meeting, on a date with a guy who seems way out of your league and wondering how the hell you got there—but talking confidently lets you fake it 'til you make it and keeps the balls in the air. Half the time people aren't really listening to what you're saying anyway. Quiz them next time, and you'll see they barely remember what you just said! Authority

comes more from asserting your personality than saying something extra-smart. So why are *you* held back by the fear of sounding stupid?

I'd always been the kid who wouldn't shut up. At home, I would constantly haggle with my mom, demanding to know why I couldn't stay out beyond curfew or do my homework in front of the TV. Since she was the sole head of the household, the negotiation would always turn into a long, head-to-head discussion at the kitchen table, with me laying out all the reasons numbered one through seven why I should get to stay out late. I guess I was pretty good at it because I almost always got my way. (By the way, I'm paying for it now, as my kids are the exact same way. But that's another subject.) At school, I would sit front and center, with my hand constantly in the air, asking questions and knowing all the answers. I was never in the back row writing notes and eating candy. I was hungry for knowledge! I wanted to know more, discover more, and I challenged the facts. I was that child who'd go, "How do we really know that's the truth? Who said so?"

In school that was rewarded because teachers love that stuff. It's called intellectual curiosity, and it makes them feel better about their jobs—finally, a nerd who wants to learn! Out in the real world, however, it sometimes rubbed people the wrong way. I was literally the youngest model who had ever worked for some of the top fashion houses. I'd barely had time to start flipping through my *Mademoiselle* magazine before becoming the mademoiselle pictured in the magazine. I was the least experienced but most curious person around. And I was an American in Europe, where we're not exactly famous for our subtlety.

For me, that early lesson from Karl was like an all-access pass. There I was standing like a statue in the workroom, while the seamstresses wrapped me in yards of pink organza or navy crêpe de chine. But I was the talking statue who asked, "Why does the dress have to be buttoned right-to-left?" and "Who says I need to wear *black* stockings?" As far as I was concerned, I was just being excited and bubbly; to them I was probably precocious and deeply annoying. I definitely got poked with more than a few pins and needles. And I'm sure Karl quickly regretted giving pointers on the

BE A MODEL OF SELF-RELIANCE

Modeling teaches you pretty early on that not everyone is your friend. At the beginning, a major supermodel took me under her wing because I used to cry from homesickness. I was running up the phone bill all the time, and she said, "I know how it feels to be away from home and be so young. It's a really big thing you're doing, you're so fabulous, and if this is what you want to do, you have to do it." But that was one of the few times anyone put their arm around me. If you want to try to make it as a model, you must, must be emotionally self-reliant.

art of rhetoric. But I didn't care. I was no jaded Parisienne! I wanted to know everything about everything. I mean, Coco Chanel had dressed the most iconic, beautiful, and wealthy women in the world, from Greta Garbo and Marlene Dietrich to Jackie Kennedy Onassis and Mrs. Gordon Getty—who would not find that a hundred times more exciting than history class? In my experience, you usually only get one moment to be in a truly special place, and if you're a wallflower, it will just pass you by.

It may be more controversial to speak your mind, but it's better than staying mute. Backstage at the shows, there would always be these women who were very shy and afraid to speak up for themselves. They were nice girls who just wanted to be cooperative, do a good job, and not get in anyone's way. But being shy reads as being a bitch to me. It's standoffish! When you're quiet, people think, "Who do you think you are—are you too good to talk to us?" And probably no, you don't think you're too good; you're just sweet and shy, but no one's going to wait around to find out. I'm not standoffish—I'm loud! Yes, being vocal sometimes gets on peoples' nerves. But I think it is much more genuine: You know where I'm coming from. You can read me from a mile away.

What I've seen happen in all areas of life is that she who puts herself quietly in the corner will remain in the corner, especially if

you're trying to make it in entertainment or anything related to style. Nobody *wants* to help you—and if they do, you better check their motives, especially if you're a teenage girl and they're a straight guy. For most of us, it comes down to personality. Which is why I tell people, "If you're shy, get the hell over it: You're slamming the door in your own face."

Kimora's No-Fear Manifesto

You may not be a model defending yourself against slap-happy makeup artists. But the ability to speak up, speak out, and stand your ground against powerful personalities is one of the most important skills any woman can have. Whether it's dealing with your career, your romantic life, your health, or your kids, the harsh reality is that no one is going to be your advocate. You have to demand the best in all areas of life for yourself. Your kids have asthma, and you want to see the doctor for more than five minutes? You're getting jacked by your landlord, and he's not fixing the roof? Your boyfriend says you'll lend him that money if you really love him? Be fearless in saying, "No, that is not acceptable." Take a risk that you'll be disliked or be called a bothersome bitch. It's not the end of the world.

Or just take a lesson from the guys: They can tell it like it is without worrying that it's personal. I see women worrying about overstepping the boundaries of polite behavior all the time, and they get walked over. Sure it's stressful and anxiety-inducing to enter into conflict, but it's way more stressful to be screwed over in silence and have to deal with the consequences for three months. It's like tearing off a band-aid: You'll be a lot happier if you grit your teeth and rip!

Of course, the most important part of being a good communicator is knowing when to state your case—and when to just shut up. Even I picked up on that one. I remember one time when I was modeling for a very big Italian designer, and they put me in one of

YOUR HOMEWORK: PUBLIC SPEAKING

Speeches can be scary. So can getting up to state your mind before a big room of listeners. But once you do it a few times, the terror fades, and it actually becomes fun. Here are the four things I keep in mind when speaking to a crowd.

1. *Use humor.* Be loose, be funny, and show some personality. Getting a laugh from the audience makes your nerves settle down.

2. *Focus on the audience.* Don't get too self-conscious about your own voice, looks, or posture because it will make you more stressed. Look at the audience; think about what they want to hear. Who are they, and why did they come to hear you? Your goal is to deliver a good experience to them.

3. *Practice.* On the walk to the subway station, at home, or in a group. You have to get used to hearing your voice projected loudly across a room so that it doesn't freak you out on speech day when it's magnified on loudspeakers.

4. *Pretend you're someone (or somewhere) else.* Think of the most confident public speaker you know, and feel free to steal a few of their body postures and vocal styles. If it works for them, it'll work for you.

those oversized-sweater-and-leggings outfits that were, for a brief moment in the late 1980s, the coolest thing ever. With my skinny legs sticking out of the bottom, I looked like a tent on a stick. It was excruciating, but I knew better than to knock it. When the designer says, after staying up every night for two weeks to finish the collection, "What do you think?" you do not tell them the truth! I saw girls who straight-up said, "Uh, I don't like it." They didn't come back the next day. They were out! I was very diplomatic. Which is why I'm so outspoken today—after a few years, I was busting at the seams from not being able to have a critical opinion. Now it's like I have to give a warning, "Don't ask me if you don't want to know! Because I will tell you what I think." But I'm the boss, so I can say that.

Top three communication tips I learned as a model

1. Don't tell other models anything personal, such as your mental state, eating habits, or info on boyfriends.
2. Learn to say "Please," "Thank you," and "Where's the bathroom?" in the language of your host country before you get there.
3. Don't talk while the makeup artist's got an eyelash curler clamped to your eyelid. And definitely don't tell him or her how to use it.

Fashion was such a crazy blend of fantasy, glamour, and publicity stunts; it taught me the power of being larger-than-life on *and* off the runway. In towering gladiator sandals and big Kabuki wigs, I felt how empowering it was to grow beyond the parameters of my normal self and take on kind of superhero dimensions. I remember thinking, "Wow, people actually do trip when they see you and do a double-take just like in cartoons!" Since then, I've had a bigger-than-life style. If I can have something custom-made in technicolor with rhinestones, I will. We live in a cluttered world these days—to stand out, you've got to grab the world by the horns and make a statement.

Does this matter to you if you don't want to be trotting around the fabulista circuit and have never met a paparazzo in your life? Yes, it does. Because speaking out and standing tall and proud is your claim to power in any realm of life. It's about taking up space—kind of like the way men do when they sit spread-legged on the couch—and taking all that entitlement I already told you to tap into and using speech, attitude, and style to physically express it. *By taking up more room, you're reserving your own space and creating an awareness that you're there.* You're giving yourself permission to be at that senior-level meeting or at that celebrity event, or maybe at that intimate party for twelve that you've just crashed! In my case there's probably an extra element. Maybe I've always

HELLO, GOOD-BYE

No matter what industry you want to get into, be outgoing, make friends, and talk to people. Force yourself to get over any shyness you have. How to start? Learn the discipline of great greetings and solid good-byes. Any time you walk into a professional environment for the first time, be it for a temp job or an interview, identify the person in charge, introduce yourself with a smile, a firm handshake, and a brief "Pleasure to meet you." When you leave, take a second to say good-bye and thanks for their time. When I get that from models or from any of the freelance employees who float in and out of our offices on jobs, it makes a strong impression. They seem competent, graceful, and like they've got it together. Once you're in a working environment for the long-term, keep up the
(continued)

been making up for the fact that women who looked like me—black, Asian, and mixed-Asian faces—were almost invisible in fashion, so I'm making up for lost time. To do this, I'm twice the size! Twice the extravagance! Call it *cojones* or just plain nerve, but to the people who don't think I'm beautiful or anything special, my instinct is to be even harder to miss.

Claiming your space with Fabulosity

I'm all for a being ladylike and not spreading your legs on the couch unnecessarily, especially if you're wearing a short skirt, so I have my own favorite ways for taking up space and claiming some of the power in the room.

1. Heels, heels, heels. My motto: Four inches, no less.
2. Carry an extra-large bag in cherry, emerald, or orange—not beige, not camel, and definitely not black.
3. Wear a dramatic coat that almost demands someone help you take it on and off.
4. Laugh a lot. It makes everybody wonder if it's more fun to be at your party.
5. Turn up the music in every room you enter.

Okay, so it might be impractical to work a major coat in May or June (in which case consider substituting lots of shopping bags, which also take up a few extra square feet). The point is to live large and tell the world that "I'm here, so clear some room." If you at least incorporate the heels into your daily routine, you'll be on the right track. You'll be bigger, you'll walk with a strut, and if they're metallic or rhinestone, you'll get extra points because accessory-glitz has a presence of its own.

The experiences I had as a model opened my horizons. Sure, I had to just pinch my nose, close my eyes, and jump into the deep end of a pretty intimidating world. But taking that leap gave me a

(continued from page 52) greetings! Make the effort to say hi and bye to everyone around you no matter what mood you're in—it's a small gesture that leaves a big mark.

The same thing goes for talking on the phone. The first thing you say can determine the mood of the whole communication that follows. My brother-in-law Reverend Run picks up the phone with a "Praise the Lord!" each time. How could anyone have a negative conversation after that? My assistant is not quite as dramatic, but she says crisply and clearly, "Good afternoon, how can I help you?" instead of a slangy "Wazzup?" It makes the caller feel confident that their business will be well-taken care of.

DON'T GET TOO BIG FOR YOUR BOOTS
(A CAUTIONARY TALE)

I never had a social life, I was too young. The bigger models could party because they were more established. But there was a limit to what you could get away with. One younger model in particular was always out clubbing. Even though she was a big model, you couldn't book her without having her home phone number on the chart cause you'd know you were going to have to call her first thing in the morning. We shared rooms at the top hotels, and I'd see people urgently trying to call her to get up for her first show—and she'd be in bed not answering the phone! Then the show producers would call me and ask to get her out of bed, or her mom would call me. She'd piss people off badly to the point where they wouldn't use her even though she was an incredible model. So it was engrained in me at an early age that there's a fine line between being a diva who everyone wants and a drag who nobody can deal with. The fashion world won't wait too long for someone who's a mess.

much bigger sense of possibilities for my life. I knew that I never wanted to be the big fish in the little pond. I wanted to be the big fish in the *big* pond, and I'd even accept being the little fish in the big pond because I want to see and expand and spread my wings.

By speaking up and asking questions, I got my best education. I was so young when I was modeling that I was a complete sponge, and I absorbed everything I would use later as a businesswoman. I acquired an encyclopedia of real-life knowledge about how things were done by the ultimate pros—the best designers, stylists, CEOs, creative directors, and publicists in the world. By osmosis it all just entered my pores and morphed into the next stage of my career. That's not to say I think I've gotten to the level of the Lagerfelds, Lacroixes, and Saint Laurents—this is a different game. But I am living a lifestyle that I've built into a brand, and I learned how to do it from watching them.

I also had to hold my own in foreign cultures and navigate

around airports and new cities just to survive. I learned French and Italian, handled money in many different currencies, met new people, and got exposure to new things culturally. Sure, I still got my high school education. Most of the time I was back home in the United States by semester's start, but if I missed classes, I worked on my own. I got all my books shipped over to Europe—they're so heavy, it was hundreds of dollars to have them FedExed—and I mailed in essays, had a tutor I met with occasionally, and did all my tests. But it was the participation in the real world that most shaped who I became. I feel like I graduated from the University of Life.

In the hip-hop world that I later married into, I found a thousand kindred spirits. Almost everyone in hip-hop is animated and oversized. They are fearless about projecting themselves onto the world. It's all "This is my car, this is my music, this is me. Deal." It comes from being an underdog culture in which you have to scratch and claw yourself out of the barrel to be able to express yourself and get a shot at being heard. At first glance it would seem even more impenetrable than fashion because it is such a macho environment. But I learned to turn my gender to my advantage: In a sea of tough guys wearing sneakers, a diamond-clad female who speaks her mind truly does stand out. Underneath their baseball caps and big clothes, half those guys don't know how to talk to a woman! My training in the fashion trenches set me up perfectly. I could be as fabulous and real as I wanted to, and it all seemed right.

"Each of us will have to make the choices that allow us to be the largest versions of ourselves."

—Julia Alvarez

"The most courageous act is still to think for yourself. Aloud."

—Coco Chanel

"I was not raised to be beautiful and not say it. I was not raised to have grievance and not cry out. Some people would prefer to say, 'Be pretty and don't talk too much.' But you gotta keep talking or people forget about you and your agenda."

—Lauryn Hill

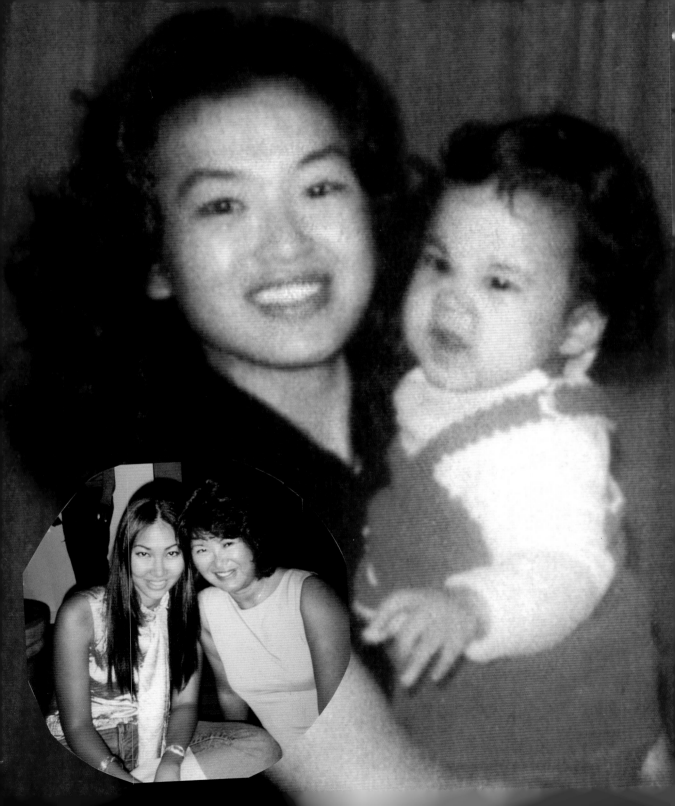

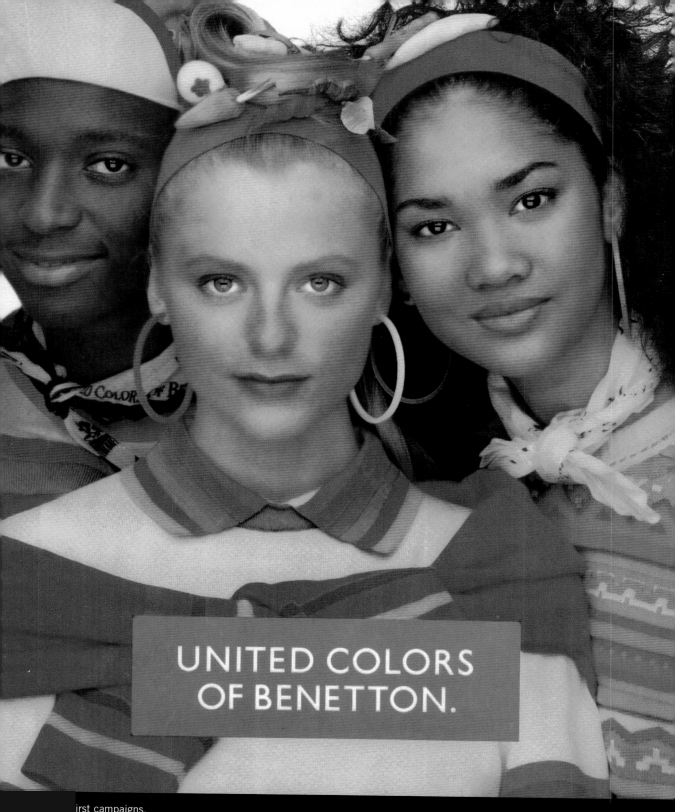

UNITED COLORS
OF BENETTON.

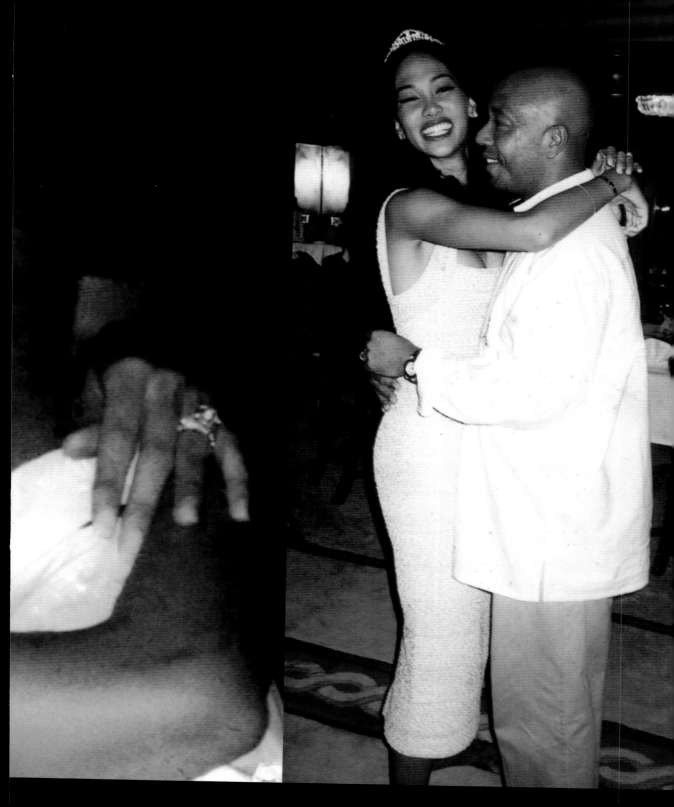

Here's a shot of me with one of my best friends from school, Shani.

Oprah's white tie Legends Ball 2005

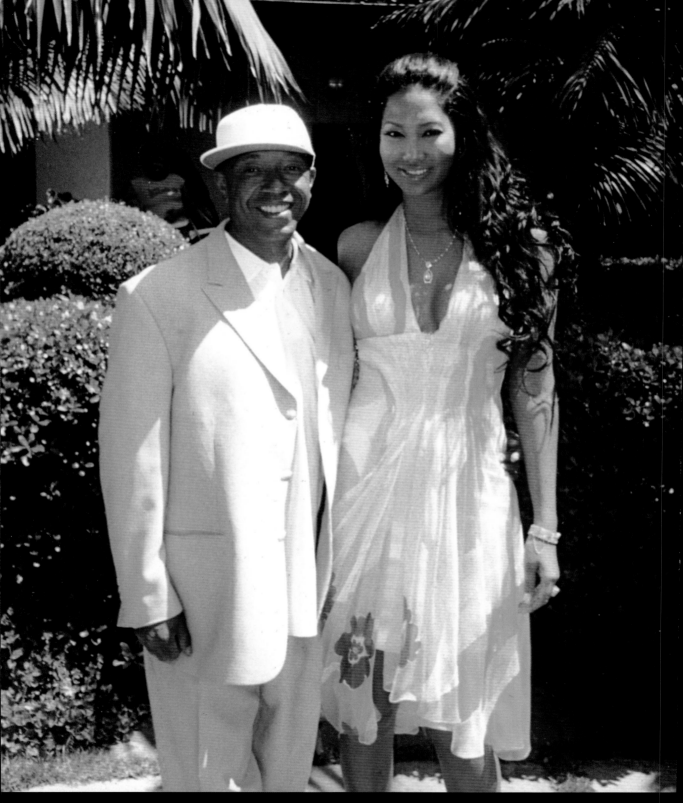

Me and my babies' daddy

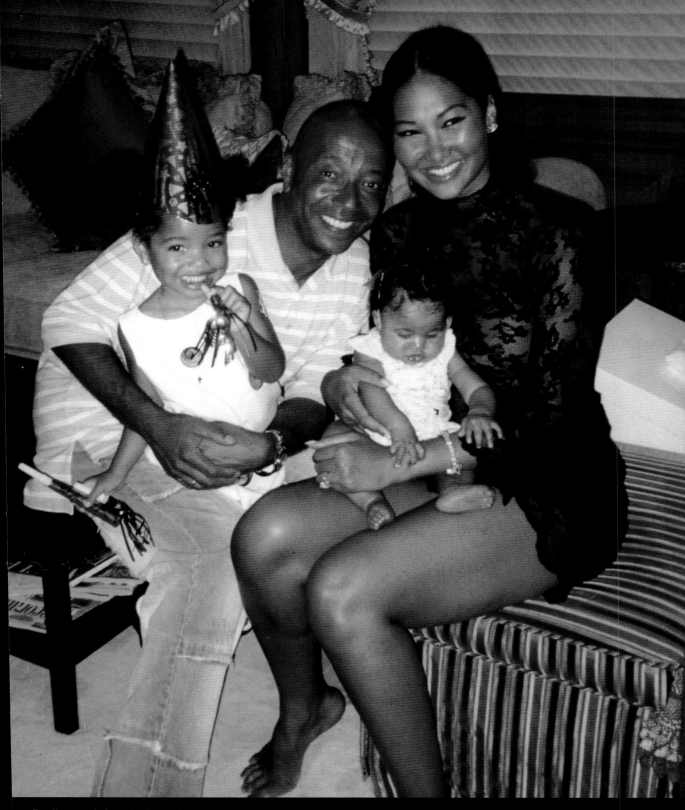

Family portrait from St. Barts, Christmas 2002

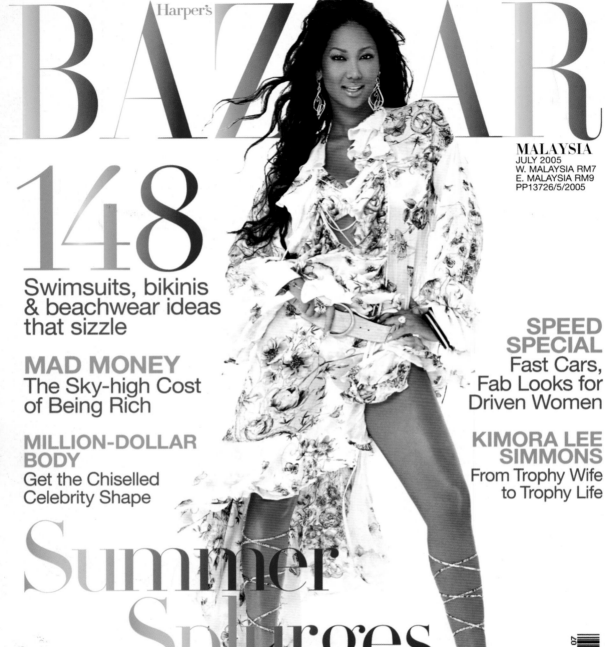

Harper's

BAZAAR

HARPER'S BAZAAR

JULY 2005

THE LUXE ISSUE

RM7.00

MALAYSIA
JULY 2005
W. MALAYSIA RM7
E. MALAYSIA RM9
PP13726/5/2005

148

Swimsuits, bikinis & beachwear ideas that sizzle

MAD MONEY
The Sky-high Cost of Being Rich

MILLION-DOLLAR BODY
Get the Chiselled Celebrity Shape

Summer Splurges

Luxurious buys for a lavish life

SPEED SPECIAL
Fast Cars, Fab Looks for Driven Women

KIMORA LEE SIMMONS
From Trophy Wife to Trophy Life

This is one of my favorite covers, shot on location in Malaysia. © 2005 by *Harper's Bazaar*
Opposite: Mommy, Ming Lee, and Aoki Lee (in the belly) on the beach. I was nine months pregnant!

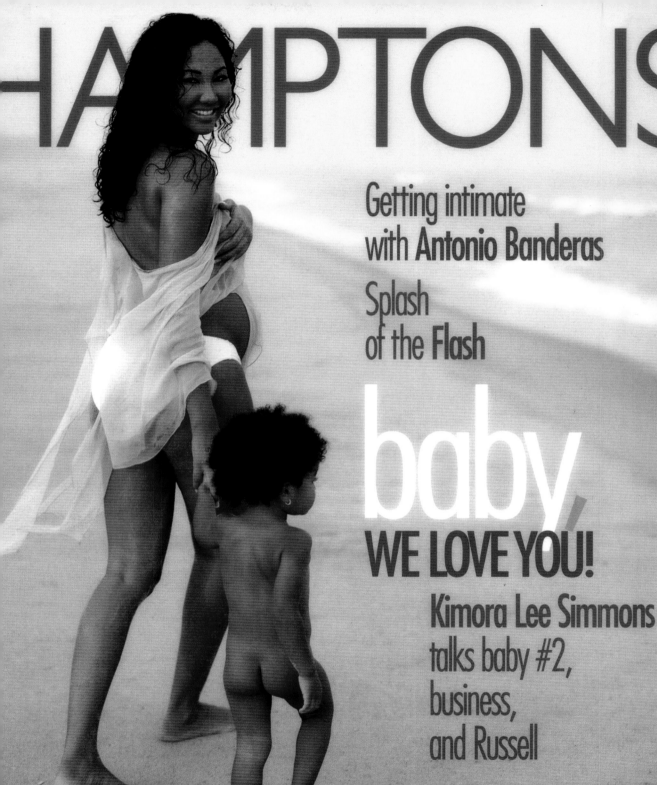

HAMPTONS

Getting intimate
with **Antonio Banderas**

Splash
of the **Flash**

baby,
WE LOVE YOU!
Kimora Lee Simmons
talks baby #2,
business,
and Russell

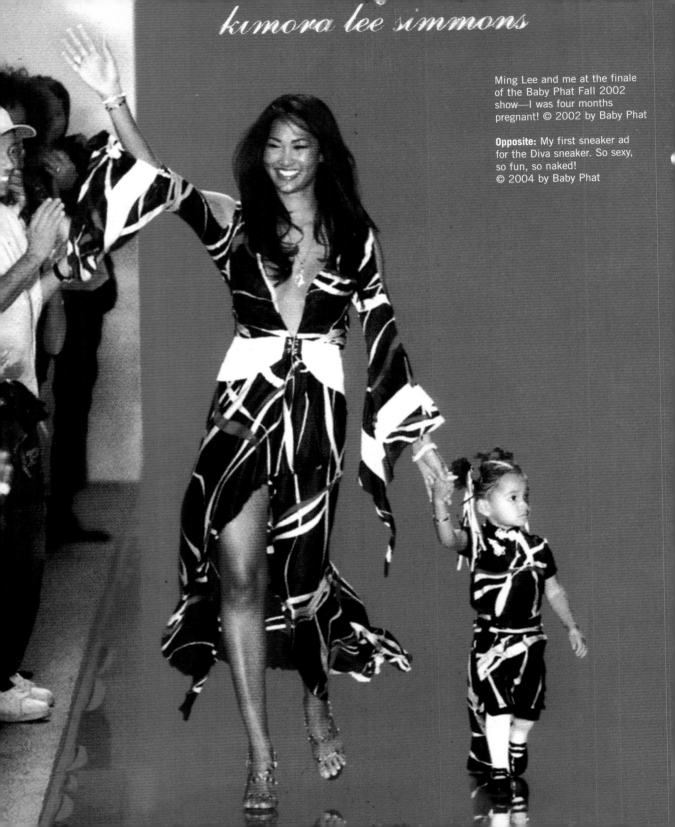

kimora lee simmons

Ming Lee and me at the finale
of the Baby Phat Fall 2002
show—I was four months
pregnant! © 2002 by Baby Phat

Opposite: My first sneaker ad
for the Diva sneaker. So sexy,
so fun, so naked!
© 2004 by Baby Phat

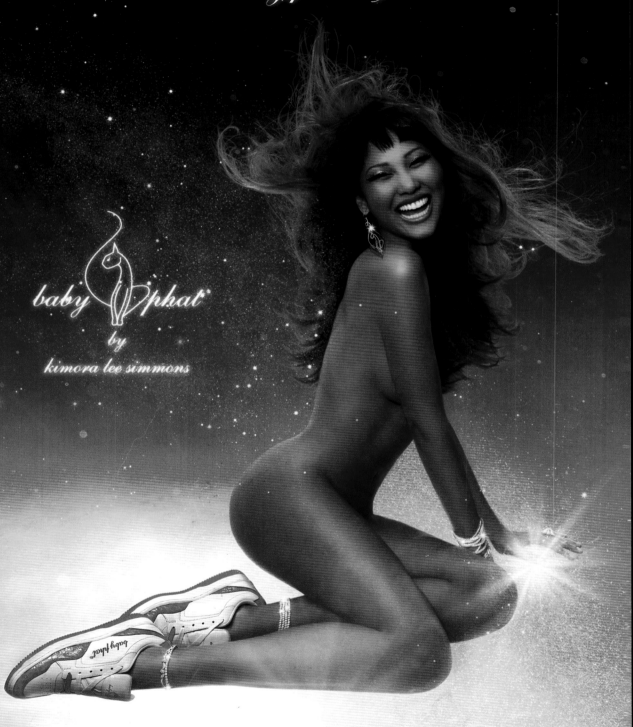

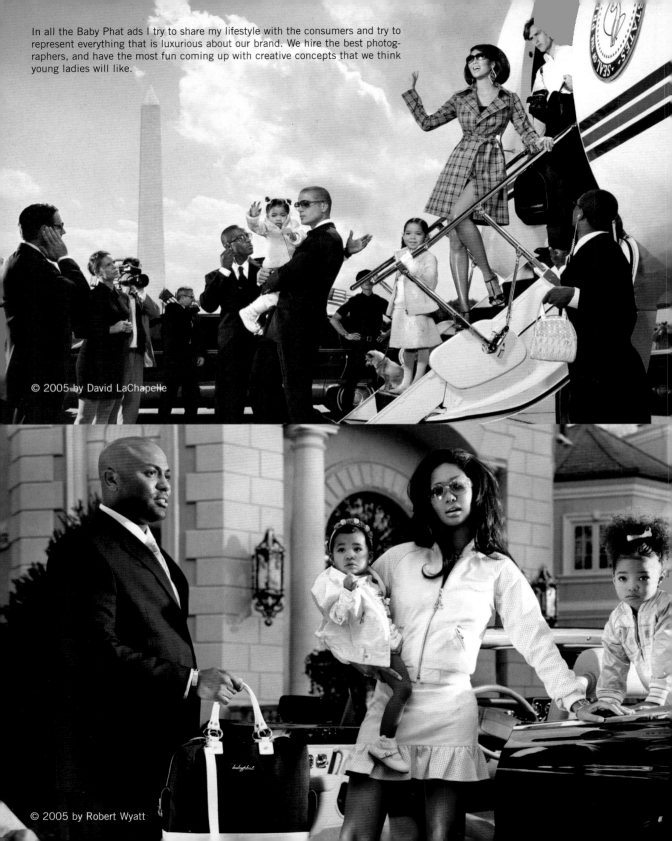

In all the Baby Phat ads I try to share my lifestyle with the consumers and try to represent everything that is luxurious about our brand. We hire the best photographers, and have the most fun coming up with creative concepts that we think young ladies will like.

baby phat
by
kimora lee simmons

© 2005 by Markus Klinko

baby phat
by
kimora lee simmons

© 2005 by Brett Ratner

My first fragrance ad (Goddess).
© 2005 by Mario Sorrenti

baby ❤ phat
GODDESS
by
kimora lee simmons

THE NEW FRAGRANCE

Work
&
Power

Throw away the manual (and find your own way into business)

KEEP THOSE TRUTHS IN MIND, and you can make it to the top just like anyone else.

Three truths

1. There's no such thing as being discovered.
2. The person with the most talent doesn't always get ahead.
3. Life's a bitch sometimes.

Forget what everyone tells you. There is no "right" way to get ahead in business. My entire company is proof of that. The people I rely on every day have arrived in all kinds of ways and from very different places—and many of them have risen to top jobs in the fashion industry at an extremely young age as well. Kind of like me!

We've got the college-educated kid who started as an intern during vacation and became the company's PR Director by age twenty-four. The Oakland spitfire who used to work for my hair-dresser, got recommended to me by word of mouth and now trav-

els the globe as one of my most trusted assistants. We've got probably the youngest director of advertising of any brand anywhere: He was an entry-level junior who, after his boss quit, proved that he had more ideas and connections than candidates twice his age. He scored the top job at twenty-three. . . . Meanwhile, our superefficient senior brand manager got *her* job at twenty-four, having originally arrived as a fashion intern! And we've also got the hypereducated professional who followed every rule in the book to the max and gets an incredible salary—but who, between you and me, doesn't have the sense God gave to a billy goat when it comes to the real world. It's a funky, mixed-up tribe of personalities, headed by *moi et mon amour*, and what all of them have in common is that they work long hours, are passionate about their jobs, are deeply connected to youth culture, and are all just a little insane. You have to be to work with me!

I share that with you so that the next time you hear somebody say, "No fair—I don't have those connections/degrees/work experiences," you can tell them to get up off that stoop and start banging on some doors. There's always a way in; you just have to get a little creative sometimes. And that remains true throughout your whole career. No matter where you are in the game, no matter how successful you might be, there will always be others out there who are more talented or more beautiful or more connected than you. Get used to it! If you start dwelling on everybody else's genius, it'll become a huge tidal wave of doubt. Yes, there is an entire universe of brilliant people out there, but they probably don't have the exact cocktail of smarts + style + initiative + right-place-right-moment timing that you can have—if you stay positive. There's an Arabian proverb, "Compete, don't envy." A desire to compete gets you in the race, but envy leaves you green and sick, sitting on the side.

I snuck into the fashion world, despite the fact that I looked nothing like the cover girls of the time. Later, when it came to Baby Phat, I grabbed the chance to direct a new woman's urban fashion brand even though none really existed. A headhunter would've laughed me out of the office if I'd applied for this job! But my gut told me I had something special to bring to the table, and I

DO-IT-YOURSELF #4:
GETTING STARTED AS A MODEL.

1. *Don't spend money on photographs to try and land an agent.* A very simple high-school snap or a Polaroid is enough to show your talent. Fancier shots will just get thrown away.

2. *Never, ever pay to get an agency.* Any legitimate agency will take you on with no money exchanged; they get their money when you get paid. If they're asking for money upfront, they're not legitimate.

3. *Under your agent's guidance, you'll want to build a diverse portfolio of photographs that shows a full range of work you can do.* It will often mean working free at the beginning, doing "tests" with talented photographers who want to try new looks. So don't quit your day job.

4. *Pounding the pavement is going to take up most of your time— possibly for a long time.* Get out there, go to every casting you can, see and be seen. Treat every casting like an important job interview: look sharp, be charming, leave a good impression.

5. *The only professionals who can get you work as a model are legitimate model agents.* Sending queries and pictures to anyone else in the fashion biz, like a magazine or fashion brand, is a waste of your time and money. I hate to say it, but your photos will never make it to the boss's desk anyway.

wasn't shy about saying it. So my story is definitely about coming through the back door of life. The front door is not necessarily open to all of us, so don't get caught up on getting in that way. Climb in through the window! Go on in through the back! The point is that you have to get into the house whichever way you can.

The no-rules approach has always come easily to me. School was a love-hate situation. I was good at it, despite my weird schedule of work and travel. I was a Grade A, honor roll student, always on the Dean's List. I was a Future Business Leader of America too. But from the get-go, I resisted what they tried to teach about structure and the right way to do things. I hated it! Like in group

learning where you get an A, and someone else gets a D, so the group gets a C. I'd complain all the time: "It's not my fault they're dumb!" And the teacher would explain, "Out in the world, in a working environment as well as in life in general, it's based on a group." Then in basketball the coach would always yell, "You can not do everything yourself. You have to pass the ball even if you can shoot really well." (Which I couldn't.) "Life is a team!" It felt suffocating; I always preferred going off on my own trip rather than waiting to get the team lined up and the authorization paper signed. Life is too short!

Still, I tried the conventional route for a while after high school. I graduated on time with my class—and I have to credit my mom for that because she absolutely would not let me drop out midway through, and she was right. There is just no excuse not to finish high school, no matter what kind of incredible career opportunity a person might be presented with. When I got back from my last stint overseas, I had three or four scholarships on the table from different universities thanks to my grades, several of which were fully paid. And after years of cajoling, bartering, and negotiating with my mother for my freedom, this was the one thing she got super tough on. I *had* to go to college—she would've practically disowned me if I hadn't. My Asian heritage kicked in. To not try to please my parent after all she had done was just too guilt-inducing.

I gave it a shot for a few semesters at a local university. But I'd become a fast-paced girl used to the bright lights and big city, and back home in the sleepy Midwest, I felt landlocked and out of my element. The years of doing runway shows got me hooked on instant gratification—that's why I always liked them better than editorial, when you'd have to wait months to see the photos in a magazine. I was addicted to the adrenaline and excitement of being in a fashion capital—and besides, nobody appreciated my gilt-buttoned tweed jackets with the weights hand sewn into the hems! Fabulous style, right in those sorority sisters' faces, and they knew no better than if they were varsity sweats. It was tragic! So I transferred to college in New York, found an apartment, and couldn't help but let my agents know I had relocated. Pretty soon, the calls

REMEMBER WHAT I SAID IN LAW #1? "Frustration breeds motivation?" This is what I'm talking about, people!

started coming again for jobs: Fashion Week in Manhattan; the shows in Milan. All that felt so much realer to me than sitting at a library desk. I couldn't resist.

Fast forward a few years (we'll get to the interim later). I was newly married to the "Godfather of Hip-Hop." My husband, Russell Simmons, had founded Def Jam Records and then Phat Farm clothing; as his wife, I had the opportunity of enjoying a pretty cushy set-up. But I'd been financially independent, not to mention very busy, since I was thirteen. Life was a hustle for me, an ongoing round of making ends meet, getting paid, and coming up with new jobs. So to suddenly stop and be idle, without challenges and creative ways to give back, was no fun at all. I tried to be a good little domestic partner; I did! In fact I thought it would be fun! But once I finished designing our house, ordering every stitch of furniture, and putting it all together, it was all too . . . quiet. It was depressing. I noticed that when you don't exercise your talents or put energy out into the world, it's almost like your sense of self starts to shrivel. Whatever almighty force created us didn't intend us to spend our days contemplating, "French manicure or regular?" I was going nuts! No hustle meant no challenge. No service meant no reward.

Fortunately, I'm an opportunity grabber. I'm good at sensing the void in the marketplace, noticing, *What's not out there that should be?* I enjoy taking the stuff that I feel passionate about and seeing how it could be repackaged and customized for another audience. It's like making myself the missing link. And what I was thinking, as I watched my husband do his clothing line and as I became more immersed in hip-hop culture, was that it was screwed up how urban females didn't have access to "fashion." Urban culture has its own brand of style, but it was missing the real-deal, bells-and-whistles, super-feminine kind of clothes that I had gotten to play around with as a model. And here I was, a girl who'd come up through the ranks and who had worked for most of the best fashion houses in the world and was now partnered up, 'til death do us part, with a big-time hip-hop figure.

I saw with total clarity what I could bring to the party: I could blend the world that I'd come into with the world that I'd come

from. Hip-hop with high fashion. Beats and bling. That was my sense of business. And it didn't exist before! You might think it's obvious now, but it was radical at the time. I mean, a lot of people didn't even know who Cavalli was when I was rocking his $3,000 jeans in the early 1990s. Young people weren't rocking Versace on MTV. It was the dawn of hip-hop glamour—entertainers were making their own stage outfits, not coming to see Donatella or Armani in Milan. I wanted to offer women the clothes that would make them feel as fierce as I did—looking and feeling fabulous should be every woman's right! Not every girl can afford a pair of Cavalli jeans, but I was pretty sure I could make a jean that looked just as good and grabbed your butt the right way, for many dollars less.

Moreover, I saw that it could be way more than jeans. Everyone wanted a piece of this whole living-large, gems-and-stilettos, ghetto-fab reality, but there was no need to rack up years of credit card debt to get it. What if we gave people just a slice of it, at a budget they could afford and introduced *them* to high fashion, too?

When I saw my opportunity open, I busted in. Phat Farm was getting set to launch a women's collection. They'd had the name "Baby Phat" for about six years, as a logo emblazoned on little T-shirts. By 1999, Russell figured it was time to crack the women's market. He thought, "Hey, if we can succeed this big doing men's clothes, how hard could it be to do women's, too?" But my husband and his team didn't know a thing about women's apparel, let alone women's real needs! Being men, they assumed that if they just copied the menswear and made it in women's sizes, that girls would want to buy it. *What?* Because we love your baggy pants so much? I don't think so. It was a mess! I mean it was slouchy jeans, football-jersey tops, sweatshirts—it was totally a girls-in-their-boyfriend's-clothing thing. Typical guys—they believed they were so fly, of course we'd want to dress like them.

I spoke out and said, "I would *never* wear that! I would never even think to design clothes like that!" It just wasn't what I would consider to be sexy or feminine or fashionable or fabulous at all. Because it was not an independent wardrobe for an independent

woman. If I want to wear my boyfriend's jersey—in bed, by the way, and never anywhere else—I'd just borrow it. Why would I go out and buy it? That's not fashion! Russell conceded. He was like "Go for it. Show us what you would wear because you know more than we do."

The first thing we came up with was the logo based on my cat, Max. We hired a graphic artist to draw a very sexy, sensual, and fluid rendition, and make her pink, naturally. It was a hot little logo! It's the first step for any business, no matter what the industry. *Brand yourself well.* Make your logo something that people recognize and respond to. Women just love my Baby Phat cat. It represents a certain level of status, a girl who's fly, sexy, and cunning. Since that time, thousands of women have approached me with the cat tattooed on them—I'd bet that more women have my cat on them than the Playboy bunny, which I think says something about a brand. If you think of Polo by Ralph Lauren, does anyone have that tattoo? Does anyone wear little horsy earrings with polo players on it? I'm not so sure. But you would wear my diamond cat around your neck or wrist, and you would stamp it onto your lower back. After all it's a glittering pussy—could there be a more fly logo for a girl?

So I had my logo, but no collection of clothes to show. At that point, there was just one person working with me on this whole new endeavor. Yet from my long experience of doing shows during the supermodel era I knew that, before you even start to talk about product, you have to have the spectacle. It's exactly what Gianni Versace did so brilliantly at the end of the 1980s, when he had the biggest supermodels in the world strut the runway to George Michael's "Freedom." Knowing as I did that in the apparel world, *image is everything*, I had the chutzpah to do my own little version of that. Our marketing director and I hustled like crazy to throw together a bunch of girls' outfits to scatter throughout the regular Phat Farm men's show and topped it off with my exit as the final model in a white fur triangle bikini that I made myself. It was an example of my fake-it-'til-you-make-it philosophy. Nobody had to know we didn't have a fully functioning label going yet! I knew

YOUR HOMEWORK: ACE EVERY INTERVIEW

Step A: Make sure your résumé has perfect spelling; a clean, neat layout; and is concise and clear. Even if you got referred to the job by a friend, you should hand a résumé to me at interview time, so I'll get an instant look at who you are. Make it professional.

Step B: Be excited about the job! It's good to be serious and pulled-together, but if you are so stern about your goals that you've lost the twinkle in your eye, I'm going to wonder, "Do you really want to be here?"

Step C: Research a couple of smart, thoughtful questions about the position and the company. When I ask you at the end "Do you have any questions for me?", impress me with one insightful comment that shows you've done your homework.

Step D: If you're interviewing with me or any other fashion company, don't try to suck up by dressing head-to-toe in the brand. In fact, avoid wearing the brand at all, but focus on putting together a look that is in sync with the brand, so I see you and think, "Yes, she fits here." In other words, if you're interviewing for a denim company, don't wear a grey pantsuit. It only says, "I.R.S. employee."

Step E: Keep all styling sleek and chic and verge on the side of caution rather than going O.T.T. One cool piece of jewelry or a one-of-a-kind belt is all I need to see to know that you've got your own unique style.

Step F: Don't be freaked out by the interviewer's fancy job title or position of authority. Here's one thing someone told me years ago: Just picture them at eight weeks old, and they'll be less scary. Does it work? I don't know, but at least it makes you smile.

Step G: Always send a neat and well-written thank you note the next day, by mail, no matter how the interview went! It could totally swing the balance to your favor.

that if it generated enough interest, *then* we'd start to make the real collection. The crowd went crazy—who wants to see guys in oversized Oxford shirts when they can see a beautiful woman?

That first exposure got people talking. It was like the electricity began to flow between me and the girls in New York City. I

started hearing that they were dying for fab clothes. They wanted fashion—now! And they didn't want the kind of Upper East Side, stuffy, ball-gown clothing that up until then represented New York fashion. Where are they going to wear that? They were Harlem girls, Brooklyn girls, downtown girls who wanted jeans, furs, diamonds, sexy shoes—fashion that was rooted in the street and that was realistic to their lifestyles. They were ready to branch out beyond Tommy and Ralph, but they weren't getting serviced by any companies. We were the pioneers.

And that is how it began.

People always ask me, "How do I get my start?" "Do I need to go to college?" "Should I study fashion and marketing?" There is no single answer. I'm more street smart than book smart, albeit in a worldly kind of way because my streets were London, Paris, Milan, New York . . . and St. Louis! I didn't even finish college. I don't sketch, and I didn't go to fashion school. But I have lived a certain life where I got to learn fashion from the inside and see the gurus at work. As president and creative director of Baby Phat, the whole brand follows my ideas, it's my image that gets represented, and it's my vision of fashion. I personally don't know the technical elements of sewing, but I have the confidence to project my own creativity and a strong point of view. I am hands on in every single area. I approve every design, color, and material. I help develop the advertising images, the stores, the merchandise, and the events. I also oversee a team of designers for every single category—from jewelry to shoes to accessories to purses to outerwear and jeans, of course.

So creatives in my position do have a good time and can get by without a degree—but realize that we rely on kids who went to school, kids who can sketch. Which is why I tell people all the time, "You're way better than me! You're at Parsons, you're at FIT! You're smart! I need *you*! The best thing you could do for me right now is finish school and come get a job with me and embrace your talent." On the other hand, if you are not trying to be an actual designer and are aiming to work in fashion-related marketing or media, you can get a degree in whatever you want. In fact, often it's the person with a totally different kind of background—in mathe-

matics or French lit—that will bring something new to the mix. It's really about your personality and whether you are great to be around, you totally get fashion and advertising, and you understand the subtleties of working with style, celebrity, and media. And that comes from work experience, interning, and sucking up knowledge whichever way you can.

That's why I personally love someone who's got street smarts. That kind of intelligence is all about intuition, dedication, determination, and desire. Street smarts is when you're all alone and you don't have anything else to go by but what you have. Street smarts is more raw; it's either inherent to you or it's not; it's about your survival not just your G.P.A. If you've got streets and no school, you can still impress everyone with your brilliance. A lot of things for me are word of mouth anyway: Someone else says you're good? Then maybe you're good. I don't do some kind of Big-Brother background check on people, and I'm sure that's the same for a lot of other creatives and entertainment folks.

If you've got streets *and* school—that's double gold star in my eyes. Because life is not always about how I did it and how Russell did it. In our company, yes, we are grass roots, and we support one another and bring up our family, but we also hire big executives for big pay for legal, managerial, and financial roles, and the first question to them is "Where's your degree?"

*Checklist for being
my employee*

a) Don't be last minute. I can be last minute because I'm the boss. You need to be *ahead* of the game—always thinking a few minutes into the future, ready to jump into action because you know what's developing. If you let yourself run late, you're sabotaging yourself.

HIRED OR FIRED?

*W*hat gets you hired by KLS: Support, leadership skills, caring, understanding, sensitivity, listening to one another, and respecting other people.

What gets you fired by KLS: Rudeness. Having an attitude. Being a dictator, being bitchy, and being a control freak—because one person can't do everything, you have to delegate! Also: defensiveness. Even if I understand it comes from anxiety or insecurity, it does set me off. It makes me think, "Get the hell out of here; no one has time for this. We appreciate your work, but you're not the only one who can do this. There are tons of other people out there hungry for your job." If I'm unhappy with your performance, ask me how you can improve it and be willing to find a solution. But don't tell me I'm wrong.

b) Don't ever say, "That's not part of my job." *Make it* part of your job. *Everything's* part of your job! I don't want to hear how you get it done. Make it seamless. Just do it!

c) Be ultra-organized. Bosses want employees who are sticklers for detail. Focus your attention on the minute and catch all the tiny things that might be going wrong. Noticing everything that could pass under the radar makes you invaluable to a higher-up.

d) Be fabulous! Our showroom has a certain standard that sets us apart from other urban brands. Look sharp, act sophisticated, be gracious to every client. Express confidence at all times. (This rule applies to every job—unless it's not pragmatic or possible to dress up.)

e) Be a gold-medal multitasker. You should be able to discuss the new Ludacris video whilst correcting the merchandising spreadsheets, picking the right shade of snakeskin for next season's mini purses, and catching the dog at the same time! Quick-

ness, mental agility, and the ability to keep up with a high-speed work flow is a major asset.

f) Be discreet. Know when you're getting played and don't gossip about my, your, or anyone else's personal life. It's plain common sense—one of the most underrated, and highly valued, qualities a person can have.

REQUIRED READING
We have the problem of bad attitudes in the office every day. We always tell people to read *The Seven Spiritual Laws of Success.* Russell tells them to read it, to do a report on it, and kind of live their life by it.

I've had an unconventional rise in business and learned on my feet. The best advice I could give anyone is to turn every situation into a chance to learn, to make contacts, and to create personal relationships. Be scrappy and hungry and know your industry! If you get complacent and don't seek creative ways to improve your situation, you're probably going to stay there in Xerox hell when you could have leapfrogged somewhere more exciting. When it comes down to it, business stuff is not nearly as intimidating as it seems when you are standing outside the walls. There are a few basic truths:

Business Truth A: The people who succeed are the ones who act on their ideas. You don't have to come up with the most incredible idea ever made to be successful, so don't sit paralyzed in fear that your idea isn't "good enough" to execute. I don't. My way is about taking the thing that already exists—and making it better than anyone else. Sure, I am filling a gap with my companies and offering products that I feel fill a certain void, but in a lot of ways, I'm just doing things that have been done before. What you figure out is that *everything* has been done before. But can you come up with a way to do something in a new way, for a new era or audience? And more importantly, are you going to do it rather than just talk about it?

Business Truth B: You need a new idea every month. Can you figure out ways to constantly innovate and grow? To its core, Baby Phat is about my taste and way of life. It's not just about fashion; it's about a whole lifestyle. I mean, I know I'm not the only girl who thinks Pottery Barn is just plain out boring! A few years back, I told *Vibe* magazine that "I want to be like a permanent household fixture, from the pots in your kitchen to the sheets on your bed. I

FOUR DRESSING-FOR-SUCCESS RULES YOU NEED TO KNOW!

1. *In general, more skin = less power.* Find other ways to say "fabulous" other than exposing lots of body, such as interesting silhouettes, sparkling accessories, and shoes that make heads turn.

2. *Get creative with conservative dress codes.* If you've got to wear a suit, don't see it as soul-crushing; see it as a blank canvas on which to express your style. Wear a feminine cami-top underneath in a vibrant color, add a striking pin to the lapel, or cheat the rules with a softer cardigan-type top paired with a pencil skirt (very 1950s chic).

3. *Giant Lettering.* Lettering on your clothes is fine if you're on a football team, but in an office environment, it's just too hectic and distracts from what you're saying! Save the superlogo'd tops and jackets for after-hours.

4. *Scuffed, banged-up shoes are an instant image-buster.* It's kind of like coming in to work with toothpaste on your face—people notice it right away. Keep those shoes well-maintained and know when to down-grade them to weekend status.

want you to sleep on me." That's the way you got to think: What's next? What's new? What have I missed? I like what Ice Cube said on a talk show recently: "I had small dreams when I started. My goal was to get just one song on the radio. That was it. But I also recognized opportunities. My dad said, 'Opportunities will come and go every day. Be careful which ones you let go because they might not come round again.' So I kept my antennae up: If I was on a video set, I'd think who can I meet here, who can help me do something new?" Because he kept looking for the next good idea, Ice Cube's now a movie star with amazing avenues open to him that he never expected to find.

Business Truth C: Everybody needs at least one mentor. Ask anyone from 50 Cent to Alicia Keys to Oprah about their success, and they'll tell you how much they've learned from the profes-sionals around them—smart lawyers and brainy accountants and

innovative producers—and usually, from some older, wiser people who passed on knowledge at key points in their careers. In fact, there's not one single successful person I know who didn't benefit from some kind of powerful mentorship. All of us need those people along the way who will recognize our potential, help us to see how much bigger we could be, and push us to try harder. I was fortunate in that I married one of the best brand builders popular culture has ever seen, and for so much of the stuff he was doing, I was right there alongside. I saw all the bumps and all the victories. So I learned first hand, and I did what I saw.

I would not have had the success I've had without several peoples' wisdom and knowledge to get me out of sticky situations. I believe everyone needs some kind of proximity to a mentor, an advisor, or maybe a whole handful of people who can keep nudging you along the way. If you are just starting out, find a woman you admire and try to develop some kind of relationship with her. You'd be surprised how many people are flattered to be asked for advice and insight. If you are already established in your career, don't forget to look back. Whom of the next batch of kids could you help out?

What I've noticed as I watch younger people coming up in the business is that the biggest barrier to getting in the game is usually a person's own self-doubt. It's easy to let negative thinking creep into your mind and sabotage your chances—all of us are vulnerable to that, and it's usually because we're scared of what challenges and responsibilities we'll have to face if we *do* get the gig or score the promotion. What's crucial is to build up a certain resistance to these self-sabotaging thoughts that not only drain you of enthusiasm, but also they make you no fun to be around, and therefore even less employable. It's mental self-defense: If you build up a solid battlement by believing "I can, I will," nothing can knock you down.

Kimora's instant empowerment guide

1. *Don't deflect blame onto the system, the screwed-up schooling you got, or the chances no one ever gave you.* It makes you powerless and means you are not in control of your destiny. Saying "It's not fair" gets you stuck in quicksand: the more you say it, the more you believe it, and the less traction you have to take any kind of step. Recognize that you might have your particular barriers when it comes to work, but just like many other successful figures have done, you too will figure an innovative way to overcome them through networking, interning, and lateral thinking.

2. *There's almost always a way in to something.* It may not be the perfect job or the ideal platform for your vast talents, but if it gets you in the work world and positioned somewhere close to the kind of job or industry you want to be in, take it. Remember: A lot of successful people started in the mail room.

3. *Potential will be noticed.* If you work hard, are committed, and bring your best self to the table, your efforts will be noticed. At our offices, we tell people, "Work for free." Do whatever you can to get in the door! Because if you fulfill a need and become invaluable, and on top of that have a fantastic attitude, we will not want to let you go! Did you know that several presidents of departments at Phat Farm started as interns back in the day?

4. *See the upside of rejection.* One door closing *can* mean another door opening. You might not be the right person for a particular job you just interviewed for, but if you impressed the employer, they will almost always keep you in mind for openings down the line or refer you to their friends. That's how so much gets done in the business world: positive word of mouth! So even if you're told, "We don't think you're right for this position," put your game-face on and say, "Thanks. I enjoyed meeting with you, and

I'd love it if you kept me in mind for future jobs." Better yet, send a hand-written note of thanks the next day. Swallow that pride and smile!

5. *Lack of experience and knowledge seems like a huge handicap when you're standing outside the gates, but they're the simplest ones to overcome.* There's so much information out there for you, even if you have been nowhere near a university in your life! Start learning. Go to the city library or Barnes & Noble and gather research. If it's fashion you're aiming for, look through all the top magazines: who did the hair, who did the makeup, who are the top-ten models in the business and the best photographers, which agencies are reputable? Watch the fashion news reports on TV and read all the show reviews during Fashion Week. Want to go into photography? Take photography classes, know everything about every camera, who uses what lenses, what camera was used for this cover shot? Seek out all the info on your craft and know it. Knowledge is power. And start a notebook with thoughts and inspiring quotes from those you admire, too.

6. *Once you get your foot in the door, maintain the attitude that this is my chance to learn.* Hands-on experience, no matter how tedious it might get sometimes, is your education. Before you know it, the fact that you "didn't go to school for fashion/marketing/writing" has become irrelevant because you're armed with major insider knowledge (even as a volunteer or an entry-level assistant).

So how does someone get from intern to company president? How do they become so "invaluable" that a person like me creates a new position for them rather than lets them leave? It comes down to a combination of inspiration plus perspiration. Are they thinking creatively and taking initiative even within their low-level job? Are they offering something that nobody else is offering? And—it almost goes without saying—are they logging the kind of hours that show commitment to a team? If you pack your bag and leave at 5:01 P.M. each day, I'm going to assume that you're not!

How to kick up from the bottom (aka ascending from entry-level)

Be someone's "in-the-know" source.

Be the kid who comes in and tells the boss about the show you saw last night in the Bronx or what you heard the boys in Harajuku are wearing on their feet. Be someone's person on the street, fly-on-the-wall, and real-life Google site. *They* don't want to go out every night; they probably want to go home to their million-dollar apartment! Put your antennae up, and use your youth to your advantage.

Be the Connector.

Be the one who's hooked into all the other young people in your industry. Attend the functions, get out there, and have a fat Rolodex. Socialize and get key friendships going early. When the crap hits the fan and there's an urgent problem to solve, you'll be the one who knows exactly who to call on the outside for help. In almost every business, building good relationships is what creates your solid foundation. You'll come back to those people over and over again as you all mature.

Keep Your Grief to Yourself.

Make it easy for people: Be clear, positive, and above all, simple with your communication. Don't come in to work carrying all your personal baggage! I don't want to hear about how long it took you to get to the office because you live in Queens and "oh boy the subway sucks." I don't want your life story or your thoughts on what I'm doing . . . keep that for your friends. When in doubt, keep the conversation professional when talking to the higher-ups. Once you've got a relationship going, you can throw in *positive* personal stuff now and again, like shots of your hilarious sense of humor.

If you have a job where you don't have to wear sneakers for comfort and all-day running around, avoid throwing on your favorite pair of kicks in the morning. I always say to girls in fashion and media, "Don't wear sneakers to the office if you want to make a good impression." Wear them on the subway *to work* if you have to, but for the office, you need heels or a dressy flat. Wearing sneakers conveys the wrong message of casualness and not being fabulous—it messes up your illusion of authority and sophistication. (And they'll kill the subtle-sexy vibe you might be going for in that pretty top!)

Be Nice to the Receptionist.

Don't ever write her or him off as just the front-of-office clerk. That girl or guy is a genius. They handle seven hundred calls a minute, she knows the maze of company workings like she's got a GPS system in her head, and she can help or hinder your rise with the flick of a switch. Same goes for anyone else who supports your company—from the Fedex guy to the cleaning crew. Treat everyone with the dignity they deserve and chances are that when you're in a pinch, they'll come to your rescue. And if you are the best damn receptionist or mailroom guy ever, know that every single day is a new opportunity to impress the top dogs.

Don't Be Too Cool for School.

Be warned. Fashion, music, and media attracts all kinds of players whose natural tendency is to rock major attitude. But acting super-cool and above it all can backfire, if you're not a bona fide original or innovator in your field (yet!). If you're just getting started in your career, turn the freeze button off, push your perforated-leather sleeves up, and get sweaty alongside everyone else. I promote people who can push their whole team forward, not the ones who automatically think they're Queen or King Bee.

"To hell with circumstances; I create opportunities."

—BRUCE LEE

"You can't just sit there and wait for people to give you that golden dream. You've got to get out there and make it happen for yourself."

—DIANA ROSS

"There was no manual how to write my first album; there were no guidelines to how that was written and I think that's what made me special."

—NAS

"Women have to harness their power—its absolutely true. It's just learning not to take the first no. And if you can't go straight ahead, you go around the corner."

—CHER

No success without effort

IN THE EARLY YEARS OF MY CAREER, I learned the ropes without shouldering too much responsibility. As a model, my job had been to present fashion designers' fantasies to the public each season. My duty was to show up on time, pay attention, and be whoever the designer wanted me to be—for a few fleeting moments before returning to my real self. Sure, modeling required that I have good discipline and better organizational skills than the average teenage girl, but as an occupation, it's kind of like being at the top of the food chain: The runway girl is the beautiful cherry on top of the ice-cream sundae, and she gets to come in after a lot of blood, sweat, and tears have been shed by other people. The demands of that job were nothing compared with running a fashion brand of my own! With Baby Phat, suddenly it was *my* dream that was on the line. And as I quickly discovered, nobody automatically believes in your dream. Nobody! You have to turn it into reality through your own sheer grit, bullheadedness, and persistence. It's one cliché that is completely true: Champagne dreams only materialize when you really do the work.

Any youthful illusions I might have (secretly) had about get-rich-quick, overnight-millionaire schemes were instantly dis-

solved. Launching and developing a new clothing brand involved *labor*—and it was the stay-up-all-night-stressing, everyone's-banking-on-you-not-to-screw-up kind, too. Because the truth is that in any competitive business field, you get about five minutes' goodwill from your industry and the media when you announce your intention, especially when you have the kind of back story I had: a model who married a big-time mogul and had the guts to create a major job for herself. After those five minutes, everyone's waiting to see if you'll stumble or fall. If you do, you'll get dropped like a hot potato—it's like a sick form of entertainment or as if the vultures are circling in advance because they know that most everybody's a quitter. My husband, Russell, always says, "Very few people stick with their dream." My goal was to be one of the few who did.

Compared with the exquisite ateliers and showrooms I'd worked at in Europe, the clothing industry centered on New York's Seventh Avenue was a hectic reality check. If you come to the Baby Phat offices today, you'll see what I mean. Outside our doors, a sea of pedestrians pushes and shoves you down the street, burly garment-district workers rush rolling racks across your path, and taxi cabs will take you out in a millisecond if you hesitate at the crosswalk. It's kind of a wake-up call! There's nothing soft or romantic about making fashion—every day hundreds of potential brands jockey for position in the best stores, and ultimately your success can be measured by one simple criterion: the numbers. Does your brand sell, or doesn't it?

From the get-go, our concept caught on amongst a certain demographic of trendy city girls. It was hot! Because there was nothing like it out there. There'd never been a clothing line made by a young woman like me: a multiethnic woman who has one foot in Gucci and one foot in the ghetto. Was I the first nonwhite designer? Of course not. Even when I was coming up, there were stars like Patrick Kelly. But I wasn't trying to do that kind of straight, high-end fashion! This was street fashion—affordable, funky, and authentic. And I'm pretty sure I was the first woman of any ethnicity to do *that* in any kind of relevant way. I knew that a generation of black girls would love it, and so would white girls,

> ### YOUR HOMEWORK: MAKING IT THROUGH A TOUGH DAY (OR WEEK, MONTH, LIFE, ETC.)
>
> 1. *A great smile is always very important.* When you smile, your brain starts to believe you're happy, whether you are or not. It's like a physical exercise for your brain. A workout! It's magnetic too; once you start smiling, other people start smiling.
> 2. *Factor in time for some spiritual rejuvenation no matter how busy you are:* A ten-minute phone call with your funniest friend, a play session with your dog, or anything that takes you out of your stress zone. Meditation is a great way to "still the noise" of your mind—even if it's just a few minutes.
> 3. *Exercise never makes you feel worse when you're sluggish and cranky.* It almost always gives you a shot of optimism and energy. Put down that Mars bar and get to the gym!
> 4. *Remember the words that a successful Hollywood composer told me recently:* "If success takes a long time, and takes a lot of persistence and effort to happen, you're lucky. Because if you get success too fast, you blow up too soon. You're the flavor of the month, everyone wants you, and you don't have the know-how and expertise to deal with all the projects you get. Slow and steady sets you up for a longer career."

Asians, and Latinas, because it was a new style coming from a young woman's point of view.

Right away I saw the challenge we were up against. In cities and towns across America, small independent stores only had to hang our clothes on the racks, and their female customers immediately discovered us. They knew Phat Farm well, they immediately got what Baby Phat was about, and they became our loyal fans. But the real volume of sales has to come from department stores, where the foot traffic is a hundred times bigger. To gain traction you have to have prime visibility. And most of them automatically stuck us in the urban section with whatever "hip-hop"

type brands they thought only black people would buy. My team and I used to be so mad! I'd say, "We make the same kinds of jeans that Tommy and Ralph make! Why are they over there in the proper womenswear section with bright lights and big photographs pointing the way—while we are denigrated to 'urban?'" It's such discrimination; you wouldn't believe it. We weren't even on the same floor as those guys! As if all the ethnic folk have to go be on a floor by themselves! I knew the stats: There are forty-five million consumers between the ages of thirteen and thirty-four in this country with a cumulative annual spending power of $1 trillion. Eighty percent of them are white. I was not going to get pigeon-holed into one niche and miss out on that—no way.

I figured that these obstacles were tests of how committed and persistent I could be. Was I going to take a deep breath and power through them or just sit there and complain? I chose the former and focused on my goals. I needed to differentiate my brand and make it stand out in a sea of conformity. After all, we were basically a denim line, albeit one with huge ambitions. And the people we most needed to impress were not the celebrities, the fashionistas, or even the customers. First and foremost, we had to seduce the department store buyers—the executives who decide how many pieces of each fashion brand they'll carry each season and how much floor space every designer gets. Sounds a little too mathematical to be fabulous? Well, they're not famous, the public wouldn't recognize them, but they're like the Dons of the fashion industry: They can make or break you. If buyers take a liking to your brand and believe that their regular Saturday-morning shopper is going to drop cash on your product, they'll give you more floor space and a bigger push. If they don't, you'll languish in the far-back corner where the sun don't shine! I needed to show them that we were going to be the next major player in retail and make them feel like they'd be *crazy* to miss out. I was going to be totally shameless about self-promotion. And I had the experience that none of the other brands in the urban department had: using the power of high fashion to sell a fantasy.

As soon as we could afford it, we staged our own runway presentation during New York Fashion Week. If you've never been to

the tents at Bryant Park, you may not realize how gutsy that was. I mean, we were selling $70 jeans, cute tops, and party dresses—for us to stage a show at Fashion Week was kind of like the outlaws crashing the white-tie party. It's a pretty precious scene that follows its own system of unwritten rules, where *maybe* if you're a new avant-garde designer and you get a top magazine editor to like you, *then* you can have the audacity to put together a runway show. But like I've said before: I've never been seen and not heard. I didn't care if the fashion establishment gave me permission or not—I was going to pay for a show, hire the best deejays and models in the city, and shake that boring scene up! It was a chance to show the whole world—*Listen up! This is how we do*. It wasn't intended to just show pieces that would be on sale in stores, but to also include extravagant, one-off creations thrown in for fun.

The most important—and I guess the most risky—step came at the very last minute. As we were going through the final stage of setting up, I looked up at the backdrop hanging behind the catwalk. It had the pink Baby Phat logo with the cat in the middle. And it dawned on me: "It has to say 'Baby Phat by Kimora Lee Simmons!' Because this collection is my baby! This is my vision!" Everyone told me there was absolutely no way the workmen could do it this late; to start cutting out new lettering and changing the lighting would be impossible. And I said, "We *have* to do it. I don't care how much it costs or how you make it happen. You can hand draw my name on with black markers if need be, guys, but it must be up there!" Because this company was me. It was my style. I thought, "I'm going to meld myself and mold myself, liquefy myself, and float into these peoples' pores!" That's what branding is all about. Sticking hard to your gut instinct and putting yourself out there in the most potent way possible.

Doing that show was stressful as hell! We had to do it in the earliest time slot, which is kind of like the dead zone for Fashion Week. The big magazine editors wouldn't give us the time of day. But we got it done. We got the exposure we wanted in the fashion trade papers, the younger and hipper magazines, and the all-important gossip pages. We were on our way upward with a reputation that was bigger than we were.

Rule of Persistence, Part 1: When you have a good idea, be tenacious like a pit bull. Hang on tight and get it done your way—and don't let people who aren't particularly invested in your success tell you otherwise.

From that first show onward, our shows grew in scale and glamour as we could put more money into them. It was always a glam-fest with as many lights, drama, and action as I could pump out on my budget! Beautiful girls dripping in diamonds and strutting their stuff to pumping beats. Some of the biggest models in the world, from Africa, Europe, Brazil, and Asia, were in the line-up, and they represented the whole mixed-up and unstereotypical look that I wanted to promote. Our show became the biggest party in New York: By 2003, it was like the crazy jump-off to Fashion Week, and almost everyone from the fashion world, the music scene, the downtown scene, and entertainment would bum rush the doors and try to crash their way in. It was hyped and high-energy and chaotic—we had the largest audience of any fashion show in town, and there were still another one thousand people trying to get in from outside! Our message was clear: This was a new fusion of fashion, hip-hop, and Las Vegas showmanship, and it wasn't following any of the usual rules.

In our own way, we'd created a new version of the rock-star excitement I remembered from the Versace shows in late 1980s and early 1990s Milan. Only this time it was totally New York: The audience included rappers and real-estate moguls, and the audience members mixed street style and haute glamour the way only New Yorkers can. It was a sexy, high-voltage, people-watching spectacular! We'd have fun watching the audience turn their heads obsessively before the lights went down and think, "Aha. That's why you come to my show! You want to see who's sitting next to you." You could just feel the electricity in the air: This was the place to be.

The upshot was that the store buyers *had* to take note of Baby Phat because the suburban audience got the fever for our flavor. It's like osmosis that happens—you put all the color and glitz and fun out there in the magazines and on TV, and it kind of permeates the collective unconscious. Our joint was hitting with white girls

PERSISTENCE 411:
KEEPING THE FLOW GOING

I will make a confession. All that busy-ness and effort doesn't come easy. I'm not some kind of superhero—in fact, my major flaw is procrastination. Give me a chance to catch a few extra hours, and I will be sorely tempted to get back in bed because frankly I'm exhausted half the time! So I've figured out ways to guard against the procrastination. I have to be active, rushed, and on-the-go as much as possible, so I don't slow down enough to stop. I will override my schedulers and organizers and take over the plans if they're not hustling enough! I need to keep the flow going. If I'm doing a photo shoot and I've had my hair and makeup done for two hours, I'm not going to stop and rest after one job: I tell 'em, book me back-to-back, interviews, TV appearances, meetings, just throw it all in there. For other people it would be a nightmare to talk to a thousand people in a day, but I want to throw that ball and hit as much as I can with that one shot. I've learned you never know what the next day will bring. And I know at the end of it all, when I give out, at least I've gotten something accomplished.

in the suburbs just like it had with black girls in the inner city, and stores started increasing our floor space, treating us with more respect, and eventually building out our own separate areas, so we occupied floor space just like the major players. By persisting and pushing forward with my vision, when fifty-percent of the people thought having big expensive shows was just berserk, we carved out our own identity and got recognized.

The success of the line definitely gave me a boost. I guess we hit a moment in time when it was already happening anyway. Urban culture and hip-hop and pop culture were all mixing up together, and because I'm young and everyone who works for me is really, really young, we moved a bit faster on the game. Actually, that's a good point, and I always forget it ('cause I feel so old!). Don't ever underestimate the power of youth. If you know what's going on, you can turn out some wicked ideas six months before

the big companies even sniff them in the wind. I mean, I think it took a long time for corporate America to figure out that "urban" didn't even mean "black" any more. It's a youth-culture attitude that transcends whether you live in the inner-city or you're a farm boy out in the sticks. You either feel it, or you don't!

The more the sales figures affirmed we were on the right track, the more confidence I had to come up with out-there ideas—like an almost $700 cell phone that was pink, gem-covered, and totally fabulous. It was a luxury item for a new kind of woman, the ones who Dior and Vuitton don't try to court. If haughty fashion critics didn't get it, I didn't care. I just went with my instincts.

Only five years after we launched Baby Phat, we'd grabbed our turf and really staked a claim. Maybe it's because we were pretty authentically a young brand for a young crowd. Teens and twentysomethings were now shopping on *our* floor first, and a whole bunch of new brands followed our lead. The industry that had once been skeptical started sniffing around to see how *we* do— suddenly even the big brands were doing sexy women's lines, and I couldn't help but see the connection. It's like, they hate you 'til they want to be you. Hello!

Rule of Persistence, Part 2: When you put in solid effort, you build yourself a solid step from which to reach higher and stretch farther—you can stand up strong on the back of all your hard work and view new horizons you couldn't glimpse before. Coasting through a job and never applying yourself will keep you forever on that flat ground.

Going into business was basically me trying to find something to do with myself and offer that to the world. But I think the same law, no success without effort, applies to whatever a woman does. Staying at home with your kids is just as much a job as anything else—and it requires the same attitude as business! It requires investing your energy, serving other people, and doing something structured with yourself each day rather than waffling around. To my mind that's how you find happiness. Effort just breeds happiness because no matter how tired you are, it's fulfilling to commit

DO-IT-YOURSELF #5: DEFEAT STRESS

When things are really, really stressful, this is what I do. I imagine the happy ending I want to whatever challenge has got me anxious. I take a few minutes and let the scene unfold in my mind, and let it flow so that it ends with everyone going, "Oh my God, this is the best thing ever! How did you pull this off! We're so impressed!" I visualize this happy ending almost like it's a movie, and I focus on how relieved and grateful I *feel* that everything worked out fine. Then I write the positive statements from the scene onto a card and stick it where I see it every day. If I start thinking I'm going to fail or get anxious that a challenge is too big, I turn and look at that card instead and let it rewrite the future with a positive outcome. And invariably, that is what happens because when you start actively imagining positive endings, you usually make the decisions that lead to them, without even realizing it.

to yourself and to other people around you. To get up every morning and figure out what to give. What are you going to give? What's your service? That's really the point of it all, isn't it? Whether you're giving as a mother, as a volunteer, an employee, or an entrepreneur who thinks what she's producing is going to put a smile on people's faces.

And I think that's everyone's homework: Figure out what you're going to give! Focus on your motivation and find a process that fulfills you every day and makes you juiced. Because if you're obsessed with only the end results—the walk-in wardrobe of designer gear or the garage full of cars—it won't be enough to keep you going on those days when you've got the blues and hate the pressure. Yes, aim high and want all that good stuff in your life; just remember it might take a lot, lot longer than you think to arrive, so let it function as your reward but not your reason.

As I've gotten older, I've seen that my motivation is the hard work and dedication and determination itself. I didn't think that at seventeen obviously, but these days, my happiness is much more

related to my achievements as a person than to my possessions. That's what drives me and that's what makes me feel alive and useful and like I'm doing something with my time on the planet. And then by doing the work, that's how you save. Nobody instantly becomes a billionaire! You work toward it.

Maybe what differentiates me from the norm is that I don't quit and I don't crack—at least, not often. I am not a quitter. There was never really a time when you didn't see Kimora for three years; no, "What the hell happened to her?" or *VH-1 Behind the Music* special tracking me down. I stayed visible and tried to stay current in peoples' minds. You always saw me, whether it was through modeling, attending public events, appearing on TV, or working on my clothing line. My theory is that you don't necessarily know what the heck you're doing, but you get up every day and do *something*. I've said it before, and I'll say it again: I didn't know where my journey was taking me; I just showed up and responded to what I saw and tried to make smart decisions at every turn.

Rule of Persistence, Part 3: It's scary to take a leap and put yourself out there in whatever capacity. You know it's going take a ton of effort, and so you can stall for a long time thinking about it. Should I take this job, or shouldn't I? Should I move to this town for work or not? Should I take a loan out for school or go flip burgers? But when I start a new venture, I tell myself, "Life is a series of adjustments: You can make changes along the way, but if you don't start moving forward, you'll never get anywhere."

I don't want to make it seem like it's easy. Oftentimes it's a struggle because even to this day with successful businesses under my lead, I still get looked at as just Russell Simmons' wife. Come on people! I pump my heart and soul, my image, and my feelings into my products. It's my life, and it's my family, and there's no way to separate the business me from the personal me. A lot of people don't understand that I hold my own weight. But luckily, the other quality I am blessed with is emotional resilience. Maybe it comes from my mom and her old-school Asian character. She

might have had feelings inside at times during my childhood because her life was tough and quite lonely, but I definitely did not see it. She's very strong and powerful, and she doesn't let temporary stresses push her off track.

That's made me have a pretty good attitude when things don't work out as I expect. Although I never understood what "fear of failure" was because I just never had it, I recently discovered that I am susceptible too and what I do is just push through it and ignore it. It crept up on me when the daytime TV show I was cohosting got axed. Because the press gave me a lot of attention throughout the run of the show, they also gave me a lot of attention when it tanked. My mind knows better than to listen to that kind of gossip because I was there, and I know the whole story, and it didn't go down at all how the papers reported.

But hearing that kind of negativity is enough to break anyone's spirit. I had to tell myself, "Kimora, you're a great person, you're working your way toward greatness in terms of your job, your family, your community, what you're giving through working every day. You're taking bigger and better projects and setting your sights higher and higher, and a part of greatness is *developing* things." Yes, that show ran its course a little sooner rather than later, but I figured, "You tried it, you did it, and now you're on to something new." It's my Keep-it-Moving speech again.

I made a choice to not get worked up about it— I refused to let one setback stifle me. I sure was not going to climb under the covers and cry! My point is yes those negative thoughts come up, and just like a breath of air, they leave. They blow in, and they blow out. In the case of the TV show, I never descended into misery and tears about it! It's nothing to be miserable about! The press spins total b.s. about my behavior on the show, so I get all the crap dumped on me. And that's fine. *I don't care.* They key is to not go out and say anything bad at anyone else and to remind myself of the truth: I've got a job before and after this show; I treat everyone as well as they deserve, and one door closing *is* another five doors opening. I don't get caught up on mistakes; I learn from them.

So life moves on bigger and better, which it does for everyone whether you're a writer, producer, an actor, or whatever you are.

What do you do if you have incredible talent and opportunity, but are so young it's hard to get people to take you seriously?

1. Avoid discussing your age. Don't lie, but don't bring it up unnecessarily. If you're young, people will judge you, and if you're older than they expect, they'll probably judge you, too!

2. Dress with authority and sophistication. Don't dress like a kid, even if it's cool in your line of work to be super casual. That means no sneakers, no humorous T-shirts, and no trucker caps.

3. Educate yourself beyond the call of duty. People are going to assume you don't know much, so surprise them. Know what's going on in your industry, who's who, and read the national and international news as well. Broad knowledge impresses people way more than age.

4. Don't ever waste time worrying about what you don't know how to do. Surround yourself with experts and keep your focus on what you do know how to do.

Things get big for a minute, then they die down. You can't let a temporary drama build up and take over your existence because it will sit and fester into a bigger fear that you actually can't overcome. I truly believe that if you don't keep moving at the difficult times, your self-doubt grows a hundred times bigger. Times of challenge are when you need positive affirmation the most! That's true in all areas of life. You got dumped by a guy? You better get back out there and go on a date or two, honey, or you might believe all that mean stuff he said about you. You failed a test in high school? Who cares, take it again! Everything goes up and down—friendships, finances, and your mental state, too. I'm saying don't use the down times as an excuse to get off the roller coaster because you might get too skittish to ever get back on.

I'm not saying I'm perfect. I'm absolutely not! And I do sometimes give in to others on creative decisions when I feel like they know better—then lie awake at night regretting it because I realize

that those other people aren't *me* and what they thought was hot is not exactly what I thought was hot. I talk the talk about persisting with a personal vision and then occasionally second-guess. But I think I'm like a marathon runner: I keep going through the pain because I set myself really bold goals, and I'll be damned if anything's gonna stop me crossing that yellow tape! I don't stop and drop ever because I've got a lot to do—I've got to stay on track! Sure, there are times when I indulge in fantasies of flying off track—like being that black-stallion racehorse who suddenly jets off the racecourse and up through the stands and makes a bolt for freedom. I definitely have that fantasy. Except that they always shoot those crazy horses in the head . . . so maybe that's not a fabulous way to go out! My point is that the biggest challenge today is learning how to deal with the sheer amount of different demands and how to balance everything—and that goes whether you've got four kids yelling in the kitchen or thirty-thousand dollars in credit-card loans hanging over your head. It's a fight to keep a grip on it all.

For any woman, it often feels like we're living life for other people and working so hard just to meet their expectations. It's important to bring it back around and realize your potential and take advantage of it. You've got one life; you are supposed to use your talents for good. So you *can't* get tired of it. You've just got to make adjustments, so you can always keep it moving and keep growing. Learn to expect much of yourself and screw what others think of you!

"Luck has nothing to do with it, because I have spent many, many hours, countless hours, on the court working for my one moment in time, not knowing when it would come."

—SERENA WILLIAMS

"I hated every minute of training, but I said, "Don't quit. Suffer now and live the rest of your life as a champion.""

—MUHAMMAD ALI

"Even when you're failing, you're successful if you're applying yourself. The world sees your success. It only comes after you've proven it to yourself and you pass certain tests. But if you have a dream, all you have to do is go to work. Happiness comes from letting go of results. Letting go of the anxiety that comes from not having enough."

—RUSSELL SIMMONS

"Pain is temporary. It may last a minute, or an hour, or a day, or a year, but eventually it will subside, and something else will take its place. If I quit, however, it lasts forever."

—LANCE ARMSTRONG

"In yoga, the word "tapas" means a burning effort under all circumstances to achieve a definite goal in life. A worthy aim makes life illuminated, pure, and divine. Without such an aim, action and prayer have no value. Life without tapas is like a heart without love."

—B.K.S. IYENGAR

Be a woman warrior

I NEED TO PUT SOMETHING TO REST. I've recently acquired this image that I get all Michelle Rodriguez in *Girlfight* and bust people up when they cross me. Yes, I was quoted in the press as saying, "I will beat a bitch's ass!" which made it sound like I carry boxing gloves around in my Birkin bag. What I meant was I *would* beat a bitch's ass, if I really, really got pushed to the edge, and she was trying to mess with me, but normally, I'm a peaceful person! Needless to say, those six words got reported like I was one round short of a T.K.O. with every female in a five-mile radius.

Look, I've only had one fight in my entire life, and quite rightly so because the school bully tried to give me a smackdown in the junior high cafeteria. She was this chick who tormented everybody—she was a *Million Dollar Baby* candidate if ever I've seen one. I saw her cheating on a test, and I laughed at her, and that drove her crazy. Let's just say she was highly insecure. So when the bell rang for lunch, she came right up in my face to scare me, and she made a threatening lunge. I probably would have shrunk back into the corner like most everyone else in that school did when faced with her fury, save for one thing. Her arm caught my brand-new Etienne Aigner handbag, and it went flying through

the air. Ooh, that did it! That really did it. In a flash, I knew, "I'm gonna fight her!" Seeing my first-ever designer bag go hurtling across the cafeteria tables sparked some kind of demon in my spirit and *Bam!* I smacked her down so hard, she was horrified. And then she came at me again. Instantly, the whole eighth grade gathered around us—it was a real live catfight! And they were all chanting, "Kimora! Kimora!" because I was like the superhero who was doing it for all of them. That girl had bullied just about every kid around, and finally someone was doing something about it—and it was I, the Chinky Giraffe with her double-long arms and legs!

In my memory the fight lasts for about an hour—all slow-motion—but in reality it was probably just a one-minute scuffle before the teachers pulled us apart. And guess what? I got detention, not for fighting, but for cussing at the English teacher when she tried to pull me away. The injustice of it all! Nevertheless, that fight triggered something in me I didn't know I had. The fight or flight instinct that I guess all animals are attuned to, that instantaneous act of self-preservation in response to danger or to being provoked. In this case, I was backed up in a corner, plus completely visible to the entire junior high—if I'd run away it would have confirmed my status as a Grade-A loser. There was no "flight" option. So I turned toward the challenge and *kapow!* I proved I had about 500 percent more power than I'd ever thought possible.

Since that day almost twenty years ago, I've known that when I need to be, I can be a woman warrior. I know exactly where my inner ammunition lies, and I let people see that if they try to screw with me or disrespect me, I am not gonna slink back into the shadows. I guess it's pretty radical because it's not what our culture expects from a woman who's in the limelight, has a successful career, and attends charity events dressed to the nines. She's supposed to always be that beautiful trophy I talked about earlier—shiny, golden, and pleasant to look at. Seen but not heard—even when people are spreading lies or being mean to her friends well within her earshot. I say, "Why?" If trouble's brewing, that's a truly phony way to be. I don't want to be confrontational if I don't have to be, and 99 percent of the time I take a breath and avoid the is-

sue, but if you deliberately send negativity my way, I become a bull facing a red flag, and I can get pretty ghetto.

Now listen, I am not—repeat, not—advocating getting in fistfights with other girls and dealing with differences through cat-scratching and hair pulling. That is just not chic or fabulous at all! In almost any situation, it is far more devastating to keep your icy cool while the other person gets herself in a flush-cheeked, teary-eyed hot mess yelling in your face. Just watch a Lauren Bacall movie or anything with Rita Hayworth: Their response to impending disaster was one perfectly raised eyebrow, followed perhaps by a long, full-throated laugh. Genius!

But if you need to stand your ground and prove your worth, it's good to have a vein of molten lava running somewhere through your body, to tap into and use when necessary. I call it being a Glamazon: a glamorous, foxy, Amazon warrior woman. Sometimes life calls for offensive tactics! A kind of, "Don't even try it, sucka" approach. Because people don't always play nice in fashion, in business—or for that matter, in the New Mommies day-group, either. They look at a woman who's got it going on and think, "She's soft; she doesn't even understand we're being mean to her. What a ding-dong!" So I make the first strike by cultivating a kind of glamazon attitude: I come armed with a killer smile and fierce femininity. There's something totally hot about using glamour as your armor—if you utilize your height, have some bling, and incredible hair and makeup, it really does throw people off their game. I call it Operation Shock and Awe.

The Glamazon also has one very powerful weapon in her arsenal. She's gotten to the place where *she does not have to be liked.* That's one of the biggest things that holds women back from reaching their true potential: the fear that they might rock the boat and irk people around them and get a bad rap. Well listen up ladies! Yes, your friends and family should like you; yes, your lover should like you; but as for everyone else, isn't it more important that they respect you first and foremost? It's not like you want to be friends with all of them anyway. Life is not a popularity contest.

Of course, as it is obvious by now, I'm writing this with such a passion because I'm still trying to get over that hurdle, just like

most of you! I'm a human in development and I do have my own insecurities to fight. I'm an only child, ergo, need to be liked. Product of broken home, therefore, want to ensure happiness and smiles of everyone at all times. But as I've achieved more success, I've learned that there are some situations in which you're faced with such vicious, unkind energy that it's not about being nice or not nice—it's about surviving with your sense of self and your confidence intact, any which way you can!

I'll share one example with you. There is one deeply powerful lady in New York society who, it's clear by now, despises me. She is very successful in business, yet obviously unhappy in her personal life, and I don't think she's fabulous at all! At several major events in the city, the kind where everyone in the world is watching, she will warmly greet my husband and the other men around us, and then pivot on the heel of her Blahnik shoe to swing her hair in my face as I stand there smiling and trying to be nice. Believe me, it's happened repeatedly. The first few times it happened, I felt destroyed. I really took it personally! It felt like she was slapping my face for having the audacity to be there, like, "Why are you here? How dare you make it in here on your own!" To be snubbed like that in front of everyone! My jaw dropped to the floor because I felt so shocked and embarrassed.

I think she's intimidated by me because I'm much younger than her, I've got power and money, and let's face it, I'm a Chinky Giraffe who somehow crashed her party. It put me into a whirl of self-doubt and insecurity. Is it me, is it something that I did? It made me realize that damn, for a lot of women that's daily life. One powerful personality can make them feel like crap, and they start believing it completely!

So rather than get sad, I got mad. I tapped into my Glamazon ammunition and told myself, "Kimora, get a backbone! Do some mental self-defense! Be Xena the warrior—fight your fight and don't worry about what enemies think!" Suddenly, I stopped caring whether I was liked or disliked all the time. I know that my babies, my husband, and the people I'm with all day, every day feel me as a person and benefit from my compassion. Getting upset about whether near-strangers like me was gonna lead to a spiral of inse-

THE "FABULOSITY" FREE TO BE A BITCH THEORY

Be a lady 99 percent of the time, but in that 1 percent instance when you need to be a bitch—be it! Own it! Do it. For your sense of pride and a good story if nothing else. I try to command respect and to teach the younger kids who work with me, as well as my own daughters, that you have to have respect and at the same time be grateful for being in a certain position. But there's a part of me that is always going to be a tiger who wants to play with other tigers. There's a part of me that loves hearing people standing up for themselves or criticizing the status quo—we're all so politically correct these days, we need people to shake things up and be provocative from time to time. It gives us all something to talk about! So I'm the last person to say you have to play nice *all the time* or bat your eyelashes and smile when you think something's really screwed up. If you've got a strong opinion, and you're willing to deal with the potential fall-out, speak up and say it—take a risk!

curity that would only take me one place: down. In fact rage seems to me like a very healthy response to this scenario! It keeps a girl hopping and moving rather than giving up and curling in a ball with her L'Oréal Extra Lash streaking her cheeks.

Of course, once I let my fury get going, I can get a little carried away with revenge fantasies. I remember telling my husband about the meannie old hag, "Ooh, one day I'm going to slap her teeth down her throat." And he said, "Honey, you need to try to pray and let it go; it's gonna make you bitter and old. But I understand what you mean, and if you're gonna slap her, make sure you do it in public. Make sure you do it on camera!"

It's unlikely that I'd do it: I don't want to ruin a manicure on that sneaky snake. In fact what I did do was a total kill-her-with-kindness tactic. Because when I thought about it, I realized she was just plain jealous of any woman younger than her who gets equal attention from men. That realization was like throwing wa-

ter on the witch—she melted in my mind, and I saw that I had nothing to fear. Next time I saw her, I cut right in front of her, saw her phoney smile freeze in horror, and wrapped my arms round her in a big old hello. It was kind of a cruel diva trick on my part—the poor woman couldn't get away, she couldn't hide, she squirmed in distaste. Since everyone saw it and knew how much she hates me, it was hilarious. I took back the power because I refused to be denigrated. It was invigorating to feel that I could behave the way I wanted. That I don't have to "play well with others" if the "others" are royal pains in the ass.

Now that I'm getting older, things have shifted a bit. When I was in my teens and early twenties, I took the concept of assertiveness training to the max. I don't think I would've known there was any other way to be; I guess since I was always the youngest one in the room, I felt like I had to be extra-strong, ready at the first provocation to prove my power and my smarts. Now I'm starting to understand other concepts of strength.

Not long ago, I was invited to be at a tsunami-relief benefit concert in Malaysia. The event was called "Forces of Nature," and the concept behind that name was that even though nature hurls her disasters and horrific events at us, inside every person there exists a force of nature too. It's a strength we can apply to make things better, an ability to react to events with courage and determination, to uplift and improve, and make change happen. It struck me that women are forces of nature, too: We can do anything. When we set our minds on something, there ain't nothing gonna hold us back! And that's revised my definition of "woman warrior." It's not so much about offensive or defensive moves and being in conflict, it's about having access to a well of deep, meaningful power.

Being a woman in the business side of the fashion world is hard. You'd think that in fashion it'd be better to be a woman because of the clothes, hair, and makeup—that's our joint! But running a company puts you firmly in the business boat. And I've found that men in suits can be very condescending; they just don't think you have it in you. They think you're surely going to be irra-

tional and emotional, and it's all, "How are you going to run a business?" and "Whose money are you controlling?"

Yet in my opinion women have way more advantages than men. Women are very sensitive in the way they communicate; they can multitask the hell out of a situation—talk to the bill collector, authorize a new hiree, and balance the kid on the lap at once—and if you're talking about pain, well, men are punks! If men had to give birth to babies, they'd die! They just can't do it! Much less give birth and then go back and be in a movie the next week or handle a business conference. Men don't like pain. The woman warriors in the Trojan War supposedly cut off one breast, so they could shoot bows and arrows better. Now that's badass. And as for us modern women, well we do get Brazilian waxing done! Ain't no man going through that! Men just can't take it. I think that women are built for challenge. And at some point, men just got in our way. Sometimes I think we should all live back in a matriarchy again and sacrifice most of the men.

I'm quite sure that my appraisal of women has gotten even stronger the more I've met women in business, in the music industry, and especially in the hip-hop world. It's still a male-dominated world in general, and hip-hop is an aggressively male-dominated business, so the women who succeed have to be pretty damn aggressive and smart to get anything done. I've learned some crucial things from women at the top of the entertainment industry.

Warrior Rule #1: Don't apologize unless you step on someone's foot—and even then, you better make sure they didn't put their foot there to trip you up. Do guys apologize for being assertive and moving quickly to the front? No. Do dogs apologize for marking their territory and defending their turf? No. It's natural to want to claim a space and run at the front of the pack; if you want to be there, you can be, and you don't have to conform to any outdated rules of how a "lady" should act.

Warrior Rule #2: Make a clean strike. When things go south at work, I don't dress people down very much because I'm like a

WOMEN WARRIORS ARE:

Assertive

Unapologetic

Surprising

Stealthy

Effective

When I walk into a room, I hold my head high even if there are people over there talking about me, going, "She thinks she's all that." I make an effort to communicate total control and power even if I'm not feeling it inside. Sure, internally I struggle every day like the next person with anxiety about how things are going or nervousness about my choices. But I fight that anxiety and try to battle the weakness of my mind. No matter what I'm feeling deep inside, on the outside, it's all about projecting confidence and calm. A big smile. Direct eye contact. Fantastic posture. Deep breaths. And taking up space. When I feel vulnerable, I resist the temptation to hide in the corner. Instead, I expand my wings like a butterfly coming out of a cocoon and live larger.

lion when I'm stirred. I'm scared to come out cursing everybody—they'll cut their damn wrists if I let my true feelings show! So I try to send the message through the grapevine: "Tell her she better straighten up." I think that's an issue for a lot of women—emotions run close to the surface, and it's hard just to be calm and angry, not crazy and angry. I'm learning to just pick up the phone, tell the person I'm upset, and explain why. And if it gets heated, it gets heated, and that's okay, too.

Warrior Rule #3 (a): Don't let them see you cry. That's a strike against the home team as far as I'm concerned—the kind of thing that makes men think women are weak. If you're in a meeting or with people you don't know well, do not ever let them see you crumble. Do what you need to do, run to the bathroom to fix your contact lens, get out of there before you bawl! Control your wildest emotions: There's very little place for them in the workplace.

Warrior Rule #3 (b): And don't cry to try to manipulate people either. I don't cry at the drop of a hat, and I definitely don't cry

to get my way. It's because when I was younger, I used to try the manipulative tears, and my mother would say, "Your tears don't move me. You still go in there and clean your room!" I say the same thing to Ming Lee now when she has a fit, crying, "Mommy, I can't help it." I say, "Ming, those tears don't move me." And she gasps and stops, and she gets it together. So I learned early on. Don't use your tears to move people; it won't work.

Warrior Rule #4: Strive to be a graceful warrior. Tapping into anger from time to time has served me well over the years. It's given me a shot of courage when I was lacking and a bump of adrenaline when I was fading. But these days I'm trying more and more to find grace under pressure and to not even let myself get that fiery feeling. Maybe I've got a new understanding of where strength has to come from for you to truly endure—somewhere much deeper than anger. Mostly it's that I don't want to get high blood pressure! I don't want to have a heart attack down the road! I know I've got a hot, fast temper, and with age, I'm more and more impressed by those who are not at the mercy of their emotions all the time.

That is perhaps my most important Warrior Rule. Grace under pressure. Strong and silent until necessary. It's the mantra I try to always keep in mind: *You don't have to fight all the time.* It's not easy to get to this place if you've come up from below as a scrappy little brawler and scratched your way out of the barrel. But the truth is there will always be frustrations, disappointments, and conflicts in life; you can't change that, but you can change the way you respond to them. More and more I try to smile and make the best of the situation. Because any anger you have, any tension you have, it only builds up on you, and that means you're letting your reaction to other people make you sick. Stress causes your cortisol levels to raise, your lactic acid to build and cramp up your muscles, your adrenal glands get exhausted, and no doubt about it, if you don't make a change, you will get ill. We ladies are sensitive creatures, and we tend to take on the stresses of the world!

So I'm saying what I've discovered with maturity is that a strong warrior is one who almost never has to fight. I think of that thing Bruce Lee, the most kickass fighter of all time, said: "Notice that the stiffest tree is most easily cracked, while the bamboo or willow survives by bending with the wind." I want to be a nice bamboo reed at ninety-three, not a cracked old oak tree! Having some flexibility and not holding on to what I think is right all the time has helped me deal a lot better with a high-stress lifestyle.

Since I live with a yoga fanatic—my husband—I can't help but make a yoga analogy for all this. My personality makes me like the warrior pose. That pose is not the part of yoga that's all about meditating and being quiet and looking inward. It's the pose where you're standing there strong with your legs all powerful and your arms spread way out, and you're holding it until you're so tired you can't hold it any more, but you keep pushing through anyway! You just dig deep and bring that power from way down below without ever frowning or holding your breath. So I'm more the warrior of the family, and my husband is more the Gandhi of the family—the peace and love guy who never flinches if a bug lands on his head. But it takes both to work. You have to know when to go into warrior's pose, and you have to know when to go down on the floor into child's pose and rest, too.

My Mr. Zen husband has also taught me to pick my battles. I'm definitely working on knowing when to put down the sword—but I'll never totally lose my edge. I'm still the guard in our house. He'll say, "I've got to do this favor for so and so," and I'll say, "Are you crazy? Do you remember what he just did last week to try to ruin you?" And sometimes I'll make him see the truth that you can't have every kind of character coming around your family even if you are a forgiving guy.

I always knew that women are cunning and smart, but now I'm realizing that the most important thing that women have that men don't have is grace. Women are graceful! We know how to be gracious. We just naturally have that in us, and I think that goes a lot farther in terms of business, in getting your way. It can be a better shock tactic than anger actually because people never expect you to even be nice. They've read all the stories, made up their minds

YOUR HOMEWORK: PICK ACTIVITIES TO DEVELOP STRENGTH AND GRACE

Keep Yin/Yang in balance: Try having a combo of activities in your life to keep the two sides of your warrior—the assertive and the graceful—in balance. Examples: martial arts + yoga, boxing + dance, video games + reading. Or poker + gardening if that's what turns you on!

Yang Energy: active, focused, bold, courageous, independent, direct, will-full, rational.

Yin Energy: receptive, gentle, feeling, open, compassionate, subtle, connected, creative.

that a glamorous woman in stilettos is going to be a tough bitch—so you pull out the honey not the vinegar, and it's amazing how many more bees you catch! That's not to say be a pushover, but positivity almost always clears the path, and negative b.s. usually puts a big old block in the way.

Not so long ago I was in a situation with a photographer who was really getting my goat. He and I were about to go head to head over a disagreement, and I was so irritated I could've screamed. So there I was getting all ready to stomp off into the sunset with a catty little remark, to give him a big fake smile, and a shot of attitude as I sailed away like Marlene Dietrich. Well, he mistook my smile for a real apology and thought I was reaching out to be friends. And believe it or not, he responded back with a smile and a hug. Next thing I knew, the whole argument was over and off we went to take some great pictures. Which just goes to show that even if you don't intend it, niceness and sincerity will rise to the surface and make everything go right. So that's my catchphrase around the office: "You can catch more bees with honey than vinegar!"

I'm never going to be the female buddha or some silent, strong type. Everything I do is in-your-face! But I'm shifting somewhere

in the middle and learning how to conserve power and use it more efficiently, more directly. It's more about precise strikes applied when necessary not a hail of crazy bullets spat all over the place. I'm half angry-warrior, half graceful-warrior, practicing compassion and figuring out how to be. Get back to me in ten years to see how far I've come.

The Fabulosity "tough-soft woman-warrior" way

1. *If you have one good friend in life, you're lucky.* You don't have to have ten and don't tell everyone your business. Women can't always be trusted. They will screw you over, take your stuff, and go behind your back. You hear it all the time from women, how their friends or even their sisters betrayed them! I have a few friends that I've known forever, a couple from high school and from early modeling years, and that's about it.

2. *Cut off dead boughs.* Saw off old friendships and ties that hold you back. Such as people who think you've gotten too big for your boots, have sold out, or that you're snobby for moving to a new neighborhood. If they're not going to celebrate your success and push you higher with their applause, ditch 'em. You don't need bad energy bringing you down!

3. *Walk toward your fears.* Just like that fight in the junior high cafeteria, sometimes you have to turn and face the thing you're most frightened of. I was scared to get on a plane and go halfway around the world with my kids recently, even though I used to travel nonstop. I had gotten out of the practice and was anxious about all that could go wrong. (Same thing with cartwheels: used to be great at 'em, but now too scared to try even one!) It's crazy. So I made myself get on the plane and go without thinking about it because to let silly fears hold me back would have been weak.

4. *Put out positivity.* I definitely practice the discipline of being positive. To everyone who walks in the office, I give a hug or say something nice like "You look great today!" It's a preventative measure to kind of fill the air with good vibes, like creating a positive force field and putting out what you want to get back. Because God knows somewhere somebody is saying something negative about you, and that affects you even if you don't hear or see it.

5. *Hold your tongue.* The mean words you say will hurt everyone, and the effect of putting out negativity does take a toll on you. Just stop it! Bite your own tongue and be one less negative energy in the universe. If you don't have something good to say, try to shut up. And if you don't have a genuine smile to give, fake one.

Badass warrior

"When a woman is assertive and adamant about what it is that she wants, she's totally branded a 'bitch,' 'difficult,' 'hard to work with,' or whatever the case may be. You know what? I'll take it. Call me a bitch, call me whatever, it doesn't matter. What it all boils down to is when the day is over, I'm still walking away with what it is that I came in there to get."

—KELIS

"Bravehearted and strong, definition of a warrior/ gonna keep punchin' on to the sound of her own beatin' drum."

—ALICIA KEYES AND NAS

"If I have stepped on some people at times because I am at the top, it couldn't be helped. What should I do if someone gets hurt . . . retire?"

—MARIA CALLAS

"Guys will just go out and do something. Females will talk about it—a lot. I don't care if I break a nail. You have to be aggressive to get the same respect as the guys."

—MYA

"An eye for eye only ends up making the whole world blind."

—GANDHI

"He who controls others may be powerful, but he who has mastered himself is mightier still."

—TAO TE CHING

"For a long time I thought that being relaxed meant you were running slow, but it's the contrary. When you're fighting against your body instead of letting go. Relaxation was the key."

—FLORENCE GRIFFITH JOYNER

Independence

Take control of those bills, bills, bills

The A B C s of finance, according to me

A. Never let someone else control your dough.

B. Save before you spend.

C. If you don't understand money, you will always be a slave to it.

I was the biggest nerd at my modeling agency when I was young. Out of all the girls, the agents would tell me I was the only one who filled out the work vouchers for each job to the most extreme state of perfection. I'd note every expense, clip all my receipts, and sign off on the fees I made and the agency's commissions with all the I's triple-dotted and the Ts quadruple-crossed. And I kept copies of *everything* in my little Louis Vuitton calfskin organizer. Finance is the one area in life where it truly is beneficial to be a control freak.

I noticed back then that there were basically two approaches to dealing with income: You can be aggressively on top of it, constantly bugging people to pay you now not later and know what's going in and out of your account to the dollar. Or you can trust that people will do you right (because everyone seems *so* concerned about your well-being, right?), cross your fingers, and skip out to meet your girlfriends for a café au lait. Guess who ends up totally screwed?

In any creative field like fashion or entertainment or pretty much any time you're self-employed, a dirty little game goes on. You, the struggling underdog, do some work for a company that's loaded with cash; they agree to pay you a certain fee for your efforts, and then you wait weeks, sometimes months, to see the check. And because you're dealing with lots of little amounts floating in at different times from hundreds of clients, there's a major margin for error. I saw so many girls just throw up their hands and hope that their agent, or their mom, or their older, wiser boyfriend was looking out for them and dealing with the taxes. *What?* That's like throwing it away because it's giving up all responsibility. These girls would work their skinny little butts off to score the great jobs and the magazine covers, and then wonder why they weren't flush at the end of it. The problem was nobody was watching the books and realizing that so much of the good life was coming straight out of the girls' own earnings—all those dinners and car services and plane tickets and thousands of FedEx's were automatically deducted by the agency. And in some cases, a loving step-dad, husband, or mother mismanaged (or gambled) their way through the money! The lesson? When it comes to finances, ignorance is never, ever bliss.

It's kind of like rappers and singers in the music industry today. The kids finally start making the cash, and they just let someone else control it! They're young, and they're excited, and all they care about is flying here and there, First Class this and G4 that, Cristal and Rolls Royces 24–7, without figuring that all that stuff is just taken out of their advances from the record label. It's like, who the hell do you think is paying for that? You are! Wake up and smell the coffee, people! Nothing, I repeat, nothing, is free.

That's why I think it's an excellent skill to be good at math. Because showing up and doing the creative work is just one part of any business—and it's worth absolutely nothing if you don't follow the paper trail of bills and fees all the way through to the other side. It's exactly the same if you work at Kinko's or the Winn Dixie, just on a smaller scale. Do you trust that all those deductions on your check are correct, do you trust that they've got your hours right and benefits too? Have you ever stepped back and really taken stock of what you're getting per year and what you're spending, done an accurate budget, and figured, "Can I even live on this, or is this situation keeping me stuck in a hole with no way out?" And most importantly, are you paying yourself first?

That's the biggest takeaway I got from my experience of making money as an independent agent. I learned to pay myself first. Which means I put a certain amount of every check I made into my savings account without even thinking about it. I just did it—before I spent money on anything else. Any girl with her first job, even if it's just babysitting, should do it: Out of every dollar, put a dime away or whatever you can. It's your plan for the future. That money will be a resource that you control and that nobody can take away. Sure it might not be much when you're young, but it's the psychology of the behavior that counts. You're imprinting on your brain that putting money away for yourself first is more important than buying that new blow-drying hairbrush you saw at the store. Be stingy with your money! Don't splurge at the mall and definitely don't give it to your boyfriend.

Okay, a confession before we go any farther with this money stuff. I learned all these lessons that I'm preaching to you now because I got burned bad. I was messing with more money in my mid-teens than most women get to play with. So when I started making it, I was all, "Whoo hoo!" It was heaven! To be in Paris and Milan with all that disposable income and discounts in all the fashion boutiques—I actually thought I was getting great deals, and I'd be crazy *not* to buy stuff. So I spent every penny I had on shopping. I was living that whole pay-check-to-pay-check, order it custom-made, just-give-me-three-of-everything kind of lifestyle— at fourteen years old! As I've said, I'm a Taurus—we're very mate-

rialistic, and we love luxury—and I've always adored trinkets, gadgets, accessories, beauty products, shoes, and sunglasses. Ever since I was a little girl, I've had that urge to own the best, the newest-latest thing, the name-brand product, not the generic. I guess you could say I've always been very in touch with my inner princess, but I had to learn the hard way that even princesses need a budget plan.

When I started making my own money, free of parental guidance and in several different currencies at once, I was on dangerous ground for sure. I'd never gotten schooled in how to spend smartly—what child is? So my concept of cash was that it was this liquid thing that poured through my fingers. I wasn't picturing it in the boring but solid form of bonds and CDs and diversified investment portfolios (with a few rolls of c-notes on the side for fun). It was just a green liquid flow: into my hands, out of my hands, hard to hold onto. I mean, I made pretty nice money as a model, but I wasn't exactly a Paris Hilton heiress or a massive pop star. I didn't have a trust-fund to blow—but it all seemed like so much to a girl my age that I was acting as if I did! I was spending like it was Monopoly money. If I wanted a ponyskin clutch or a Fendi Filofax, I just bought it. Didn't even need the carrier bags. It was grab and go.

When I came home from Europe for the first time, the American spending habit mixed with my stash of silly money made for a dangerous cocktail. I started getting into credit like all young kids do—all those credit card companies, they catch you at college campuses or sign you up at the mall. "It's easy, just sign up today!" Especially if you already have other cards, you're almost guaranteed to be approved on the spot. So like anybody else, I accumulated a walletful of multi-colored, department store charge cards, got the 15 percent off the first purchases—what a steal, I thought—and basically walked straight into the trap. When the time came to get my first car, I insisted upon a BMW. My mom had a total fit and nearly threw me out of the house for it, but I insisted and fought and debated: It was my money; I could do whatever I wanted with it.

It wasn't 'til I stopped playing around for a second and realized what the interest rate was on those damn credit cards, and how much got taken out of my earnings for taxes, and what percentage of all my fees didn't even go to me but went to my agency, that I had a major reality check-combo-panic attack. I didn't have nearly as much money as I thought I had, and a lot of it was going to cover high interest rates and late fees on my bills. It was embarrassing for someone who thought herself so mature. Here I was thinking I was so independent and sophisticated, but if I didn't change my ways, I'd go from Fendi back to T.J. Maxx in a snap.

As it happened, I got a huge lucky break. I scored a big job that paid me an outrageous fee, about $50,000 for seven days' work. When I got that check, I went to town. I paid off every single credit card and charge card, cancelled them, and cut them up into tiny pieces. I paid off every outstanding bill I could find. My obsession was to ensure crystal-clean credit—I was still a teenager, but I got it in my head that I could screw up my whole future! I even called every debtor I'd ever known of—like doctors' offices or dentists—and asked, "Do I owe you anything?" Because you never know where you might have missed payment on some tiny fee that follows you around for years and gets on your credit report. And it turns out my paranoia was right! Every place would say, "As a matter of fact, there is an old charge here." So I cleaned up my act by the skin of my teeth, and to this day, I pay my credit-card bill in full every month.

Since that time I've been a cold-hard realist when it comes to cash. No matter if you have a lot or if you're just making ends meet, living in la la land and thinking that either Prince Charming or the government's gonna scoop you up in times of trouble is infantile. These days it's tougher than ever: Have one major accident with no health insurance, and you'll be handcuffed to debt for the rest of your life! I don't want to scare you; I just want to put it in your head that nobody can truly take care of you but you. Not taking complete control of your finances is like renouncing your power as an individual.

It doesn't take a genius mind to stay on top of things. Frankly

Nothing will cramp your dreams more than being in debt. It can suck you down for years because the interest compounds—meaning the amount you owe grows way bigger on its own. Plus, once earned, a bad credit report can stick around and haunt you later when you really need the loan. So hold up: Is it worth getting bad credit over a stereo you can't afford today if it means you'll have bad credit years later when you need a mortgage? Remember that what you do with your money today will *always* affect you down the road. Here's how to take charge.

1. Develop a budget for monthly spending, and be strict with yourself.
2. Save part of every check you make and build up three to six months of living expenses in your savings account as a backup plan.
3. Although I encourage you to have top-shelf dreams and aspirations, when actually buying consumer goods, be sensible. Don't persuade yourself you need "quality" brands if something equally good exists at half the price. Come on now! Treat yourself occasionally but make rational decisions about the day-to-day stuff.
4. If you do purchase luxury goods and high-ticket items, approach the transaction like a connoisseur: Read up and educate yourself on what product is the best-made and is going to hold its value. Don't be impulsive or follow the trends to get the "flavor of the month" product—it's often not the best one.
5. Pay off credit cards every month, and try to keep your cards limited to just one. The average American family has eight credit cards! Resist the temptation to sign up for store credit cards at all costs.
6. If you do sign up for a new credit card, read all the fine print three times over: what's the interest rate and the penalty for late payment? It may add up to much more of a trap than you realize. Remember, credit card companies exist because they make money off of you! They're going to get their hooks into you, and if you don't notice, they'll suck you dry.
7. Remember that wealthy people don't get wealthy by spending like every day's their last. They get wealthy by saving.

I think going over numbers is more boring than watching my Chanel Pink Mink nail varnish dry, and I can find a page of stats and percentages totally confusing, but knowing that, I force myself to sit down and focus. My reasoning is as much energy that I put into shopping, I should also be putting into surveying my bank statements. I make it my business to keep informed of what I've got and where it's going to take me.

As you acquire more money, managing it doesn't get easier. It just gets more complicated. Like Biggie said, "Mo' money, mo' problems!" You end up paying other people a lot to take care of your money, and then you should really be watching them as well! I know if I paid more attention, I'd save a lot more cash—a couple hundred thousand dollars a year I'm sure. But it's a question of relativity. When you're dealing with multi-millions in your business and your life, you can't fret about every single separate amount or you'd end up in the hospital with nervous exhaustion. I do my best, and I hire the best people I can, and we try to keep this ship on course.

The Fabulosity money must-dos

1. *Always sign your own checks.* Don't hand that basic responsibility over to anyone else—not your man, not your mom, or if you have one, not to your assistant either. You should know where every single payment from your account is going!

2. *Ask questions constantly.* Of your bank, of your credit card company, of other friends or mentors who seem to have their acts together. How can I save more and spend less? Where can I get a free checking account? What is a bond, and can I put only one hundred bucks in a mutual fund? I've never been embarrassed to admit what I don't know and to get people to repeat the explanation five times over until it clicks. If they work at a financial insti-

tution, that's their job! Make them work. It actually makes you look smarter to ask questions. If it's a friend, they'll be flattered that you think they've got the Midas touch.

3. *Evaluate the answers.* Don't just swallow what you get told. "We can't lower your interest rate." "We can't give you the loan for your small business." Who says? Read the fine print, get a second opinion, stop for a second, and think about it: There is so much money running through this country—there is no way that some bank "can't" give you a loan or reduce the interest rate on your debt, even if you're the littlest fish in the littlest pond. If you think you're getting the blow-off, you've got to pull yourself up tall and ask why or go someplace else where they'll treat you with respect. Educate yourself!

4. *Negotiate better terms.* The biggest handicap you can impose on yourself is to think, "Rules are rules, and I can't get around them." Wrong! Everything is negotiable, that's why some people end up with the fully financed car and double-overtime pay—and some people pay full price for everything. I'm not the best negotiator; I think it's a true talent to be able to talk your way through a tricky negotiation, and I don't think I have it. Whenever possible I get someone who's good at it to help me sketch out my talking points in advance. (My sister is great at negotiating because she's in real estate, so I listen to her.) Like I said, I'm a nerd: Sometimes I even write a script for myself.

5. *Don't just live for the present.* When I hear people say, "Why save money? I may die tomorrow!" I think they're just plain scared. They don't want to face the reality that they've got nothing to fall back on, and they're standing on fragile ground. You've got to know how much you need to live on each month, not just spend 'til you hit zero! Calculate the amount you can afford, and don't go over it unless you're investing in something that will give you payback like a business or a house. If you're self-employed, are you saving for your retirement with an IRA? You're *not?* Get over here, Mama needs to slap you!

6. *Keep a sense of value.* As fun as it is to have designer this and that and buy top-of-the-line toys, you've got to be a connoisseur and know what's actually worth the big bucks and what's just a sham. Don't be a sucker for a fancy name or label! It's the same thing with buying services, too. When people smell a lot of money, their greed comes out like you wouldn't believe. Fees get inflated and demands go through the roof. I always try to get quotes for things anonymously before a provider knows who I am or sees my house—otherwise they double the rates.

I was driven to work by my fear of not having enough money and not being provided for. Many of my decisions over the years have been driven by a need to be financially independent. I'm sure a shrink would say it goes back to my single-mom household and not having a dad passing me dollar bills for pocket money or whatever. Even after I married, I couldn't chill out. In fact the urge to make my own money got even more intense. My attitude wasn't like some women's would be—just use all of my man's money. Because my self-protective instinct kicked in: I thought, "Just because I've married money doesn't mean I'll have it all the time!" If anything, I felt this need to prove my independence even more and to carve out my own platform that I could keep standing on if our joint one ever crumbled. Again: paging Dr. Freud. Yeah, I know I take this self-reliance thing to an extreme level (if you tone it down 20 percent, you'll still be fine).

Which is not to say women should have to be a self-supporting entity in a marriage. No, indeed not! It is a partnership, and it almost always ends up that the woman is the one making the home, keeping it running, caring for the kids, plotting out their futures. So that's why in marriage, I have a bit of a sassy attitude. I believe what's mine is mine and what's yours is mine too, honey! Because I'm allocating the family money for all of us—handling the kids' expenses and everything we need as a household—and at this point, my husband still makes a lot more than me, so it's only fair the funds come largely from him. And as for keeping some financial autonomy? I think women are too quick to throw everything in the communal pot without keeping something back that they own

all alone. It doesn't mean you don't have faith in your marriage! Just that you have complete faith that you'll always take care of yourself and your kids. My advice is to own something under your name. A piece of property. Some investments. Whatever you can afford. Set yourself up with security.

And most of all, talk about it. The biggest cause of marriage break up is finance not infidelity. Couples fight over money, fight over their expectations of who's responsible for what because they never made it clear in the first place. I've always been very clear about the way I see it, and in my family, the lines are pretty well defined. Whether a woman's married with a whole houseful of people to care for or is a lone ranger doing her thing on her own, she should never consider money one of those boring or scary topics she'll "deal with later." Pull out those bank statements, make a cup of coffee, and wrap your head around your numbers, ladies!

"I think not signing the checks and not knowing where the money is is a sign that you are losing control. It's God's way of telling you that you have too much."

—OPRAH WINFREY

"Some of the guys who are rapping now, all they can see is right now. It's about their music and that's it. They don't have a vision. I ask questions like 'What are your plans?' and there is no plan. I feel that this is just a stepping stone. I don't see me with a record deal at thirty-five. I see a lot of properties, a lot of investments. I see me as a businesswoman, maybe in music, but maybe not."

—EVE

Don't let other people cash in on your game

NOW THAT WE'VE ESTABLISHED your financial foundations, let's get to the real meat and potatoes of my philosophy. Owning your game for good. It's not enough to be cute, talented, and smart. You've got to legally ensure that your name is glued to the thing you do and that you position yourself not just as an artist, an innovator, or entertainer, but as a businesswoman, too. It's something that gives a lot of artists in the music world a harsh awakening: There's no "show business" without the "business." Same thing with small business owners—the great idea means nothing if you haven't made your hold on it watertight.

The way I learned this was pretty accidental. It was when I appeared for the first time as the face of Baby Phat in the print ads. Before this ad, we were like every hot fashion company—we featured top models in the ads and changed them every season to keep it fun. We had some top girls, like Rhea Durham and Helena Christensen. Rhea went on to score a Revlon campaign after doing our ads, which made me pretty proud.

But given the kind of company we are—multiethnic, serving lots of different kinds women with lots of strong feelings about

beauty—I got a lot of backlash on the models. Black women said, "We're tired of seeing all these skinny white girls; we don't have that body; we don't look like that!" Fair enough. So then I put a black model in the ads, and women of other ethnicities didn't immediately identify with *them*. Everyone had a different opinion and was trying to throw their five-cents into the ring!

I was so tired of going through it every single time, I thought, "Screw it, I'm going to put myself in the ads! Now you won't be able to say anything about it. You can't say that I'm too fat, or too skinny, or too black, or not black enough. You can't say crap because it's my damn fashion line. I'm the mother! This company is my child! This is me." And we went all out with a really bold image—me and my kids coming down the steps of Air Force One! Why not? I had married the guy many considered a leader of hip-hop, so I was kind of poking fun at the idea of being a new American leading lady, part preppy, part ghetto fabulous. It was a traditional kind of image with a sneaky, fun twist.

And I put my kids in the ad because I didn't want just me hanging out in the private plane or in the big mansion—that would be just too self-indulgent! So I brought my kids into the ads to kind of add a drop of humility and say, this brand is coming to you from me as a fabulous woman who's made it, and also as a working mom who loves her kids, and also as a regular girl who loves to play with clothes. And besides, I'm a proud momma who happens to think her girls are really cute!

The point is, putting my face to the brand like that changed everything. It was risky—I'm sure a lot of people hated it. But it was super successful because suddenly there was a personality to the name, somebody real to see and to connect to, whose life you could read about in the papers. If you think about it, fashion designers have always starred in their own lifestyle ads. Calvin Klein used to put himself in the ads. Giorgio Armani did it years ago, too. He was so handsome; that's what made you fall in love with him: his signature black T-shirt, tanned skin, and silver hair. So I was continuing that legacy for a new generation.

Putting myself in the ads was a powerful way of claiming own-

DO-IT-YOURSELF #8:
SECURE YOUR GAME.

1. Be responsible for knowing your worth and charging the right amount for your services. Women have a chronic pattern of undercharging and accepting lower salaries. Knowledge is power, so ask around and find out what the rate is.

2. Once you're established in your field, resist the impulse to give up your work for favors or for cheap—unless it's gonna pay you back with some kind of excellent experience or is helping a worthy cause. Working under your rate just sets a precedent of low pay. All you have to say is "If you don't have the budget for me, maybe we shouldn't do this deal."

3. Don't be scared to ask. The biggest mistake women make in business is not negotiating. When handed an opportunity or offer, they think they've got to either say "yes" or "no." But men rarely hesitate in asking for more money and better terms before they accept. If you know your industry and what's within reason, your request will be treated professionally. The worst they can say is "No way!" Then you both move on and figure out a compromise. Easy.

4. Seal the deal so that no one else can take credit for your work. Get a contract in writing, so your name is featured on a piece of work if it's appropriate or use other creative ways to make your efforts known in your industry, like getting a story about your project placed in the trade media. Self-promotion is not the same as showing off, if you do it in a businesslike way.

ership of my work. I am the image of the company because it's my lifestyle that women around the world are wearing. It's my life! So if you get some other guy to try and go in and oversee the collection tomorrow, honey, good luck. Because what the consumer is looking for is a Bentley and a fur jacket, and they're looking for Ming Lee and Aoki Lee, and that's what they get from me— a whole fabulous universe that they know and love and get to be part of!

This tactic, which started out kind of as a default plan, became the major driving force of my company. Once I started to really own what I did and to put my face and name to every single thing, our success soared. I was empowered. When a huge manufacturing group bought all of our brands, Baby Phat was a very big part of the negotiations because of the tight associations between my name and my face and the actual products. Therefore I had a much bigger say in defining the terms of the deal than I would have if I'd been passive about taking ownership of my brand all along.

So how does this apply to you?

It's just a philosophy of working everything to your favor. Life is a hustle. I know that. Most women don't get the opportunity I had, let's be realistic. You can count the number of strong, visible females in fashion and entertainment on your fingers and your toes! For most women the focus is on getting by, getting some recognition, and trying to get ahead with small steps at a time. I want to encourage you to periodically take a pause, pull back, and see it all unfolding from an aerial view. Where is your place in this field? How are you going to increase your worth, so it seems like nobody but you could possibly do this job—ensuring that when you ask for 50 percent more, they give it to you?

It's about building up your persona—which we'll talk about in the next chapter—and leveraging that image to your benefit. And it's about having a cool, calm, collected approach to what you do. Think clearly and be a little bit more about your business, whatever your job is! Don't get me wrong and think I only care about you if you want to make it up the corporate ladder or get your name in the *Wall Street Journal*. Not at all! I would never tell you that what you do for a living is right or wrong, good or bad; I'm just concerned with the *how*. You can be a pole-dancer or the girl on the video shoot, that's fine by me—I'm using this example because music videos are constantly playing in my office and at home and a lot of my clothes show up in them—but just don't be the girl who gets paid $20 for the day when others get a hundred times that much. Don't be the girl who gets a little too involved with the guys on set because she thinks it's going to short-cut her to the top.

(Newsflash: It won't.) Make smart decisions with a long-term plan in mind and know when to turn down the wrong kind of gigs.

You might be the hottest model or dancer out there, but I want you to study and know your value as *a business commodity* not just a pretty face. What's the going rate for your job, and how much could you push that rate higher because you're offering more talent or more originality? I want you to always have a bigger view of the work you're doing: What do you want out of this ultimately? What is your bigger plan? And do these small jobs you're taking get you on the track to that goal—or are they wasting your time and energy? And if you *are* the hottest dancer out there, don't just aspire to be eye candy—be eye candy with a business plan and a really good handle on the numbers.

Or maybe it's the total opposite! Maybe you're a stay-at-home mom who's starting to look after other women's kids as a business on the side. I'm saying, consider taking it pro. Find out what the competition charges, get yourself a daycare license, and turn your cat's name into your company name if you want to. If other people are doing it and inventing their own career from nothing, so can you. Use your smarts to make it legit and double your gains.

"Don't let anyone cash in on your game" is ultimately about you making the money so that you can turn any opportunity into something much more for yourself. And if you respect yourself enough to be businesslike about it—not chasing after the glamour like a teenager or letting people take advantage of you because your attitude's so casual—you'll get respect in return.

"If you don't own anything you do and you're just doing it for a fee, then you'll see someone else take your hard work and make millions of dollars on it. . . . Well, I never wanted to see that happen. I tried to own everything I could. It makes you feel like you own your life."

—ICE CUBE

"The industry thinks there always has to be some man somewhere puppeteering the whole situation. It's unfair, and it's also realistic, so I have to approach everything that I do very carefully. Because there will always be people who want to claim authorship for what I do. Or just because their name is next to mine will wanna take the credit."

—LAURYN HILL

"The first album, nobody cared. After we blew up and it became a situation where you can definitely make money, everybody wanted a piece of the pie."

—LISA LOPES

Image
&
Body

LAW
#9

Build a powerful persona

IT'S NOT ENOUGH TO *THINK* FABULOUS, you have to *be* fabulous. Now that you've got your foot in the door and your eyes on the prize, don't just creep along, quietly doing your thing, and hoping that someone, somewhere is noticing (and don't eat so much humble pie that you shrink into the corner). Girl, if you're on the ups, grab a little *more* power by building a reputation for being something out of the ordinary! Because all the hard work in the world won't get you anywhere if you don't powerfully project your personality and style out to the world through everything you do. There are millions of people working hard out there; the question is how are you going to differentiate yourself from them?

Dreaming big, paying due diligence, seizing opportunity, and making smart decisions—all the things I've talked about so far— are all essential components of Fabulosity. But now let's add the pizzazz. The fun! The color and the light! I'm talking about spending a bit of energy considering your image. How are you coming across to the world, and is your image helping your cause? *Does anybody out there know who you are?* There's an art to self-promotion—and unless you're a genuine, certified genius or you've discovered the miracle cure for AIDS, chances are you'll need to

put effort into building your reputation all throughout your life, starting with your very first job. Look, we live in a cluttered, busy world where almost everyone has some form of A.D.D., myself included, and if you don't project yourself out there slightly larger than life and shoot a few spotlights up into the sky to announce your talents, you'll end up invisible—not to mention bored and dispirited.

I don't want you to do all the hard work and then not be seen! There are so many ways to add a bit of oomph to your image. It could be as simple as the fantastic way you walk and the confident way you talk, or it could be as involved as tricking out your vintage Mustang in a way that makes folks say, *"Damn, girl!"* Or it could be the e-mail newsletter you send out to friends every month, about the latest trends in street style or beauty, that establishes you even in the most casual way as "someone who knows what's up." Basically, everything you do in the public sphere, the way you interact with the world at large, is a chance to telegraph something about who you are, what you stand for—and what you want from life. Don't get me wrong—image is not the be-all, end-all. But it is the *beginning*. It's what helps you grab your spot, so you can be heard. It's what makes other people want to hear what you've got to say.

We've all seen how celebrities tweak their images at different stages in their lives. Picture Jay-Z in his impeccably tailored suit—he's created an image that radiates authority and success, and with one glance, you sense, "This guy's got the power to make things happen!" L'il Kim uses cutting-edge fashion and beauty to convey that she's queen of her own, ultra-fab domain. Her image says, "I'm not your average rap star—I make the rules." The Williams sisters? Everything from their clothes to their confident speech to the way they hold their bodies tells you "We're the *new* guard of sports, and you ain't seen anything like us before: sexy, powerful, entertaining." If any of those people tried to do their thing simply by "working hard at their craft" without a thought to their public persona, they'd lose a hell of a lot of that fascination factor.

You might not be trying to sell three million copies of a new album or score an endorsement deal with Puma, but the rules still apply. Because no matter what any of us do, all of us are selling

ourselves, every single minute of every single day. Each one of us is building our own "brand of me" and saying, "buy into me, put your faith into me, give me this shot, I will make it happen." Whether it's in work, in love, in art, or in just getting that damn realtor to give you a break and forgo the finder's fee on your apartment! We want to be perceived as special. That's why spending time on your image and persona is not an indulgent afterthought—it's an act of self-reliance. You've got to give *yourself* the edge to get the attention and props you want because otherwise the phone won't ring, the opportunities won't arise, and the fascinating personalities you want to surround yourself with, well, they just won't appear out of nowhere! I want you to work on developing your own unique "brand" no matter what that is because if you are a magnetic person, you will do what a magnet does: attract.

Of course, one thing's got to be in place before you even start. Your self-belief. Every salesperson can only truly succeed if she believes in what she's selling. She must believe that her customer's getting a really great product—top-of-the-line stuff. Without that confidence, her sales pitch's going to stink! (If your self-belief isn't starting to peak by now, turn back to Law #1 and start over, my friend!)

I've had to become pretty savvy about image building since I have a lifestyle brand that's closely tied to my own personal image. Its success depends on whether consumers understand what Baby Phat and Kimora Lee Simmons are all about—and they have to get it quickly because there's a lot of competition for their attention! What I've learned is that whether you're selling a denim brand or simply selling yourself, the rules are pretty much the same. An article on marketing recently put it this way:

1. Good brands tell us immediately what they're about.
2. They have differences that are immediately observable and highly defined.
3. They're salient: Highly intrusive, you can't avoid noticing them.

By now, most of you all know how I roll. You've probably seen

DO-IT-YOURSELF #9: PUT YOUR PERSONA OUT THERE (WITHOUT DROPPING MUCH CASH).

1. Start a blog. You're the lowest on the totem pole, but you've got opinions and cool ideas about your industry or your art. Tell people! If it's smart and innovative—and if you gather new information and link to great sites—you can quickly establish authority in your field and have free reign to project your persona.

2. Create a homepage. If words aren't your thing and you're more of a visual person, build a homepage with photos of the places, people, and events in your world. Everyone wants to be a voyeur, so if you're doing original things or having unusual adventures, share them (and promote new pics via e-mail).

3. Gatecrash the right parties. You may not get the invites to the hot parties in your field, yet. But just like there's always a back door into a career, there's always a back door into a party. Trust me. It takes charisma, networking, and style so sharp they *can't* turn you away—or sometimes just an eagle eye for where the catering truck is parked!

4. Get snapped. If you want to make it in the glamour industries (fashion, music, movies), it'll help a lot if your picture shows up in trade papers and magazines. Don't be shy! Strike a pose with your bad self (and make sure that sharp style you put together really pops for the camera)—and smile!

the TV shows and the magazine articles that give a glimpse of my lifestyle or go behind-the-scenes at our office. And you can probably call out a few things that are "very Kimora." There's the denim + stiletto sandals + tank-top combo that's become my style signature (more on that in Law #10). There's the house that's luxurious but pretty unpretentious—a place people want to come and hang, not where they're too scared to sit on the furniture. (Sure, it's got the marble and trompe l'oeil thing going on, but it's also got provocative paintings and photographs by black artists on the walls and numerous rescue dogs and cats wandering around—it's part

grandeur, part freestyle chaos.) And there's my office in the pent-house of a forty-five-floor building on Seventh Avenue that kind of flips the stuffy company-president image on its head: It's outfitted with gold-brocade swag curtains, a giant Louis XIV desk and chair upholstered in pink-velvet, a huge flat-screen that I keep tuned to BET, and usually a Pomeranian dog or two and kids' toys scattered in the corners of the room.

All these things: the clothes, the home, the office, are deliber-ate choices, not lucky accidents. I've developed what my stylist calls a "regal fly girl" public image—opulent, urban, fun, and youthful—and that's what Baby Phat was built off. No matter that on my days off you'll find me barefoot in the kitchen in velour sweats and zero makeup, playing patty cake with my kids! That's irrelevant. The point is that any time I'm in the public eye, I stay consistent with my public persona and put effort into finessing it because I know its value. Projecting a consistent image of success and glamour—the hallmarks of my brand—is what makes people feel they can place their bets on me. How would things be differ-ent if I had a cookie-cutter house, a beige office in Paramus, and wore those track pants to work every day? Well you wouldn't be reading this book, that's for sure. You probably wouldn't even know my name.

Thing is, you don't have to actually possess those things (your own business or designer clothes) to get started! You can project full-on Fabulosity no matter what you do or don't have back home—whether it's through creative dressing, associating with a certain crowd, or treating people graciously. When you act like you already possess it, then like a magnet, your aura of confidence and positiv-ity will attract more Fabulosity to you. Remember when I said, "Everything you can imagine is real?" Now's the time to put it into practice! Because when your persona is founded on self-assurance and self-belief, other people want to believe in you too—they want to buy into your brand. It's the same way that a start-up business with little capital can do wonders with a great logo and stylish, ultra-modern website. One great outfit and hip business card could do the same for you.

Don't get me wrong. When I use the word "persona," I'm not talking about faking anything or pretending to be a character that you're not. It's the opposite: I'm saying, project more of what is *authentically you* and use whatever you can to communicate it: your haircut, your pet (and its accessories), or even your choice of lampshades if you want! Smart self-promotion can mean just finding a few elements of your personality that resonate with people and enhancing them a bit.

I've discovered the elements that work for me—let's call it my Brand DNA—and I stay true to them, no matter what I do. They're like the threads of my story; I make sure they're woven through my brand so that my message stays clear.

New Glamour: My personal brand is about taking the icons of old money—diamonds, luxury goods, and decorative arts—and turning them upside down. It's like reinventing Fabulosity for a new generation: a group that's younger, hipper, and much more diverse than the old-school establishment. Doing that has helped build my reputation. Here's an example: I wanted my first diamond watch when I was twenty. At that time everyone and their mama wanted a diamond Rolex; it was the total status symbol of the time. On the other end of the spectrum was the diamond Franck Muller watch, which was like an establishment watch, totally elegant and upscale, and to my mind, utterly fabulous. Sure, the preppy people had it, my Syrian friends in the Jewish community had it, but no one in the young crowd, or in the hip-hop crowd, had ever even heard of Franck Muller. So I bought one, rocked it, and everyone in my and Russell's crew loved it. Soon enough one big hip-hop mogul got that same watch, then another major rapper had one too, and it was on the cover of the luxury magazine, *Robb Report*, as the quintessential luxury item!

A few years later, I applied the same attitude to my own jewelry line, the Hello Kitty Collection by Kimora Lee Simmons. It was hip, sexy, deluxe, and a little irreverent—the old guard would never wear diamonds in the shape of a childhood icon! But I knew the new-guard girls would go crazy for it. And they did: The collection became the number-one seller at Neiman Marcus and started

CHOOSE YOUR COMPANY WISELY

Heads up, people. Your public image is not *only* about the shoes you wear or the ride you roll in. It's also defined by the crew you hang with, the way you behave, and the manner in which you treat other people. Don't be complacent, hanging out with a sketchy crowd that harms your reputation! Don't show up to a party in a crappy mood and turn people away from you with your bad attitude! (I love what a makeup artist once said to me: "I only go out when I'm in a fabulous mood, so everyone thinks I'm the happiest person around." If he's not got good vibes to offer, he stays in for the night.) The point is you've got to take a minute to reflect on how your public behavior adds to or hurts your image because you will get judged on those things whether you realize it or not, no matter if you're a woman who's in the spotlight or a student just starting out. Let your default setting be "gracious" if you can—no matter what your true mood might be underneath. And choose your company wisely: Friends and associates can reflect well on you or quickly tarnish your image.

showing up on pop stars, socialites, and all kinds of fly girls I'd spot sashaying down the street. The style choices I made personally helped my public image become that of a new American Dream, one that's open to anyone, of any background.

Authenticity: Young girls who come up to me at in-store appearances or on the street always look so surprised. They go, "You're rich, but you're real." Because I am pretty much like they are—young, into a hip-hop lifestyle, a lover of glamour! I'm excited to share the lifestyle, and I want to play with it. And I'm approachable. You can come up and talk to Kimora. I won't tell you to get off my white sofa with your sneakers; I say, sit yourself down and let's talk! And hey, can I get you a glass of wine while we chat?

Fun Luxury: I truly appreciate the finer things, but I also don't take them too seriously. I don't take *myself* too seriously! I mean, I'm the Chinky Giraffe who now collects bejeweled giraffe statues

Here's the reality: To live your most fabulous life, it's not enough to be the workhorse who logs tens of hours of overtime because few are rewarded for virtue alone! Nor is it enough to be pretty, if for example you want to make it as a model or actor. Without projecting a defined personality and a strong sense of what you're about, you'll be that beautiful girl who no one can quite remember. "Hmm, what was her name again. . . ?" Beauty without a powerful persona is kind of like an empty vessel—nice to look at but not very useful to anyone. Good-looking women, quite frankly, are a dime a dozen these days. Style, charisma, and a powerful way of being, on the other hand, can substitute for pretty features and perfect legs any time—just flip through a book on the style icons and legendary women of our time. The women you remember are the ones tones who've catapulted themselves out of the "generic" category and into the "premium brand" aisle. Something about them just radiates deliciousness: "I've got better flavor, better texture; I'm the Haagen-Dazs of women, in a class of my own."

HAVING A PUBLIC IMAGE is not about being so cool that everyone's too scared to talk to you. I think it's smarter to go the other way. Shock 'em with friendliness! Chit-chat with everyone! Offer to help people meet one another and make connections. Being upbeat and positive can make you stand out way more than being the absolute guru of cool.

and puts them on display right where everyone can see them. Some of them are in the form of diamond giraffe picture-frames—they're blinged out and totally gorgeous. They're like a combo of the person I was and the person I've become. And it's a good story for people who come over to the house and go, "What the heck is up with the giraffes?" So it's almost like my personal icon the way my cat logo is the Baby Phat icon. And since we're on the subject of animals, may I mention how I carried my pooch Zoe around the world in an LV travel bag long before the Hollywood "It" Girls did it? To me, it always seemed like a very fun way to use a fab piece of Vuitton. If you got it, use it, and don't take it all so seriously!

See how I stick to my brand characteristics to create a consistent persona? What are yours?

When you know your own Brand DNA and build your persona with it in mind, you reap the benefits. Here are what I call The Public Image R.O.I. (Returns On Investment):

1. *Big bucks come from a big rep.* Your image and your reputation are worth a lot more than your résumé in oh-so-many instances. It's a natural law: Successful/cool/interesting people want to ally with other successful/cool/interesting people. In marketing, people are drawn to strong brands. In life, people are drawn to strength and to people of character who are true to themselves. Pump up your public image, and it'll probably earn you a lot more than that graduate degree ever could. Even if you don't yet have a big rep in your field—let's say it's your first interview for your first job and your previous job experience is next to nothing—you can kill the competition by having the most fun, upbeat personality in the hiring pool. Project the image that you are someone who it'd be great to be around each day. (Just keep your eyes on the fine line between enthusiastic and annoying!)

2. *You build an internal GPS (Global Positioning System).* When you define what you're really about and act accordingly, it's like you give yourself a map. You start figuring out what your authentic purpose is and can turn down things that don't fit. It's like you take the role of creative director in your own life and can make quick decisions: "This is me, definitely. Ugh, this is totally *not* me." It works, whether you're talking about a job, a lover, a friend . . . or just a new handbag!

3. *You spread pleasure.* Expressing what you're really about and telling that to the world with unabashed confidence is a blast. At least, it is to me. I love that people walk into my house and start grinning, "This is *too much*; this is so *you!*" Their pleasure is my pleasure—why give people brown cardboard when you can give them embroidered, crystal-flecked organza? This isn't about luxury; it's about creativity. Be a little more technicolor about your life—it's so much more fun than black and white. As with anything, the more effort you put into your public persona, the more you get back.

4. *If you distinguish yourself, you feel more distinguished.* I find it fulfilling to have a world that reflects who I am. When I come

home, it really is my home. I feel safe, nested, and grounded, surrounded by the things that I've chosen with love. It becomes not just a house but a sanctuary. I feel empowered driving the car that is "me" and I feel confident acting the way that's true to how I feel. None of this has to do with scale or size. You can create the world that reflects you in one room—do it in your bedroom! Paint it purple and hang stars from the ceiling! Or hang purple ribbons from your bike handlebars like I used to do and ride it to school if it makes you feel fly! Flex those creative muscles in every which way you can and tell the world "this is me" in small ways every day. It's about taking pride in yourself, regardless of what anyone else thinks.

As a woman you've already got a head-start in attention-getting—most people would rather look at a woman than a man, and actually I think they'd rather listen to an amazing woman speak than a man, even if society's still got this way of keeping people conditioned to think men are more important. If my husband goes out to big events without me, people may say to him, "Where's your wife? I want to see your lovely wife—not you!" I guess I'm cuter than he is. The point is that women have way more power than they realize. People want to be wowed by you! All you have to do is step up and deliver—a great entrance, a glint in the eye, and either a dose of humor or a shot of drama will have a lot of people at your feet.

I read a quote from a major supermodel a few years ago in which she describes how she exaggerates her persona to make a powerful impact. "Whenever I walk into a restaurant, I take advantage of the chance to make an entrance, dressing up, walking tall, acting a little snobbish, talking with my European accent." She's got it: She knows the qualities that make her stand out, and so she magnifies them just a bit, thereby commanding attention, turning heads, and making everyone talk.

Truly successful brands have what's called a "point of difference." That's what we say in marketing: There's something about them that is completely different from anything out there, the market and audiences can recognize them from a hundred yards away. Look around at the most successful brands that we now take for

HOW NOT TO BECOME A PERSONA NON GRATA.

Warning: Expressing a persona does not mean babbling about every little thing that's on your mind! You are not on *Inside the Actor's Studio*, okay? The world is not interested in seeing the full spectrum of your personality, with all its complicated layers and secrets and fears. Keep all that stuff for yourself or your shrink—projecting your persona means a few positive attributes—you at your best!

YOUR HOMEWORK:
DEVELOP YOUR PUBLIC IMAGE.

Not everyone needs to attend big-tent charity events and parties as part of their work, but every time you leave your house, it's a new chance to add to your wow factor. Whether it's a major night out or a middle-management lunch-meeting, you can pump up your persona with a few strategic tactics.

Step A: Walk with a Supermodel Strut:

I love, love, love the power of first impressions. We've all seen that quintessential movie moment: A woman walks into a party, and the whole room turns to look. (Even better if she can pause at the top of a huge staircase for a second and then float down like a goddess, but that's a rare opportunity these days.) Or she crosses a busy Manhattan avenue and literally stops traffic. If you want to do that, you have got to have a great "special event" walk that you can turn out when you need it. A walk that radiates confidence, pride, and, femininity—with a touch of sexiness. A walk that says, "I am here, so bring it!" Modeling taught me more than any one person ever needs to know about walking in front of a crowd. It's not a natural gait: It's a "strut," not a "stroll." It's about getting attention. So it's going to be a little forced, and it needs to be practiced, just like dancing.

If you watch a fashion show—and I highly recommend looking at video clips online to get some ideas of how runway walks create drama—you'll see that each model has a different strut. Some of them are complete signature struts and recognizable a mile away. I don't recommend you pull out a full runway walk just to enter a party or a business meeting because runway struts are exaggerated to really show off the lines and flow of the clothes. But apply the runway basics to your own normal gait, and you'll automatically acquire a layer of polish.

1. Rather than planting each foot in line with its hip on two parallel lines, bring both feet closer to one single center line when you step. It gives a sexy swing and an impression of length to your legs. Stretch your steps out a little, too, because longer strides give a beautiful flow to your movement.

2. Imagine two strings pulling your hips from the front as you walk, and two strings pulling your shoulders from behind, so that the pelvis "leads" the body as you walk and the shoulders stay way back. A final string is attached straight up from your breastbone, so that the chest is lifted tall (that also keeps your shoulders from rising up to your ears!). The chiropractor won't be happy if you do this too much, but this slightly artificial posture gives a long, strong "fashion" line to your gait.

3. Keep your chin up and your neck long; if you're out there totally on your own, the gaze should be level and softly focused at a spot straight ahead in the distance as you move. This suggests assurance and pride—you know where you're going, and you know how to get there.

4. Don't over-swing your arms! It destroys the illusion of softness and makes you look like you're a military cadet. Notice if one arm swings higher than the other: That's a common model problem.

5. Keep your fingers relaxed. It's the smallest detail in modeling work—both in studio photos and on the runway—and people often overlook it because they're busy concentrating on other stuff. But tight, clenched fists or ramrod straight fingers both signify one thing: fear! Let your fingers gently curl and brush your legs as they move.

6. Unlike runway walking, where models *never* make eye contact with the audience and barely smile, in real life you should project your personality. Once in the crowd, try to engage at least a few onlookers with your eyes and a smile (though don't nod to everybody—that's too Miss Universe). It triggers an energy around you and makes sure you come across as a hot mama that everyone wants to meet, not a chilly ice princess.

7. Of course, walking with runway or red-carpet flair depends more than anything on whether you feel great. It's got to start from the inside out, and more than anything, you've got to feel good about what you're wearing. Give yourself some good time to prepare, so you don't feel rushed and stressed. Last-minute wardrobe crises will completely blow your cool. And practice walking in those four-inch heels *before* your big night out—give them a test drive on carpet, wood, and asphalt!

Step B: Study Presentation.

You want poise and presence? Turn to the movies. Rent a few movies with Sophia Loren, Faye Dunaway, Angela Bassett, and Marlene Dietrich. Women who fill the screen with elegant power and complex strength. Watch how they move, sit, and talk. Soak it up! All of us are in such a hurry today, we probably don't even notice the real women around us who've got grace and charisma. With movies at least you can hit the pause button.

Step C: Follow the Top Ten Rules of Social Etiquette.

1. It's not always what you know but *who* you know. Get out and meet people.
2. Never speak about people who aren't in the room. It's a good way to check yourself before you blurt out gossip because gossip always comes back around to bite you in the ass. Trust me on that one.
3. Even if you're a guest, be outgoing and introduce people to one another. Be a connector, keep the energy moving, put in your best effort to make the event a success. It's like showing solidarity with the host. The good karma will come back to you at your next party.
4. Write thank-you letters. I learned this when I was dating my husband. After we'd go to parties at the homes of the VIPs he knew, I always wrote thank-you notes on behalf of both of us to the hosts, and it so impressed them, they told my then-boyfriend, "This girl's got grace! She's fabulous! She's a keeper!" So it served me well. These days, thank-you letters can be either carefully written e-mails or, better yet, handwritten on good paper, with a nice ink (not ballpoint) pen. Send thank yous not just for social events but to people who've helped you out in your career and life. If they've done you a big kindness, send a thoughtful gift. The cost doesn't matter—it might be a book you know they'll love, just inscribe it with a heartfelt message. That kind of gratitude gets you remembered. (Which is why I tell my friends, invest in good writing paper with your name embossed on it, and it will more than pay you back!)
5. If you go to a lot of parties, eventually you better host a party and do payback. Don't be a freeloader.

6. When in doubt about dress code, go for neutrals. I think a woman should always err on the side of dressing up—styling herself with elegance and care shows she takes pride in herself and values the invitation highly enough to make the effort. But if you're not sure how out-there other women's fashion will be, pick a look in muted or neutral shades. That way you won't be embarrassed if you're in an Armani-style spaghetti-strap dress while everyone else is in Capris.

7. Don't mistake "casual attire" for sloppy attire. Showing up in dirty jeans even to a backyard BBQ is like a slap in the face to a host who's been cooking her butt off all day. Wear the jeans—clean ones—with cute shoes and a dressier top.

8. If it's a dinner or a gathering at someone's house, bring a gift when you arrive. It's an easy gesture to make and an expression of goodwill.

9. Never show up with uninvited guests. Always call first to check if it's okay to bring your sister's boyfriend's entire family. And if you bring them, bring some extra food and drinks!

10. To repeat what I said earlier, use parties to network, not to "party." Save the silliness and carrying on for when you're out with your real friends, not your industry colleagues. Reputations are easily lost and hard to recover.

granted. A lot of them were once considered too out-there and too unorthodox. Not tried-and-tested enough. But they kept at it and became the status quo. Think of Virgin Airlines! MTV! Even Starbucks was once thought too weird for America. Same is true with your own persona. Maybe you're not the most conventionally beautiful woman in the world; maybe your art or your ideas are considered off-the-wall. But these are the things that, if you harness them to your advantage, will make your persona *more* intriguing and more unique. Be true to yourself and stick with it through thick and thin. If you waver, do what other people want, and let yourself be shaped and shifted, you will be diluted, you'll fade. That's not fabulous. The women with real strength are the ones who never compromise their character, their taste, or their opinions and keep projecting the best image of themselves they can, in full-screen size and in full color.

The all-time persona expert: Hollywood star, Joan Crawford:

"If you've earned a position, be proud of it. Don't hide it. I want to be recognized. When I hear people say, 'There's Joan Crawford!' I turn around and say, 'Hi! How are you?' I never go out unless I look like Joan Crawford the movie star. If you want to see the girl next door, go next door.

"Nobody can imitate me. You can always see impersonations of Katharine Hepburn and Marilyn Monroe. But not me. Because I've always drawn on myself only."

"In this industry you have to *be like this* or *be like that*, 'cause if not, you gonna be picked apart, and once you get too big, they're gonna tear you down. But you can't lose respect for your individuality no matter what anybody says."

—ERYKAH BADU

"It's better to be looked over than overlooked."

—MAE WEST

Dress like you might run into your worst enemy

EVERYONE NEEDS STYLE; and by style I don't mean thinking you're stylish because other people like what you're wearing! Hell, they may *not* like it. But if you to want to start getting some recognition as an individual, you have to establish yourself, and amazing personal style is a great way of telling people who you are and what you're about. Whatever you are—designer, artist, lawyer—amazing clothes say *I am hot, I feel great, my fashion brand is what it is, my necklace collection is what it is, I'm the best deejay, you want my music at your party, here take my card, call me. . . .* No matter what you're trying to achieve, style is one of the most powerful ways of branding yourself, and as I've said before, branding is what a great businessperson is all about. You only have a moment to make an impression these days, and believe me, your personal appearance is going to do a lot of the talking. It's like being on a debate team— here's your ten seconds to say what you gotta say. Do we believe you? Did you win the debate? Come on, we don't have all day!

Remember, in business, style bestows authority. Would you really invest in the product of someone wearing a holey T-shirt and dirty flip flops? No, you want to buy into the aura of success. If

someone seems successful, then a customer believes that by buying into him or her, she too will catch some of that success.

Amazing clothes make you feel hot, and when you feel hot, you feel confident; you're on fire, you rule the world! If you want to get anywhere in life, you have to feel good about what you're wearing, even if other people don't like it—*you* have to like it. Clothes aren't something to hide behind, but they are an extra layer of armor that help you create the image of yourself you want to be judged on. And sometimes, if you need a boost of courage, they help get you going with your head held high.

The Fabulosity five-point fashion manifesto

1. Style is a form of self-promotion.
2. Developing a style is like your brandmark; it'll get you noticed and remembered.
3. Fashion betows authority and power on the wearer: Dress to impress, and you will be taken seriously.
4. Great style says, "Here I am! Pay attention to me!" I value myself enough to put effort into this, and you should too.
5. Style is individual. Style is subjective. Nobody can grade you on it.

To understand my style, you have to explore my fashion closet. It's opulent, over-the-top, and under the colorful surface, it is meticulously ordered.

My clothing closet is my hideaway from the world. It's my home within my home, the place where I feel most me. Not only is it the ultimate girly fantasy room, I think it's actually bigger than my first apartment back when I was modeling. It's O.T.T., and I know it—I mean, it's O.T.T., and I *love* it! Wall-to-wall leopard-print carpet; gilt chandeliers; a baroque, gold, and cream, French-style bureau. And more importantly, it's organized to within an inch of its life. Some people have wine cellars, others have li-

DRESSING YOUR KIDS

Kids are like little versions of us, the Big People. They look up to us, idolize us, want to be fashionable and fabulous, and have fun with us. The reality is that no matter what your age, if you're a girl, it's in your very essence to want to have a good time with clothes! I do go a bit extreme with my girls sometimes; I'll send them to school looking supercute and beautifully outfitted sometimes, and people will look at me weird, "Are they going to church or something?" I really encourage them to be imaginative and dreamy with costumes too. My daughter Aoki spends most of the time wrapped in any kind of blanket or sheet—in her mind, every old blankie is a princess dress. Of course, my kids love to dress up in my stuff too! I'm not so happy to have them tripping in my Manolos and tearing the hems of my gowns, but they're fashion girls born of a fashion mama. That said, I definitely make sure they know that beauty comes from the inside out. I tell them, "You're beautiful because you think you are. You're beautiful because you're different. You're beautiful because you help other people and give." The two things go together to weave the whole pattern of the child. They open their mouth, and I look inside—and they don't know you can't see inside—and I ask them, "We're you nice today, what's going on in there?"

braries full of rare books. I have my closet, and I know exactly what's in it. Style is what I love, and I spend a lot of time on it.

Several levels of bookcase-style shelves house my assortment of fabulous stilettos, which are separated and grouped by color (the biggest section is the metallics). On all sides of the room are yards of hangers with neatly hung clothes arranged by category: chiffon dresses, blouses, pants, skirts, and leathers. The boot section is obvious—stacks of double-length shoe boxes keep them pristine, with polaroids on the outside of each one to help me find my favorites. My jeans are neatly stacked in shelves that reach to the ceiling and scores of T-shirts, folded and arranged according to color, rainbow up the wall next to them. Because everything is in one room, it's like my mission-control center. I can stand in the

STYLE TIP #1: It's essential to make an organizing system before you even worry about what's *in* your closet. Make your closet or drawers or even the open corner of your bedroom as well-structured as you can. Containerize your clothes: Splurge on dividers and organizers! Otherwise the great stuff you get will end up curled in a ball in a dark corner somewhere, never to see the light of day again.

Know your fashion don'ts, and you'll be saved from crazy purchases—
like when you go to a sample sale and lose all your sense over ruffle
skirts because they're 75 percent off. It can happen to the best of us!
My no-nos are:

Baggy, sloppy T-shirts
Stripper tops that leave your belly hanging out
Broomstick skirts; hippie-girl skirts
Anything see-through. That *is* too much.
Birkenstocks
Distressed anything—no distressed jeans, leathers, or punk-rock torn
 T-shirts
Anything with a sports team logo on it
Conservative pantsuits. My pantsuits are coral-pink Versace corduroy
 and sexy as hell.
Wide-brimmed sun hats, trilby's, and top hats. No, no, no!

middle and survey what I've got and get ideas for how to wear it
all. What I've learned over the years is true no matter what your
closet size: If you can't see the clothes, you'll probably never wear
them.

I keep my handbag collection in two separate closets, orga-
nized on several tiers so I can see them all at once—beaded bags,
embellished clutches, and Birkins in a candyland of colors. One
door over is a closet full of Louis Vuitton bags, organized by size,
from totes down to changeholders, sunglass cases, and document
holders for the girl-on-the-go. My grandmother once said, "An or-
ganized closet is a sign of an organized mind." I like to think that's
the case with me. (And if you're wondering, yes, I have extra clos-
ets downstairs to store clothes I'm not currently using. They are
cedar-lined to keep the moths at bay.)

Inside the gold-and-cream bureau, tiers of skinny sliding draw-
ers house sunglasses of every shape and color, from Gucci bug-

eyes to pink-lensed Diors. Separate sections house lingerie. Clustered on the bureau top are vials of every fragrance under the sun—I prefer sweet, feminine scents, but I like to change it up from day to day. In short, I've created an environment that inspires me to dress up, make an effort, and most of all, enjoy creating new looks. Because that's what fashion should be about: pleasure! If you enjoy it and feel great in it, other people will pick up on that positivity.

I'm a big advocate of having fun with fashion. Sure, I know clothes are not going to save the planet! But if you love fashion and care about fashion, then letting yourself get excited about costumes and adornment is a way of getting juiced: ready to take on the world and excited about your own potential. Putting on a fab coat is like putting on a costume—you feel like the star of your own movie, and you are in charge of the plot. If you don't care about fashion . . . you probably think I'm a little crazy. But come on now, haven't you ever put on a belted trench coat and felt as charming and chic as Audrey Hepburn in *Breakfast at Tiffany's* . . . or a dramatic winter coat with a fur hood that made you feel like lovestruck Julie Christie in *Dr. Zhivago*? If you have, you know how it can totally change the mood of your morning! I won't apologize. I was born a fashion girl, and I'll die a fashion girl. I'm playing with color and texture and shimmer with about the same seriousness as my daughters do, and I'm enjoying it!

Defining a style

My style is Ghetto Fabulous Baroque: rich colors, lavish silks and velvets, and vivid prints, but all mixed with modern styling—jeans and tank tops. I don't feel dressed unless I have a lot of stuff on, and I don't understand why some people are so scared to adorn themselves. You are a goddess! Look like one! Sure I appreciate the plain white T-shirt and Levi's look on some women—it looks timeless and sexy on a lot of people. But dressing like that would make me feel like I was naked. To me, a woman should appear

STYLE TIP #2: Bring a bit of boudoir into your bedroom. My closet is a bit like a French woman's boudoir—the little bedroom or dressing room she has so she can primp and pamper in private. A boudoir is like the setting for your love affair with clothes, where you can sneak away and get immersed in the glamour (besides, who wants a man poking around your stuff, telling you you're taking too long?). If you live in an apartment, you almost certainly don't have the luxury of that much space. But integrate that thinking into your bedroom. Make it a sensual space, with soft lighting, warm rugs, and some of your favorite scarves and accessories on show. Just like with romance, dressing is all about getting in the mood!

dressed up, accessorized, completed. It says she thinks she's worth spending an hour getting ready.

It took me about two minutes of living in Paris to realize I needed a makeover. Once you touch cashmere, it's kind of hard to go back to rayon. I was thirteen, fresh off the plane, and I quickly developed champagne wishes and caviar dreams! Right away I had the best on-the-job training for being a style junkie—every day I was working with the best makeup artists, hairdressers, and photographers, and the best, most fabulous clothes. Working for all the big designers definitely influenced my style today. I felt good in the tight, sexy, dangerously short dresses they poured me into. Strutting down the runway, I felt rich and powerful, and the experience taught me about the drama of fashion: how your clothes are always talking, telling the world a story about who you are and where you are going.

Back in the States, all the other girls were in full-on street style, dressed down in baggies and sneakers. My style was influenced by Parisienne women who were always flawlessly feminine and used their womanly charm to the max, but it got a lot looser and more fun when I got immersed in music and pop culture in my late teens. I mixed my love of fashion with hip-hop culture and watched a new generational style emerge, where "fashion" is more accessible, more fun, and less snooty than ever before. Today's hip-hop has helped change the way real people wear fashion—you can participate in an upscale, aspirational lifestyle no matter where you're from and what you do. I love it! It's a new way of thinking.

How exactly does hip-hop show up in my wardrobe? For one thing, I love looking hooked-up! Just like when I was a little kid, my shoes match my bag that matches my belt—only now it's likely to be matching Gucci or D&G. And though I know it's not the way fashionistas do it, I love it! It's so over-the-top. Some would never wear accessories in this way: They break up matching pieces because they're a different kind of fashion addict; conservative, preppy, they don't push that envelope. They represent what I call "straight" fashion. It's more serious. I see it in the magazines, in

STYLE TIP #3: Mix & Match. Fashion looks freshest when you mix a high-end piece (if you have one) with something much less formal. Got a Prada top? Wear it with your Baby Phat mini!

FABULOSITY ESSENTIAL: IN-FLIGHT STYLE

Traveling is no time to get lazy with style. You know what I said about "dressing for your worst enemy?" Don't throw that out the window just because you're on a plane! People managed to travel in comfort long before sweatpants and flip flops were around! Traveling is a time to pare down your look to basics, but to look polished and pulled together if you can—hey, if they need to bump someone up to business class don't you want them to pick you? My advice:

Don't wear lots of makeup unless you are a flight attendant. It'll melt off your face sometime around hour four of the flight.

Don't go for the varsity sweatshirt just to be cozy. Wear layers of cottons and knits, so you can peel them off or add them on as the temperature changes.

Stash comfy slippers in your bag for the flight—but if you really want to be fabulous, keep the heels on to the gate.

Bring an extra T-shirt and underwear on long-haul flights. After fifteen hours on the go, you'll be happy you did.

If you can travel on a private plane, up the ante. Go major glam. It's a fantasy! Be excited, and dress to impress. For those few hours, you're living a movie-star life, so dress like one. (You can keep your bags on hand on a private plane, so why not?)

the books—it's proper "taste." But what I'm talking about is a little more ghetto. The matchy-matchy deluxe-accessory thing? You've got to go back to the street to see the origin of that style. It's fierce, super-confident, in-your-face, and it's got heart in it.

This high-low mix is nothing new. High fashion and street fashion have always been intermingled. Gianni Versace understood the "more is more" style: He borrowed it from the ghetto and reinterpreted it for his line. Once he put his name on it—remember the baroque silk-print shirts and huge jewelry of the late 1980s?—everyone thought it was fabulous! Hardly anyone

STYLE TIP #4: Most people are so busy talking about designer this or designer that they forget the absolute fundamental of style. Proportion. If you look at flawless women with all different dress senses, an understanding of proportion is usually what they have in common. They know where on the leg a hem should hit so they look fluid, not frumpy. How wide a jacket's shoulders should be, so it's totally now with a hint of retro spirit, not a complete throwback to the 1940s. There's a subtle math formula that happens with clothes, and if you understand it—like, how long a chunky-knit sweater can be (if you wear it with a mini) without making you look sloppy—you can wear the most basic, inexpensive items and look like a million bucks. How to learn? All you have to do is study the photos in magazines! They'll take a certain proportion concept and shoot it ten different ways at once. Suck it all up and study! You can adjust and alter your own clothes, so they fall on your body the right way.

TEN MOST KIMORRIFIC ITEMS IN THE CLOSET

One way to start defining and refining your style is to look at the pieces you love most from your wardrobe, and write down what they have in common, and why exactly you like them. It helps you draw a set of criteria for future purchases. Is this me or not me? Here are my picks:

- Four-inch Leopard-print Manolos with rhinestones and chains
- Orange ostrich-skin Birkin bag
- Knee-high leopardskin boots
- Knee-high snakeskin boots
- Extra wide mink and leather belt (worn with minis)
- Caramel mink bolero jacket
- Versace bag with gold hardware and gilt trim
- Silver Gucci sandals with lattice of interlocking rhinestone G's over entire foot
- Cosabella hot-pink panties
- Thirty-carat "Asscher-cut" diamond ring
- And of course, a huge pile of Baby Phat jeans, denim minis, and tank tops as the foundation of each look!
- What ten items in your closet best represent you?

knew that it was influenced by fearless girls in the ghetto with out-there style. But come on, who the hell was wearing those big door-knocker earrings before the girls in Harlem were?

The funny thing is that everything just comes around in circles. I was a girl from St. Louis, and what I wanted was what Gianni and Donatella had: the life, the glamour, the high style. I had the street, but wanted more chic. So I fused the two together in my own way and had fun with the juxtaposition—bending the rules by taking uptown boutique gear to the downtown street and creating my own identity in the process. That's what makes fashion so exciting! Taking things out of their context and wearing them in a way the designer never ever expected. You only have to look at L'il Kim, Mary J., and even guys like Biggie to see how that high-low mix pushes fashion forward. They invented a new way of wearing luxury fashion that was new and fresh and kept the creative flow moving. The point is that the European designers borrowed from us, we borrowed from them, and it's all a big mash up in the end.

People are wrong if they think that the post-hip-hop style, with its flamboyant, aspirational approach to fashion, is about accumulating as much as possible. Or that it's about blowing all your money and not thinking about how you're spending it. I believe it's more about the celebration, having fun with things, and not taking them as seriously as our grandparents did. For me, it's not about trying to prove anything, like I have the latest this or that. I'm just expressing myself! But I am not an old-money type either who's trying to be "low key," so you really don't know I'm rich. I'll never be laying low with my style. I've always had a grand concept of Fabulosity—I'm not trying to lie!

My style isn't for everyone. You may hate it—you *will* hate it if you try to dress in a way that doesn't reflect your personality and that you don't feel comfortable in. If you don't know what your style is, then look to women who you think are style icons or whose style you just admire. They could be women you see around you, your mom or your super-chic aunt, people on TV, entertainers, models, or just some cool-looking chick on a subway platform. If your eye is constantly drawn to the same thing, then Bam! There's

your style! Figure out what is it that appeals: their long, minimalist silhouette? Their funky skateboarder style? The twist of 1960s mod in the mini skirt and boots? Then pay attention to what separate elements they use to make up the look.

When you're rocking a look that feels right, you'll be naturally confident. You'll walk into a job interview and talk your way into a great position. You'll bowl over that guy on your first date. You'll get an upgrade at the ticket counter. Why? Because you'll have the aura that comes from feeling good about yourself. It doesn't matter if your parents hate it, or your friends think you look goofy—the important thing is that you feel at the top of your game—and that will only happen when you dress to suit yourself. Be confident in your decisions, put your best foot forward, and don't be worried about other people. No doubt your fashion formula will be quite different from mine. But here are the rules I follow, and whatever your dress sense, I think they'll apply to you, too.

1. *Always express the Three-Fs: Feminine, Flamboyant, Foxy.* I always say that the Three-F's are 20 percent about the clothes, 80 percent about chutzpah. (Which is a lot cheaper than if it were 100 percent clothes.) Think about it: Calvin Klein photographed Kate Moss in a wife-beater and jeans—and she looked *fabulous*. Dress her up in diamonds or put her in a cotton T-shirt and undies, and each time she reads "fab." It's because she feels feminine and foxy from her core, before she even looks at a garment. She knows she's the sexiest, most fascinating, most wanted woman in the room and radiates that in her eyes and her body language. And you know what? Everyone else in the room knows it too. So before you dress up, psych yourself up!

2. *Dress like you might run into your worst enemy.* Living with Fabulosity means putting your most empowered and confident face forward any time you're in public. I truly believe that being pulled together gives you the confidence to handle anything. Because you feel *prepared* for whatever the world throws at you. It's like you're a warrior who's "suited up" and ready to rumble (fabu-

STYLE TIP #5: Even if you have to wear the drabbest uniform to school or required dress code slacks for work, you can *own your look*. Adding even one personal touch, like a scarf or a beautiful pin, immediately upgrades you from clone to individual. It might seem like too small a detail, but when everyone's dressed the same, even the littlest accent tells a story about you. (If you can get away with it, alter the proportions of your skirt or dress-code shirt to flatter your figure, too. Your principal or boss probably won't know the difference, but you'll look ten times chicer.)

lously of course). Get lazy and grungy, and you give up a little power. Next time you're pulling on dirty sweats to run to the store, ask yourself, "What if I run into somebody? What if I run into a magazine editor? What if I run into that bitch from school, and she sees me looking like a bum and tells everyone from back home, 'Hmm, I always knew she wasn't going far?'" Now take off those grungy sweats, put on your Friday night jeans, and get out there!

3. *Four inches, no less.* My heels define who I am. If people saw me in flats other than on the beach, they wouldn't believe it was me—they'd think there was a problem. In just the way that big brands try to stay true to their brand identity in advertising or that politicians try to "stay on message" during a campaign, always wearing heels, no matter what, is my way of *staying true to my identity.*

4. *Be authentic to your lifestyle.* Have you ever seen a Hollywood bombshell show up at divorce court (or, for that matter, shoplifting court) in a demure little suit and thought, "She looks so . . . *not her.*" There's a reason for that—when a woman dresses to fit dress codes or to be something she's not, it shows. It doesn't matter how well her formal suits fit her, if it's not true to her style, she'll look unhappy and off-kilter. Don't be fake! Dress true to your personality and your lifestyle—great style is so often about looking like you perfectly belong in your environment.

5. *Use trends to fit your style.* I love to buy what I consider staples—the Chanel tweed tote bag instead of the crazy Jean Paul Gaultier purse. I want to *follow the trends but not be a victim of them.* When Gucci shows leather pencil skirts, I might buy several in the hottest colors, but I'll have the atelier cut the skirts down into minis to suit me. Their trend; my style. In general, I stock up on simple clothes that are always in fashion, like sexy, well-fitting tanks. Of course, I *love* buying crazy-hot clothes too (I can't lie), and yes, often they're trendy, like handbeaded pants from Gucci that are so "of the season," but I might only wear them once. I

STYLE TIP #6: Periodically, spend time in your closet coming up with new combinations of clothes so that nothing's left hanging with the tags still on eight months after you bought it. But here's the key: Have a profashional at your side as you do it. A profashional might be someone who's job it is to know fashion, like a stylist or personal shopper, but in most cases, it'll be a trusted friend with great taste or a sister who knows your style but will tell it like it is. It's the person you call on in style emergencies! (If you do want a personal shopper, they can be found at almost every big specialty store, like Neiman Marcus, Bergdorf Goodmans, Saks, and so on.)

YOUR HOMEWORK: MANAGING YOUR WARDROBE

If you're a certified fashion addict, you have to find a way to manage your time! Dressing can be a full-time job, between hunting for good pieces, altering outfits, and searching for one-of-a-kind things. I shop *a lot* when I'm traveling and out on the road, but I don't usually have time to go to stores to see seasonal collections, so I have a stylist who pulls things for me, and every season fashion houses send over look books or even bring their collections to my house for me to try on when I have a moment.

What I've learned from my stylist is that you can't be laid-back about pulling looks together. You must invest a certain amount of time in wardrobe pre-planning to take advantage of what you have. And be honest. If you don't have that personality streak that makes you want to spend hours plotting how to wear your Yves Saint Laurent chinoiserie jacket or fashion-forward 1980s piece from ebay—I mean, trying on jeans, cargo pants, pencil skirts, and mini skirts to figure out what looks right and sending it in for an alteration, if necessary, days before you need to wear it—you probably shouldn't be buying it because you only have ten minutes to get dressed most of the time, and by then it's too late to figure it out!

bought them as a very special occasion piece and knew they'd be an heirloom piece for one of my daughters. There are different reasons to buy things.

6. *Make it work.* I learned a lot of tricks modeling, but one of the most useful was *make it work.* If I end up having to wear something I don't really love, I can make it work anyway. Traveling and going to last-minute events sometimes means wearing hastily-purchased dresses that I'm not fond of. The solution is to pick the best accessories I can find to give it my personal touch and then . . . not even worry about it. It's just one night, so go on out there, and move with pride! That's what people see—your style as a woman, not the fashion you're wearing. No matter whether

you're wearing a silk gown or a polyester uniform, look in the mirror, tell yourself you're the hotness, and *make it work*.

Building a wardrobe

I got off that plane in Paris for the very first time with one bag. Until I got to the point where designers gave me some nice pieces, that was all I had. But I was okay because the things I had brought were staples: a few jeans, a few great sweaters, some cool little skirts that look pretty funny now. Do what I did. Start with the staples and add to them as you have the opportunity. Build your wardrobe from the basics up. Have a basic jean, basic black pant, black crew-neck sweater, a good set of bra and panties, a good black dress, and a few good white tank tops. Everything clean and minimal on which you can build up with a couple of accessories, like paint on a canvas. It's the same for any fashion-related purchase, *always buy the basic first*. Get the basic Cartier steel watch before the colorful trendy one. Build—you don't have to have it all at once!

I can have whatever I want now, but only fools buy things they can't afford, or that are out of their reach, or that they can't wear and really get use of. If your one-and-only big purchase is a fabulous going-out ring, you paid too much money for it, and it's a waste! You should have bought a fab watch or small diamond studs that you can wear everywhere—simple, well-chosen quality staples are what you want to buy until you can afford the crazy stuff.

Every woman needs the help of a profashional when doing closet-management: He or she will give you a fresh perspective on what you already own and see ten new ways of wearing something that you've lost faith in. My stylist and I spend hours at a time coordinating looks head-to-toe, laying out the jewelry, belts, shoes, and coats that go with each look. We have to because I'm so busy that if it was just me choosing my clothes on my own, I'd probably

STYLE TIP #7: Push the boundaries of "good taste" with something only you would have. I confess, in my case, it's Judith Lieber bags. They're super elaborate, rhinestone-encrusted evening clutches in whimsical shapes—like a Coke can, a Lifesaver roll, or a chubby, pink pig. Anyone in serious fashion rolls their eyes at them. They're like the Liberace of evening bags, which is exactly why I love them! My passion for them drives a certain fashion editor I know insane—he'd rather me have some distressed Balenciaga bag that doesn't match anything. He thinks it's kind of old-lady and wack. But I'm not old-lady, so it's fabulous on me! By the time I'm that age where most women are carrying those things, I'll probably be the other way, more Armani and minimal. I think every woman should rock something she loves almost *because* it's unconventional—life is too short to always stay in the safety zone. Be different, be eccentric, be one of a kind!

Jewelry: I love, love, *love* my diamonds and stones. J'adore! I love to play with them, change
(continued)

911: THE GO-EVERYWHERE FASHION EMERGENCY KIT

Nude thongs (for white and pale-colored skirts and pants)

Nipple petals for wearing under sheer tops

Band aids for protection from rhinestone-covered sandals

Double-stick tape for sticking down revealing tops

Deodorant (the kind that doesn't leave white powder on your clothes)

Baby Phat Goddess fragrance

Super-shiny lip gloss

Mints

repeat everything and constantly wear my favorite, familiar things. Jeans, jeans, and more jeans! And that wouldn't really help my image. She pushes me to dress up and wear new pieces all the time, rather than getting too comfy. So call your profashional, put on some music, pull out the clothes, and get creative together (then be sure to return the favor!).

Profashional Secret # 1: Polaroids

Polaroid snaps are a secret weapon when it comes to wardrobe management—it's a trick stolen from fashion magazines, where they shoot snaps of outfits before a shoot to remember what pieces they put together. After you spend the time putting together outfits in your closet, lay each ensemble down on the floor with the shoes, jewelry, purse, and any other accessory you think looks great with it, and take a quick Polaroid shot. Write the names of the pieces on the white border if they're not clear, and start an archive of your looks! That way you don't have to reinvent the wheel every time you need a good outfit—it's all ready to go. (And if you are very social, you can also record just where and when you wore each look, so you don't repeat a drop-dead dress with the same crowd.)

(continued from page 158)
them up, reset stones, find old pieces, and take them apart into something new. I guess some women do flower arranging as a hobby; I do gemstone arranging. I truly think jewelry is appropriate for any and every occasion. Wearing just a couple of things to me is an act of self-love, like saying, I am beautiful, and let me call your attention to me! Even if it's a couple of cute handmade necklaces you bought at the Farmer's Market or eight-dollar Indian earrings from a chainstore. Color, light, twinkles around your face and body—how can that not improve your look?

As for serious jewelry, bring it on. I have a pretty amazing jewelry collection, but as with my clothes, I built it from the staples on up. White diamonds and gold or platinum are the basics. My first diamond watch was classic white diamond. Don't go for the crazy pink and yellow-diamond watch that's not going to match your outfit—the one that's unobtainable, out of budget, not functional! Don't go overboard with jewels, go classic and basic, and as you get money, you can go for a color piece.

f it's my look that inspires you, I'll break it down for you. This is my hit parade—the key fashion components that make up my look.

Tank tops: The ultimate wardrobe staple, and my version of a simple T-shirt—just sexier because it reveals the shoulders and clings to the figure! You want a bit of weight and stretch in a tank, so it's a good body base and can be worn without anything on top. If it's too thin, it'll look like sleepwear. The tank is super versatile because you can layer it with another color underneath, wear it with jeans for a dressed down look, or pair it with a suit for a hot, downtown-chic look. It's a good silhouette for just about everyone, but one tip—don't buy it too small. No one wants to see the outline of your bra—that's tacky, not sexy.

Jeans: I have hundreds of pairs of jeans. (It's my business, after all.) There are a few other brands I like aside from my own, but one thing all denim should have in common is *stretch*. Stretch is great for the fit of a jean; it curves the fabric over your butt, no matter what size you are. After a few weeks, it doesn't sag out on you either. Jeans are a fab blank canvas for your self-expression. You can embellish them with jewels, feathers, or sequins (just please don't rip 'em or bleach 'em; it almost never looks right when you do it yourself). Take your Mom's sewing sissors and cut your jeans into a skirt; add rhinestones, stitching, embroidery, and patches. Or simply turn up the cuff about six inches into a capri pant and pair it with glittering sandals for a summer-party look. You can wear dark jeans almost anywhere if you dress them up enough with a great jacket and nice shoes. But keep the ultra-low riders for casual events. Denim plus acres of bare skin does not read "upscale."

Mini skirts: As I get older I'll stop wearing them, but baby, I still got a few good years in me yet for mini skirts! The key is never to wear them with regular closed-toe shoes or sneakers because it throws the proportion off and draws the eye to the foot instead of the legs. In summertime, you want to pair a mini with feminine thongs or delicate sandals—

anything that reveals skin and keeps the illusion of leg going to the final second. In wintertime, go for boots: They reach farther up the leg and again add to your height. For daytime, try cute stockings and colorful Pucci-swirl rain boots. For nighttime, go more radical: Try a snakeskin boot up to the thigh.

Color & Texture: This is a key component of my wardrobe. I am all about vivid, colored-fur jackets, soft leather pants, sheer chiffon tops, and dresses in super bright swirls. Darker skin is the perfect canvas for extra-bold colors, and mixing up rich textures is the easiest way to signal luxury. Throw in feathers, chain mail, or angora knit—anything that will be the oppulent accent to the basic denims and tanks. (What? You're nervous? Come on—do you want to be a pigeon or a bird of paradise?) It goes without saying that the color that pops up most in my collection is pink. Fucshia, magenta, strawberry, raspberry, peony, coral . . . I've got it all.

Flou: In French fashion, *flou* means clothes that flow and dance around your body. Like dreamy chiffon tops and dresses in super sheer fabrics that seem lighter than air. Everyone should have a few things like this in their wardrobe: What is this idea today that everything has to be tight, tight, tight, and flaunt every inch of flesh? *Flou* is sexy, *flou* is feminine, and it makes you want to dance and be a girl. And yes, you can wear a *flou* top with skin-tight jeans!

Profashional Secret # 2: A friendly tailor

The number one, insider-style tip in the fashion world is *alter-ation*. I mean, you go to an advertising shoot for a big brand designer, and those thousand-dollar clothes are pinned and taped, so they look good on the model. You should do the same thing (just not with tape). Have pants dropped at the waist for a slinkier silhouette; adjust jackets so they look made-to-order by hemming the sleeves to hit your wristbone. Don't forget pant length: Your pant legs should never hit so low on the foot that they cover the beautiful front of your shoe (or that you

STYLE TIP #8: White diamonds and platinum is a classic jewelry combo; it never goes out of style. So if you hit a bad spot and need to sell it, the piece will hold its value.

risk puncturing them with your stiletto heel!). And we usually take out the pockets of pants for a more streamlined, body-fitting look. Find a good tailor and ask them what they can do. He or she is the best friend of the stylish woman.

The Fabulosity accessory philosophy

The way you accessorize your outfits says a lot about you and can be a very good stand-in for owning any major designer pieces at all. Your shoes, your belt, your jewelery, or your cute little hat are like little telegraphs to the world about your attention to detail and what kind of style you identify with. Accessories can be deeply luxurious and expensive, but they can also be fabulous on a budget. The rule: If it's expensive, go for classic, not flavor-of-the-month, so you can use it for years. If it's cheap, go for a super-trendy, eye-catching piece because it'll fall apart in a month. And don't buy fake luxury-brand pieces—the people you're trying to impress will know right away that you got that Louis Vuitton on Canal Street. Go for the unexpected pieces from middle-tier brands (the ones other women probably won't pick).

I wear my accessories big. I'm not a waify girl! My watch is almost a man's watch—it has to be because I'm so tall that if I wore something dainty, it would just look wrong. My belts are often triple-wide and dripping in hardware, lacing, or fur. I don't wear hats—to me, they're too much with all my hair and my height. But sunglasses? The bigger, the better.

Bags: The absolute easiest way to add flair to your look. If you prefer to wear jeans and black sweaters, a bright-colored bag can completely elevate your look. My favorite is the Hermès Birkin bag— I've got it in all kinds of colors: lavender, hot-pink ostrich, lime-green crocodile, and shiny black. If you're going to splash out for a great bag, please treat it like an heirloom from the get-go! That means, don't take it out in the pouring rain; don't throw ballpoint pens inside (they'll leak on that precious leather); and don't stuff

them with oversized objects (leather will stretch). If you can only make one good bag purchase, make it either a large tote—a "model bag" as I call it, big enough to fit everything you need, all day long—or a classic shoulder purse that will never go out of style. One tip: Don't automatically go for "safe" beige or black. A classic style in a bright color leather will look fresh and stylish for years!

The top five jewelry rules

1. *Hook it up.* Some people never wear earrings that match a necklace, but out of a matching set of earrings/necklace/bracelet, I would definitely wear two out of the three, with some other things thrown in. Be matchy but not too matchy. Pair things around color but not exact stones, like an emerald piece worn with a jade ring, if you have precious pieces, or if not, try different shades of turquoise.

2. *Add an anklet.* Just when you have enough jewelry, there's enough room for more if you find a new body part, ladies! Glittering, skinny anklets in summertime are super sexy (just make sure your legs are clean-shaven and moisturized, please).

3. *Stack it.* Wear several diamond (or faux-diamond) bracelets and watches on top of each other. The look is kind of unorthodox and funky and totally deluxe.

4. *Secure it.* Every piece of serious jewelry you have should be insured. It's another reason to start with simple, classic pieces. If you splurge on ultra-valuable items and are too scared to wear them, what's the point?

5. *Supersize it.* As with most things in life, go XXL if you can. Don't pick the neat little hoop earrings—that's too goody-goody. Pick the giant, sparkly hoops. Think Mary J.

FABULOSITY = Inventing at least one trend in your life.

It's time to claim some credit. And since this is my book, I'm going to do it! You know Manolo Blahnik's Timberland boot-stiletto? Forget what you read in the press. I made that boot big! He'd designed it years ago; I think it was for Azzedine Alaïa because I remember wearing that boot on the runway about fifteen years ago. I asked him to make it for me again five years ago, in every color, to go with some of my leathers and furs. I was a great customer of Manolo, which is why they made it for me; they don't usually do custom orders. Before I re-ordered it from the vaults it wasn't called a Manolo Tim, but after I started ordering them in every color, they developed a line, and it became the hip-hop, ghetto-fab footwear of choice. So, what trend are you going to leave as your legacy?

I know some people hate on my style—I'm not *distressed* enough for the hipster crowd, I'm too much, I should be slouching along, toting a big, ugly, old bag and hiding behind a Starbucks coffee and big pair of glasses. "That Kimora," they say, "orange and pink, high-heels, fur, what *is* she *thinking?*" You know what I'm thinking? That everyone who sees me knows who I am, what I'm about, and what I stand for. I'm a brand, baby, and every day, I'm my own best advertisement.

"I drop, thirty or more in Christian Dior/They gotta close the store and let me shop some more."

—LIL' KIM

"Look for the woman in the dress. If there is no woman, there is no dress."

—COCO CHANEL

"I wish I had invented blue jeans. They have expression, modesty, sex appeal, simplicity—all I hope for in my clothes."

—YVES SAINT LAURENT

"Rolex and bracelets is frostbit; rings too/Ni**az 'round the way call me Igloo Stix"

—JAY-Z

"When in doubt wear red."

—BILL BLASS

"I rock diamonds that's red, white, and indigo/I'm undroppable, untoppable."

—LIL' KIM

Embrace your inner goddess (then play with your diva)

PEOPLE HAVE CALLED ME A DIVA. I'll claim that title, why not? I even named our first Baby Phat sneaker The Diva. I have a lot of fun being fabulous and out-there, as you can tell. But there's another word that I use to describe myself and other women that ultimately means a lot more: goddess. Both come into play when we talk about beauty.

They're actually two different sides of the coin. Diva is the woman you see on the red carpet, rockin' it in the Gucci pumps and rolling in the Mercedes coup. She's the fierce and foxy me: The glittering persona who is out there in the public eye, who has a way with layering lip gloss, and knows her best angles for the camera. Goddess is the private me, the woman *inside*. She's the source of that third "F" I talked about before: the feminine. In fact, I named my fragrance after her because I truly believe there's a goddess in every woman, and I love to see it shine brightly—I think the word "goddess" represents woman at her most empowered!

Every woman needs to be in touch with her inner diva *and* her inner goddess. One takes care of the external stuff: the image, per-

sona, and all that great glamour. The other takes care of all things internal: a woman's health, her well-being, and the sexy vitality that no amount of designer clothes can deliver. The diva may seem like more fun to hang with at first. After all, she's the one responsible for booking the mani-pedis and the deep cleansing facials. But the goddess is actually the source of more profound satisfaction and the one we have to all start with. She's the one responsible for making a great blank canvas of healthy skin and bright eyes, who'll put the real glow in your cheeks. (And in my case, she's *definitely* the one who gave birth, twice, so I know better than to ignore her!) Your first responsibility is to take care of her by eating right, not abusing your body, and working out—at least a little. Then you can indulge your diva. Got it?

Fabulosity goddess manifesto

1. *I am a goddess, and my body is my temple.* If you're going to make it to the top, you have to treat your body like a temple and keep it in perfect working order. Makeup is fun, but it truly is the icing on the cake: It can cover many temporary blemishes on the surface, but no amount of Touch Éclat or Dior eye shadow can substitute for vitality and natural radiance on the inside.

2. *I don't hold myself to impossible beauty standards.* That girl on the cover of *Elle* and *W*? She doesn't look like that the minute she wakes up, not one bit! I know all those girls, and they're gorgeous—but they're not perfect. That flawless skin and glossy hair, those perfect abs? Illusion. A couple of them smoke heavily, and you can see it in the wrinkles around their eyes. Another's skin is notoriously bad (we're talking your-little-brother-in-eighth-grade-bad), but you'd never know because it's all fixed on a computer. A goddess knows that fashion and beauty images are an illusion, and she doesn't hate herself for not looking the same.

YOUR HOMEWORK: NURTURE YOUR INNER GODDESS

It's easy to lose touch with your goddess in a busy lifestyle. So you must surround yourself with beauty. Things that when you look at them and experience them, give you joy. The cliché of men buying you flowers? Sure it's nice if it happens, but don't hold your breath. I happen to think the pleasure is bigger when I buy them myself! I love looking over and seeing a beautiful vase of blossoms that I picked out. It doesn't have to be costly: You can go to the market and spend $5 on flowers and make them last up to ten days if you change the water enough. That's 50-cents a day. The Way of the Goddess depends on you valuing yourself enough to take time for little moments where you revere yourself, pamper yourself, and splurge on whatever little gifts or treatments you can afford. If you can't afford a present to yourself, reward yourself with a peaceful cup of tea, meditation, or working out, whatever you can do to take time and make yourself feel like a *better you*. The whole goddess idea is about cultivating beauty from the inside out.

3. *I love myself, and it shows.* A goddess loves herself for everything she is, not everything she wishes she were. She sees room for improvements, sure. So she tunes up her health regime to get it or maybe amps up her beauty routine. Either way, she does it out of pleasure, not out of self-loathing. Imagine if women turned all the energy we spend on self-criticism toward a positive use; we could probably power a whole city with all that coiled up energy!

Beauty, part 1: The way of the goddess

My life revolves around the idea of beauty; after all, my business has been built around defining fashion and beauty, and it's what I know best. But from my experience as both a model and as a cre-

THE DIVA/GODDESS BALANCE

I loved seeing one of the all-time supermodels, Linda Evangelista, come back onto the runways recently. She was a fearless fashion diva in the late 1980s and 1990s who changed her look for every magazine cover, sparked huge beauty trends with her haircuts, and made some very controversial diva comments about modeling. (The most famous being that she didn't get out of bed for less than ten-grand a day.) She's still gorgeous today, fifteen years later. Why? Because while her diva was loud and proud, so was her goddess: she exercised, ate well, kept her life in control. Another model I loved as a kid was Gia Carangi. So gorgeous! She was feline, foxy, drop-dead sexy: She was *the* model in New York during the late 1970s (If you saw the movie *Gia*, you'll know what I mean.) But Gia never loved herself and she spent her short life desperately finding someone to love her. She had plenty of diva but no goddess, and in the end, using drugs and sex to try and fill the void where her goddess should have killed her. Two beautiful women: two very different approaches to life.

ative director of a fashion brand, I can tell you that beauty is a strange and fascinating thing; it's not just based on a woman's looks. You hear it so often in the modeling industry; photographers and art directors make comments like "That girl's gorgeous, but her eyes are dead. There's no feeling there. She doesn't make me want to look twice!" Cruel but true. So much of a woman's beauty comes from the way she feels about herself and other people. Is she happy with herself and her life? Does she feel fantastic inside and out? I truly believe you can see that a mile away, and it's one reason that someone reads "attractive."

Think about it. There are gorgeous actresses out there who are *more* beautiful and more talented than the major stars—but instead of shooting *Must See TV*, they're still hustling to auditions. Why? They don't truly love themselves, and it shows. When the director tells them they are gorgeous or really talented, they may nod

their head, but in their hearts, they don't *believe* it. So when you look at them on film, you see a pretty but insecure girl. A girl who isn't in charge of her own destiny, who doesn't believe she deserves the chance she is being given—and what director wants *that* girl carrying his multi-million dollar movie? To truly glow, to be a drop-dead gorgeous goddess, you *have* to start by loving yourself and believe you are of value. Moreover, a real goddess loves herself enough to take care of what God gave her. She's conscious of what she puts into her body and how she maintains her health because she knows that getting lax about her lifestyle choices can rob her of her passion, her beauty, and her dreams.

True, the superficial aspects of beauty—the makeup and styling and all that—are super fun, but physical beauty is an expression of what's going on in your gut and what's flowing through your veins. Do you eat a lot of junk food, and are you full of toxins? It'll show. Or do you exercise, and are you stretched out and walking tall? Do you drink enough water and have smooth, clear skin because of it? You can buy a lot of products to apply to the surface, but you can't buy the basic components of health and vitality. You just have to practice them. Of course a goddess cares for her mind and soul, too: Quiet time and spirituality are all part of goddess maintenance.

Goddess essential #1: Pride

When it comes down to it, embracing the inner goddess is the most fundamentally important thing a woman can do! It's an expression of basic self-esteem. Because it takes time and effort to care for oneself inside and out. It's so much easier to be lazy and not pay attention, but the way of the goddess is about living with self-respect and valuing yourself no matter what you have. Whether you live in a tent, mansion, or trailer park, it's about keeping your home neat and tidy and setting a certain standard

THE JUNK FOOD DEMON

It's a fact. Junk food is *deadly*; yet girls who know better than to take up smoking or to have unprotected sex think nothing of eating burgers and fries each day. I've been that girl. I had an Egg McMuffin every morning for years as a teenager! It's only lately, having married a man who turned vegan on me and having consulted the nutritionist, that I eat better. So as a former fast-food junkie who's cleaned up her act, let me tell you: *Just Say No.* I hear girls in my office moaning that they feel ugly and flabby, and I say, "What do you expect? In the three minutes you took to chow down a burger and fries you just ate more salt and fat than you should eat *all day!*" Not just fat and salt. That burger was packed with preservatives and chemicals; the fries were fried in partially hydro-genated fats, which are proven to damage your arteries. The twenty-four ounce soda you drank had enough sugar to send your insulin through the roof! I tell them, "Be smart! *You know* junk food is bad for you, so why don't you get mad about the companies who are making billions by en-dangering your health with this crap?" Do something about it!

Fast food chains have created a product that is *addictive*—and that's not just me talking, it's a scientific fact. You keep eating it, your body gets used to it, and it's like drugs. You're hooked. You need that blast of carbs and salt and fat. And when you finally do try to change, you go through detox, just like a drug addict. Next time you're at the counter, ordering up your fifth burger and fries of the week, remember that they're playing you just as well as any two-bit hustler.

that you don't ever dip below. (Don't let your kids run around in their diapers. What's that all about? Let's put a pair of pants and a shirt on them!) It's about taking pride in yourself regardless of what you do or don't own. Got one great pair of jeans and that's it? Keep 'em clean and pressed, and figure out five ways to wear them differently! Having that level of pride in your appearance is what radiates from you way before anyone notices your nails. It makes other people value you highly (and you won't have only one pair of jeans for long).

Goddess essential #2: Health awareness

You are responsible for you. No one else is going to do it. Nobody else is going to care if you don't schedule your annual Ob/Gyn or if you're too scared to check your breasts for lumps. I know that sounds harsh, but it's a fact. Remember what I said about your body being your temple? Getting check-ups and being self-reliant about your health is crucial to keeping that temple in order, and it's far more important than getting that leg wax or blow-out. Advocate for yourself: If there's something wrong, call your doctor, and keep calling until they give you an appointment. The health system in our country is a disaster, so you better have enough pride in your inner goddess to fight—and fight *hard*—for her well-being. Now, I am definitely still on a journey, not at the final destination. Don't think I've been reading *Shape* magazine all my life and drinking beet juice since whenever—this is new for me too. I'm cleaning up my act *because* my life is so pressured and intense and stressful. If I don't operate at full capacity, I will not survive. So I've had some serious revisions: No junk food, for one!

Goddess confessional: My story

I used to be less-than-stellar at taking care of myself. I mean I was pathetic! Mac 'n' cheese was, and is, my favorite food. As a kid I was like, "Vegetables, fibers, vitamins—huh? What are you talking about?" Maybe I saw them on TV, but eating them? No way! I inherited good genes, and I was running on them. But as I started to get a little older, I put on a bit too much weight here and there and started getting sluggish and cranky. My moods would swing, and my sleep was not good. My body's machine was way out of whack, like a car that had never had a tune-up! Finally I started seeing a

FABULOSITY TOP FIVE FOODS (AKA WHAT'S IN MY FRIDGE)

açai juice: Like pomegranate juice but even better, it's got powerful antioxidants and it tastes great. I mix it with all kinds of other juices and soda water, too.

dark green vegetables like spinach, kale, collard greens, watercress: I fight them sometimes, but really, let's not be babies here. We need this stuff! It's got the folates to help prevent cancer, and it's plain-out essential. Eat something green and leafy every single damn day, ladies.

pre-made smoothies: Those $3 ones you buy at the supermarket. I grab a smoothie when I'm hungry instead of a candy bar or chips. It still has a lot of carbs, but it's got good stuff in it too.

dark chocolate: Good for your heart—in moderation. Eat a couple of bites of a really good quality bar in the afternoon—the caffeine will keep you up all night if you eat it later than that.

green tea: I have my chef make me pitchers of iced green tea, which I serve with honey and lemon and drink all summer. Watch out for commercial green tea beverages—they have as much sugar as a soda!

UPGRADE YOUR DIET

If you buy your lunch at a fast food outlet everyday, I want you to try this experiment—on Sunday, go to your market, buy some lettuce, watercress, tomatoes, cucumbers, eggs, tuna, chickpeas—anything that looks fresh and good. Wash them, chop them up (hard boiling the eggs first, obviously), put them in a big Tupperware, and take it to work. Make some dressing with some oil, vinegar, mustard, lemon juice, salt and pepper, and a little sugar. There you go—lunch!

I've become more in touch with my inner goddess because my husband is a certified health-nut. When Russell and I first dated, we'd share rib-eye steaks together; after we married, he turned vegan, which is totally vegetarian in both diet and lifestyle. It was a total 180-switch. At first I wasn't thrilled when he started to change. I'd tell him, "Good for you, but I'm gonna eat a steak!" But his dietary change is slowly affecting me. Not to say I'll one day be vegan, but I understand why he went vegetarian. I understand that the American diet is essentially unhealthy. That red meat, sugar, fat, and over-processed food are the reason why millions of us are obese or diabetic. That diets like they have in Asia, where they eat much less red meat and dairy and eat more fish and grains, are ultimately healthier. But I'm also independent enough to want to live my own way. I listen to Russell because I've seen how yoga and the proper diet have changed his life, and now I eat more greens because of it. Does that mean I'm going to be totally like him? No. Am I going to have steamed tofu every night? Probably not. We've had to come to some middle ground. In our house, it means two fridges. One for him and one for me, the kids, and everyone else. His fridge has bottles of ultra-green veggie juice and that's about it! Mine is a little more balanced. Pasta, fish, lots of veggies, and my favorite pomegranate juice. And some candy as well. The point is you don't have to be perfect when it comes to food—just be conscious.

nutritionist who taught me all the right things about feeding myself. Quite literally he has added years to my life by getting me to eat just a little bit better, take supplements, and work out. Newsflash: As soon as I started making even the slightest effort to

change my ways, I saw a huge boost in my endurance and produc-
tivity. Years ago there would've been no way I could've performed at
the level I'm performing now, despite the fact that I was younger. I
was working less effectively with far, far less on my plate. Now I
have way more to deal with in every respect; business, kids, stress,
the occasional controversy. And because I am healthier on the in-
side, I can handle it.

Goddess essential #3: Love your body

When I launched the Baby Phat sneaker, I put a naked photograph
of myself fifty-feet high above Times Square. The ad we shot fea-
tured me, in the nude, with only some diamonds and the new shoe
on for cover (with my leg positioned to hide anything that would
get me in trouble). It was fabulous, and it was a statement! What
hip-hop folks do is celebrate, and this massive, eye-catching bill-
board was part of that. It was a great big banner saying: Here I am,
a young woman who owns the company I'm modeling for, designed
the sneaker I'm wearing, and has had two babies. And I'm proud of
my body, and I love myself—*and every woman out there of every
color, size, and shape, you should too!* I guess you could say it was a
goddess/diva mix moment. I felt radiant from the inside out, and I
also wanted to use my body and beauty to grab the attention of
women *and* men out there. To say for all the ladies, "Let's be proud
of ourselves and our bodies that give us babies and make us such a
powerful life force! Women are incredible!" I was naked with my
diamonds on and my sneakers. A fabulous goddess, and I love my-
self! How is that not a positive message! It was empowering to
women and put a spring in their steps.

Some people questioned why I did the billboard naked. I said,
"Well, I was born butt-naked. I came into the world butt-naked. I'll
probably leave it butt-naked. So why can't I be comfortable butt-
naked?" I'm not the skinniest thing in the world, but I felt confi-
dent that in this culture that we're living in now, it's fine to have a

little shape. A little weight! And that's the joy of it, to just say, "This is me."

Body image has this huge hold on women's minds today and to me, worrying about and hating on yourself is not fabulous. It's not being free. The twisted thing is that the people who are rewarded for their physiques are often not the ones who worked hardest on them. I think we should embrace the fact that we're all different shapes and all need to be the healthiest we can be, and then give props to those who keep themselves fighting fit! Being ultra-thin does not mean you are in the best shape, by the way. You can be heavyset and be toned and tight and have glowing skin because you're in great shape; or you can be on the slender side and still have flab on your tummy because you don't work out enough and so you lose muscle tone. Which one is healthier? The heavier-set girl. So I say, let's all stop making judgments based on the quick surface images and instead take a longer look and consider, "Is she a goddess taking care of her temple?" There's such a diversity of body size and shape in our country, and we usually only see a fraction of it represented—maybe we should all get naked a lot more often and make each other realize what reality looks like!

Goddess essential #4: Physical effort

I'm never going to be a tri-athlete, and I don't want to be. Exercise to me is grueling! I just don't like it. But just like it takes hard work and dedication to be an achiever in work, it takes hard work to keep your body operating at its best, so I'm really trying. I don't even think about exercise in athletic terms but in emotional ones. By taking care of my heart and lungs, oxygenating my system, stretching out, sweating out the drama, I make myself feel better psychologically—I release endorphins and work out stress. The good thing is, by doing all those things naturally, I'll get more svelte and toned and have a stronger heart. So I try and do my

THE GODDESS DIET

Look, this isn't going to be *Kimora's Thirty Minute Miracle Makeover.* There aren't miracles when it comes to your diet—and I'd be lying if I tried to tell you otherwise. All you can do is be smart and realistic with yourself—and follow these tips I've picked up along the way.

- If your lunch comes in a single-serving, shrink-wrapped package, and is made of cheese, sausage, and pastry—*it isn't healthy,* hell, it's hardly even *food.* What's more, if I see you nuking a cheese and sausage pastry for lunch *every single day,* you're not going to have a whole lot of sympathy from me when you put on fifty pounds and your blood pressure goes through the roof. Put it down, girl!

- Eat some vegetables every day—it won't kill you. Some of the girls I know act like spinach and carrots are white truffles—rare and hard to find. You can get them at any market, so throw out that heart attack disguised as lunch and find some.

- Count out ten heaping teaspoons of sugar onto a plate—that's how much sugar is in a can of regular soda! And you wonder why you are fat and your skin looks like hell? Cut out the soda, drink water instead.

- Love food—just make sure it's the *right* food, or if it's the wrong food, make sure you eat it in the *right* proportions: just a little treat, here and there. There's nothing less sexy and less goddess-like than a woman with food issues. If you are having problems dealing with food—or you have anorexic or bulimic tendencies—get help. Don't let it ruin your life.

treadmill three times a week, and I go to yoga now as well (more on that in Law #13).

I've tried for years to get by doing nothing, and now I am a believer that *you must do something.* Dance, do your Tae-bo tape, do a Pilates routine in front of *American Idol* for goodness sake—just lie down right on the carpet for twenty minutes and do it! And if

THE BABY GODDESS DIET

If you're blessed enough to have kids, it's your duty to take care of them and teach them how to eat. My kids do not drink soda, they only drink water or O.J. (No dairy, either.) I try to limit their candy, but I'm careful not to make it a big deal or ever ban it outright. If we totally took it away, they'd be obsessed! As it is now, they get one M&M at a time, and the only person who is allowed to give them candy is me—the nanny can't let them have any. She tells them *you have to ask your mom*. I'll give them one or maybe two at the most. Ming will eat her M&M so slowly, savoring the sugar, the chocolate, and the peanut because she knows she's not getting another one. Surprisingly the kids will snack on carrots and grapes, too. I hope my kids will grow up with a healthy relationship to food and not obsess over it—it's important to me that they think of food as a good, happy thing, and be educated about it.

you've got kids, it's your responsibility to teach them how to be active and keep them fit. Put on your *Hip-Hop Bears* CD and rock out dancing together for half an hour or take them to the park with bikes. I like to think about exercise not in terms of weight or body image, but in being healthier and living longer. Look, this is *your life*. And life is too short to not put in the effort in to be strong and healthy and happy. Make it a goal to find your natural body, and take care of it. That is the quintessential act of self-love, don't you think?

Goddess essential #5: Smile

Every so often I'll be in a stressed mood and find myself frowning at the world and getting that horrible frown-crease between the eyes. And I have to stop, pull my head up, and force a smile

on my face because to me that's part of being a goddess—
radiating out some positivity to the world. Beauty means nothing if
you keep it all tight to yourself and don't show any joy. Smile more,
laugh more, and while you're at it, tell another woman that she's
beautiful! I think we goddesses should worship one another a
little.

Beauty part 2: Hello, Ms. Diva!

Before you fall asleep and complain I've gotten too earnest and too
serious here, let's get to the fun stuff. I'm not saying goddesses
have to be earth mothers who barely pluck their brows or curl their
hair. Not at all! I am a product-loving, makeup-wearing beauty
diva, a high-maintenance goddess. I love my pots and jars and
creams and sable-haired makeup brushes. Sure, some women get
in touch with their goddess by running through fields of wildflow-
ers. I do it by painting my nails.

Diva essential #1: Great skin

Flawless skin comes from within. Something I've learned over my
life is never be complacent about your skin—even if you were born
with a great complexion. Your skin is basically a big message board
of what's going on in your body. So I don't care how much money
you want to spend on products; if you don't eat well and don't
drink a lot of water—I'm talking the real unflavored, unsugared
kind—and if you fill your system with cigarette smoke, drugs, and
booze, you're never going to have great skin. If you don't exercise
and don't go to the bathroom regularly cause your diet's junky,
again: bad skin. And if you're not happy, nothing will telegraph

THE FABULOSITY TOP THREE
SKINCARE TIPS

Water, water, water: No water = sluggish complexion, more wrinkles. Avoid dehydration at all costs.

Sunscreen: Don't leave home without it—brown girls, too!

Moisturize: Any drugstore product with AHA (alpha hydroxy acid) will regenerate skin and keep it young. The ultra-expensive creams like Crème de La Mer do have other benefits and are very pleasurable to use, but trust me, the cheaper stuff can often be great as well.

that to the world like your skin. Once you've done that work, everything else is just gravy.

It's just about protecting and nourishing the top levels of the skin so that you have a good blank canvas to work with when you want to step it up a level. I used to wear a ton of makeup every day, so my number one tip is to keep your skin clean, no matter what. That's one thing you don't have to be rich to do: Clean your skin! Dirt comes out of your pores, sweat accumulates, and makeup sinks in leaving you looking pretty ragged if you don't truly get it off. I'm very simple in my routine, I'm normally a wash n' go girl who uses a makeup remover, a good foamy cleanser, and moisturizer. I go to a facialist regularly, every two to three weeks. Sure, that's a lot, but the point is to go regularly if you can or if not, get creative and whip up similar homemade products in your kitchen with oats, honey, or avocado. (You'll find millions of natural face-mask recipes on the Internet.)

Diva confessional:
Beauty products

Although I'm simple in my routine, I am definitely a product geek. I love masques, toners, serums, exfoliators—everything! I buy everything and I know what they all do; I know which thing is

better for which skin type, even though pretty often I'm too rushed to use them or just forget. I'm like a cosmetics-counter salesperson: Just come to me with your questions and mama will sort you out.

I have a total weakness for all that high-end product stuff for the body. All those beautiful gold-embossed boxes from Darphin or Clarins or little secret institutes in Switzerland that only ten people know about—they make me lose my head from time to time. All women do, because we all want an easy fix! There's one that you put just on your thighs to slim them, another one just for your abdomen, and one for the bags under your arms. The act of pampering is essential to your goddess and your diva, so I say from time to time, if you've got a little extra cash, go ahead and treat yourself!

But the truth is that I don't really see a difference in the results I get from these products (though they sure are luxurious to apply). The difference I do see comes from doing a bit of yoga and getting in shape after having two children! That's why I always tell people to explore the aisles at the drugstore. The low-end products often have just the things you need in them at a fraction of a cost. Some vitamin E, fruit acids, vitamin K, AHA, and all the components of the fancy stuff. You can really pick up great things at such a bargain. So, do I think the pricey products make a visible difference? Absolutely not. Am I improving in terms of appearance? Yes. It must be because I'm getting older and smarter.

Diva essential # 2: Makeup tricks

My makeup artist calls my standard beauty look the "sexy seductress." I'm never going to rock the all-natural, "shades of neutral" face. Mine is glamorous, with a cutting edge of sex, which means smoky, sultry eyes, loads of lashes, glossy lips, and nice skin that glows. Sometimes I'll do a photo shoot where they ask for a really natural face, just flat monochrome with no mascara and maybe

one coat of clear gloss, and my makeup artist and I just look at each other and go, "Uh-oh." Then he whispers, "Don't worry, I'll do my version of natural." Thanks!

Warning: Makeup danger zones

1. *Smudgy Gothic*. Trying to do smoky, sultry eyes without first applying concealer to brighten any dark circles *under* the eyes = hot mess.

2. *Red lipsticks*. I almost never wear red lipstick: It takes real expertise to get the right shade and if you have full lips like mine, you can go way wrong. So be warned! I recently got a good mix when my makeup artist mixed four reds together—a blue-red plus orange-red with two red lip glosses! Remember that red lipstick stands out, just like dark brows. So you need slightly stronger eyes to balance it.

3. *Gold Overload*. Don't try to mimic the shots of olive-skinned celebs in magazines *too* closely. Remember, photo-shoot makeup is about three steps "louder" than street makeup. Too much bronzer will turn your face orange. Tap the brush to get rid of excess first, start over if you need to, and check yourself in great light before leaving the house.

4. *Pencil-thin eyebrows*. "You pluck a chicken, you tweeze a brow," says my makeup artist. So be restrained with your tweezers. Thinner eyebrows can read older. To really do a good job of shaping your brow, first let them grow in so you see your full, natural line.

5. *Rainbow face*. I hate makeup that's too wild and multi-colored. What plays on the runway should stay on the runway.

When I was younger doing the collections, my ethnic features were always a challenge. I didn't have an eyelid and no makeup artist knew how to do my face. I used to cry—I felt humiliated! But now I realize it's better to have this ethnic mix. There's a lot of drama in highlighting your unique features; if you've got lots of freckles, let 'em show, or if your skin is dark olive, enhance the shade with a fabulous deep bronzer or shimmer foundation. If you've got a cute snaggletooth like one particular hot Hollywood actress does right now, bump up your lip color because it is the sexiest little thing. It's exciting to see women playing up their unique features; it makes the world a richer place! And it shifts the beauty standard by several degrees so that exotic and unusual features become the norm. Personally, my goal is one day to not just be seen as an icon of ethnic beauty, but as an icon of beauty, period. That'll mean diversity has really been embraced.

6. *Old-school approaches.* Never match your makeup to your clothes. And please, don't coordinate your nail polish to your outfit either! That's taking the matchy thing one step too far.

Diva essential #3: Don't compare yourself to magazines

There's something I want to make clear. All magazine photographs are retouched. All photographs are generally taken after at least an hour and a half (sometimes three hours) of hair styling, makeup, and lighting. Not to mention the waxing, teeth-bleaching, colored contact-lens wearing, hair-straightening, hair-extension adding, and any number of cosmetic procedures that happened way before the shoot! This beauty thing is all an illusion! I don't mind that it's

HAIR TIP: My hair definitely defines my look. I have so much of it. It was another thing that caused problems when I was a young model because back then the hairstylists didn't know how to enhance my natural curl or to straighten it. Neither one. So it always ended up as an amoeba-like frizzy mess. The big trick when you have a lot of hair is to just do a chignon—a sleek knot of hair at the back of the head. Every day at Chanel I had one. If you have naturally curly hair, it's great. You can take a shower, pull your hair back wet, wrap it in a knot with a ribbon or something around it, and stick the bobby pins in and go. When in doubt, do a chignon. It's sleek and chic.

DO-IT-YOURSELF #11:
HOW TO GET THE KLS LOOK.

Skin: Concealer should be everybody's best friend. It brightens and wakes up your face and it covers up blemishes. As we say round our way, "Concealer's like deodorant: don't leave the house without it." I don't use a lot of foundation, but remember that in wintertime it serves as a protective barrier between your skin and the climate. The key is to get your correct skin tone. We usually use sponges and brushes because fingers can bring bacteria to your face, which is bad if you're prone to breakout. Wash your sponges and brushes regularly—every two weeks at least. Tinted moisturizer is a great way to go in summer. You can have a lot of fun deepening your skin tone without it looking too intense.

Shimmer and Color: I use bronzer *a lot.* It is an instant pick-me-up that makes my face come to life. Sometimes I use it instead of blush, sweeping it with a big fat brush onto my temples, forehead, around the chin, around the jaw area, as well as the cheeks. (The fluffier your bronzer brush, the lighter your coverage. But if you overdo it, use a clean foundation sponge to reduce the amount.) Blush is one of my favorite products, too; I love playing with peachy-colored blush, but it takes a deft hand because it is orange-based. Start from top of your cheekbone and sweep the brush down. If you smile and touch the apple of the cheek like they tell you to do in makeup magazines, you can end up looking like a clown.

Brows: If you have super-dark brows, they'll often overwhelm the eyes and become too much of a "frame." So to divert the attention, you can bleach the brows to bring focus to the eyes. With a bit of facial bleach or hair colorant, you can do it at home; just have a friend help monitor the shade as it changes! As for shape, the brows can change the entire look of your face. The absolute number-one best way to get a polished look is to have your brows in a great shape. Get an aesthetician to do it the first time for you and then keep the new shape clean by tweezing.

Lashes: Curl, curl, curl your lashes! That's my number two most important tip! An eyelash curler is easy to use and opens up the eye. We curl

once; then apply a mascara that separates and lengthens lashes, and then if it's for a photo shoot, we'll curl again. Shu Umura and Shiseido make great curlers. (Maybe because Asian eyelashes grow at more of a downward angle, they need the best curler to open up the eyes.) We use faux lashes a lot, too. Don't be intimidated by them—they don't have to make you look like you're in *Cabaret*.

Lips: I am always yelling out, "Where's that goddess gloss?" as I run out the door to an event. I'm obsessed with lip glosses. My new line of KLS color cosmetics has more than twenty lip gloss shades. They are just a safer bet than lipstick, which can look so fake and old-lady. Use a lip pencil that is close to your natural lip shade to give a clean line underneath. Then dip a Q-Tip in loose face powder and dab on the lip liner to set it, before applying the gloss. It'll last a lot longer. (Another light lip look is to dab on satin-finish lipstick with your finger to make a sexy "stain" instead of fully colored-in lips). I was on a sparkly gloss kick for a while, 'til I realized how many metallic flakes I was consuming. Gloss can be super expensive or just cheap and fun; stick it in your pocket and go.

The Bare Minimum: I'm often heard saying to the girls who work with me, "Fix yourself!" Which means, just pull it together, do a little grooming, look polished! It doesn't have to be hard at all. If you have a well-groomed brow and a beautiful curled lash on, you look great without too much of anything else. Maybe a touch of concealer, a little powder to take away the shine, and a simple gloss on the lips. You can get through any event that way, from informal to dressed up.

an illusion, and I don't mind you spending a lot of money on creating an illusion. Because it's fun. I'm totally into fashion and looking great, but I want people to see the reality. Enough smoke and mirrors, America! Let's wake up and smell the coffee. We have a generation of young women who are bulimic, anorexic, obese, or just plain sick. Let's get it together. And let's stop comparing ourselves to images of others and instead focus on being the most beautiful we can be, feeling the most fabulous we can feel.

One of my model girlfriends is one of the most beautiful women in the world, and even she has black circles under her eyes. It's hereditary; her mother has it too. So she works with it and uses concealer. Don't think everyone's born looking 100 percent perfect!

Diva essential #4: Change up your look

I don't change my look nearly enough: You almost always see me with long, blown-out or heat-curled hair, not hair left in its natural state. I wish I did get adventurous and try new things, like Madonna or Mary J. Blige! Even if it turns out a mess, it's liberating to change. That's my opinion about all of life, not just beauty. It's good to know who you are at the core, but also great to let someone else show you how they see you with a new haircut or makeup look. So turn your self over to a *beauty* profashional from time to time—a new hairdresser, or the counter-girl at a really edgy makeup brand, or your ultra-hip friend who's always wanted to make you up her way.

Diva essential #5: Surrender the idea of perfection

There are a lot of things I wish I could change about myself. But I think you've got to be happy with what you got and change what you can. You can't go through life just changing stuff. It's costly. Not only that but it's not right. You change too much, and you'll end up looking like a freak! I'm not against plastic surgery at all. It's fine if you want it as long as you know that nothing is foolproof. You're hoping to be better—but even the most beautiful per-

son whom you think is perfect is not. So striving to be perfect is not going to work. But if you're striving to change a little thing about your appearance, it may help your self-esteem. The key to the decision is this: Is surgery going to make you forget your looks and forget the flaw that makes you shy, so you are unselfconscious and freer to be you? Or is it going to make you more obsessed and want to change more things about yourself? If it's the former, you might be a good candidate. Again, be empowered, do your research, and don't rush into it.

I always look around at women I admire to inspire me with goddess energy. One of them would definitely be Maya Angelou. I remember reading her books and studying her work in school, reading her wonderful inspirational tidbits through life. I've met her, and she's such a wonderful, deep-spirited, warm woman who's definitely been through a lot. You can see her goddess beauty in her eyes and hear it in her voice. But I see the goddess in so many kinds of strong and iconic women, all of whom look totally different on the outside. From Queen Latifah to Tina Turner to Marilyn Monroe, from Hillary Clinton to Pamela Anderson to Oprah, Tyra, and Whitney. From Carolina Herrera to Carmen Electra. They are as diverse as could possibly be, but each one stands proud with her own unique style and never lets it get compromised by other people's opinions and tastes. Each one glows with the fire of life and lights up a room. There's no status quo of what you should look like or how you should style yourself to be a "goddess." It's in each and every woman, and it's up to you to let her shine!

NAIL TIP: A good manicure and pedicure are the easiest ways to up your diva status. You don't have to go to a salon, just grab a loofah, pumice, and nail file and get to work. Doing it every couple of weeks will truly upgrade your look. The most important thing to remember with a pedicure is, whether you do it at a salon or at home, don't wear close-toed shoes or even get your feet wet for twenty-four hours! Have a shower before you paint, and stick to flip flops and sandals for the whole day, if you can. It'll last way longer.

Nobody likes seeing photos of their birthday party or best friend's wedding and realizing too late that their makeup falls flat. If you're going somewhere and there'll be lots of cameras, you may want to factor it in while you do your face. Here's what I've learned from being in front of the camera:

1. *Go for shimmer.* Luminous eye makeup, bronzer, or even slightly shimmery lip gloss can look great on camera while sensible, office-friendly makeup tends to look too blah. Try an iridescent eye pencil around the lid (beware loose glitter-powder that can irritate the eye). Or try a sweep of shimmer foundation all over the face for a sexy, tropical glow. Mixing a drop of the shimmer foundation into regular moisturizer is a good way to start so you don't look like you fell into a vat of gold dust—it's slightly more subtle than putting the makeup directly on your skin. Mix it into your body lotion, too, for a hint of sparkle on your chest, arms, and legs. You don't want your face to be the only thing aglow while your body is totally matte! Note: shimmer does not mean shiny. Try topping the shimmer with a light dusting of face powder to take down shine on the nose and forehead—just check that you haven't gone overboard or used too pale a powder.

2. *Blend, blend, blend.* If your foundation ends visibly at the jaw line and ears, the bright flash of a camera will only make that beauty crime more obvious. The result? You'll be mortified—especially if that becomes the photo your mom e-mails to the entire family clan.

3. *I love the look of super-glossy, natural-colored lips in photos instead of vibrant lipstick.* It seems modern and sensual without being too obvious. Line the lips in natural-colored liner first, then keep applying the gloss throughout the night.

4. *Make an effort with your hair.* Flat, everyday hair really screams "Boring!" on camera and doesn't do much to help frame your face. You want a bit of structure, a bit of volume—even if it's slightly messy, that's okay because it's sexy. Experiment with pinning up sections, using styling products, or even doing a loose knot at the neck with a ponytail holder. The idea is to add interest and shape to your head instead of rocking that "just out of the shower" look.

5. *Reapply in private.* True divas give the impression that they always

look fabulous, and they do their best to hide the signs of effort. Have your weapons of application in a little clutch and when you spot the cameras coming out, duck into the ladies' room. It's totally excusable, if you do it quickly. Besides, who wants a paparazzi shot of themselves reapplying lip gloss over dessert?

Goddess

"You yourself, as much as anybody in the entire universe, deserve your love and affection."

—BUDDHA

"I had to grow to love my body. I did not have a good self-image at first and I guess I hit a bottom, and I was like, 'I'm either going to love me or hate me.' And I chose to love myself. Then everything kind of sprung from there. Things that I thought weren't attractive became sexy. I often find it's just the confidence that makes you sexy, not what your body looks like."

—QUEEN LATIFAH

"I believe you can make people believe you're sexy no matter how many pounds you are. When you show that confidence, you make them be like, 'Oh, she's fly!'"

—MISSY ELLIOTT

"The thing I like about my body is that it's strong. I can move furniture around my apartment. I can ride my horse . . . I can play basketball. It's a well-functioning machine."

—CINDY CRAWFORD

Diva

"Even I don't wake up looking like me."

—CINDY CRAWFORD

"It's all make-believe, isn't it?"

—MARILYN MONROE

"I disappoint people who meet me in person because I don't look like me. But the public is really hard on people in the industry, and your image has to be perfect."

—TYRA BANKS

"Hair style is the final tip-off whether or not a woman really knows herself."

—HUBERT DE GIVENCHY

Romance
&
Lifestyle

Lose your heart, but never lose your head

LET'S CUT STRAIGHT TO THE CHASE. You do not need a man to have Fabulosity. Women are the most capable and brilliant creatures on the planet with strength reserves the size of Texas oil wells, for God's sake. And we're not living in no *Leave it to Beaver* era either—can we please just retire the stereotype that you have to be half of a Mr. and Mrs. to be complete? Get real. It's just not an option for a lot of women and they're doing fine on their own!

But I recognize that we women are emotional animals too. There's a reason we all love love; when it's good, it helps you blossom into an even bigger version of yourself. (But when it's bad . . . ooh, those petals fall off quickly!) When it's good, you learn and grow and give in ways you never would alone. You go deeper into your own character when you take care of someone else. And in a way, there's something very empowering about being settled and committed because it lets you put all your energies into areas other than looking for a mate. (Okay, that last one's what I tell myself when I want to strangle my husband, but it sounds pretty convincing as I write it.)

Compared with most women my age, my story seems super

old-school. I mean, it would be normal two generations ago, but now it sounds downright bizarre. I met my husband Russell in my late teens, married him at twenty-two, had two kids, and twelve years later, here we are, still together. But the truth is our relationship is totally new-school. You know how they used to say, "Behind every man is a great woman?" We'll I'm trying to make it right *beside* every man. Russell and I each control our own business empire, we're lovingly competitive (though if you ask him, he'll pretend he's above all that and say he prays for me), and we have independence from each other—working, traveling, and sometimes socializing apart. I think that's what makes our partnership work: We always have stuff to talk about, office matters to discuss, new problems to solve together. We constantly have to ask each other's advice and opinion and support each other in times of stress. Since our companies are so intertwined with our personal lives, it's like we're building a huge project that will never be finished—and we're too busy to get bored.

I always hear from women that "There aren't any good men out there. . ." and "Men don't treat me right." And I agree that it's a really, really tough job to find a good mate. Sometimes I see women putting so much effort into finding and keeping their man I wonder if they've just gone and lost their minds—with all that brainpower, they could just as well start a company or get a PhD! But I also think women have to take a lot of responsibility for relationships: It's up to *us* to demand the best and show men the way we deserve to be treated. And I think we sometimes fail ourselves in that respect. I look around at some of the young girls who work with me—girls who've traveled the world alongside me and been exposed to all that life has to offer—and yet they're hanging around (like dogs), hoping for a call from some guy back home who won't give them his home number and has two other girls going on the side. I get so mad! I say, "Where is your self-esteem? What are you doing? Have I not shown you anything of a better life out there that you accept this from a man?" It's sick!

What's the allure of those kinds of bad boys? Nothing. They've got a power over the girls' minds; they tell them the right thing at

the right moment; they know how to be sensitive and caring at the right time and really rude and crude at the right time. They know how to break the girl apart at her seams and get into her mind. These are smart girls, independent girls with a million opportunities in front of them, but I think there must be some weak link in women's minds that makes it okay for a man to come in and say, "You're nothing," or "You don't deserve more." Soon enough we'll start to believe him, thinking, "He's right. I don't deserve more." Personally, I'm the type to come in with directness and say, "I'll tell you who I am, fool. I know who I am! But obviously there's a disconnect here because you don't see the same thing!"

I want men to put women on a pedestal and appreciate us for the goddesses we are. If I did have a son, I would teach him: your mother is a woman, your sister is a woman, so you applaud women and you put them up on a pedestal before I whup you! Because without a woman, you would not be here. Of course, for that to happen, I think we probably have to chop the tree, carve the wood, and make the damn pedastal ourselves.

I personally never had a lot of experience in the dating scene. When I was modeling, I saw that whole culture of wining and dining girls and letting them into nightclubs free to lure the guys in, but I didn't really go out myself, I didn't party, do drugs, or even drink. I was really young! I think it was my self-protective instinct at work. When you're in such a rush to grow up, I think you do end up kind of burned out. Jaded. Which is why I try and tell younger women now, slow down! I understand you're coming into your own and you're trying to figure out who you are, but take some time to think more clearly about who you get involved with and how.

I met Russell during New York Fashion Week during my late teens and for quite some time, we were just friends. He was getting into fashion with Phat Farm so he was at all the shows; I was on the runway at Mary McFadden. I remember every time I came out, he'd make a ruckus and clap and cheer. I was like "Who is that freak?" I didn't know who he was! I didn't know anything about Def Jam Records or Def Comedy Jam! I had been spending a lot of time in Europe and I didn't watch HBO! I was very mature

OLDER GUYS VERSUS YOUNGER ONES

I tell young girls all the time, go for the guys who are more serious, distinguished. That's what I like: I like the king! I'll take the boss! I was always attracted to power and stability. I've had other girlfriends who would date hot little model guys living paycheck to paycheck or wannabe rockers eating Ramen noodles every night. I never wanted the artist; I wanted the executive who ran the artists. Because that was so much more interesting. Wouldn't you rather have charm and a sense of style and maturity and a fully-developed character if you can get it? I tell 'em, go for the older guy who's lived a little. The hot model types, they're too pretty and too wet behind the ears. Besides, do you want a guy who takes longer to get ready than you? The toy-boy types are so good-looking they've never had to work at being interesting. The men who are not trading on their looks—they've had to work a little harder. They're smart. They'll teach you something rather than you just paying their bills!

in a lot of ways; I was well traveled and well versed—pretty sophisticated for my age. He was almost twenty years my senior but it didn't seem to matter—we hit it off and started hanging out together. I've always been older than my years and him—he's always going to look, act, and feel younger than his!

Russell always traveled with a crew back then. He was a very recognizable, very hip man around downtown and all the guys in his pack were real scenesters—artists, musicians, the hip-hop crowd. They were always at the coolest clubs and parties and they knew everybody. There was a part of me that thought his world was exciting, especially since I loved fashion and style so much—this was it! The New York City nightlife scene really was the center of style! But the other part of me was skeptical. I mean, these were the bachelors who ran in the fast lane and had a lot of cash to spend—for the most part, they were just looking for hot girls to get with—models, if possible. Russell and I had a different dynamic

from the get-go. For whatever reason, we've just always cracked each other up and had this friendship based on fun. Yeah, he was the famous "Russell Simmons;" he was set up, he had this big persona, but I wasn't really fishing for a Mr. Big at that point. I was along for the ride; exploring whatever life was giving me, and still had a lot of time left for all that.

There were, however, a lot of other women in that scene whose clocks were ticking. They were angling for a Mr. Big. I mean, he'd dated a lot of girls, and it seemed like every party we went to, there'd be a group of them watching me, commenting on me, and trying to elbow me out of the way so they could hang with him. Date a powerful man, and you do see women's true catty colors. With no one to give me trustworthy advice, I had to learn to navigate that group for myself. All the other models used to tell me, "Leave him alone; he's no good." And any time a bunch of girls tells you that, it makes you run straight toward the eye of the storm. After some investigating, I found the very same girls who were telling me to leave him alone would be leaving him messages saying, "Hey baby, are we going out? Call me!" I heard them because he'd play them back in front of me when I was at his house! The same people that sat me down to advise me, "Don't waste yourself on him; you have a great future ahead of yourself"—they were the ones who wanted him! And they were ten years or more older than me, so they really thought they could just nudge me out the way.

So that drove me into his arms. Maybe I was just being headstrong—"Don't tell me what I can and cannot do!"—or maybe I just wanted to see what all the damn fuss was about. But getting closer to him made me realize he was a great guy. (Which is I guess why they were all lobbying for his attention). Really nice, really smart, very charming, and honest to a fault. He was the type to say, "Don't ask if you don't want to know 'cause I'm not going to lie." As a girl who's always spoken up and spoken out, I found that refreshing—and challenging, too.

The game of love: The Fabulosity outlook

I really believe that, in general, people should not put on airs and not play games. But when it comes to snagging a man . . . it's different. Dating is nothing but a game. So the advice you get in some magazines, "Never play games, tell him how you feel, be vulnerable and show your heart"—it's so bogus! It drives me nuts because it's just going to get a girl in trouble! A certain amount of thought and strategy *has* to go into romance because our whole aim here is to maintain dignity and be a little harder to win. How's that going to happen if you're throwing yourself at a guy, or revealing your true emotions left, right, and center, being an open book, delivering no mystery and lots of temper tantrums? No—a little bit of smart game-playing is absolutely mandatory. I wish women didn't have to do it; I wish we could all be upfront and honest and cut the b.s. like guys so often do. But the fact is we *must* have a few strategies, at least at first.

I guess you could say this is the whole contradiction central to my life: I have this modern feminist outlook, but I incorporate old-fashioned attitudes into the whole package. It's like, part Halle Berry, part Sophia Loren. A fierce and strong female who expects to be treated like a lady when it comes to love. Treated with respect! With grace! Why should it be any other way? So I will fully admit to loving that book *The Rules*—that's my handbook on how I got married. Totally old-school advice from somebody's great-aunt in Wisconsin or something.

My versions of the rules

Kimora's Romance Rule #1: Date for pleasure. Do it because it makes you laugh and you have a good time. If you approach it like a job hunt or this big serious quest with a checklist in your

IN MY JOURNAL

I have a quote from Roseanne: "Soon as I marry 'em, I hate 'em." Hey, I feel that way sometimes! It's not that nice, but I'm keeping it real. Sometimes I want to kill my husband just like anybody else! And I envy her because she was free enough to say it and put her name to it—if I said a quote like that in the paper, I'd look crazy! So I'm happy she can say it. Go Girl! Someone said it—it was how you felt at the moment. Now don't be hating on me for having those thoughts. I love love, I love family, I love my husband. But sisters, let's just be real.

hand—"I have to find me a man, now!"—all the males in a fifty-mile radius will run screaming for the hills. Men have an inbuilt radar for that stuff. Neediness. Desperation. Just like we have an inbuilt radar for their sketchy behavior. I say, the moments when you feel desperate are exactly the moments when you should avoid the dating scene and go get your toenails painted or something equally girls-only. If this doesn't come naturally, you need to read my friend Mama Gena's books as soon as possible (try *Mama Gena's Owners & Operators Guide to Men*). It's about lightening up and enjoying just being a woman!

Kimora's Romance Rule #2: Don't be over-available. This is a good one. When a guy is calling you on Friday to go on vacation on Saturday, it means you were not the first one on his list. Say no! Early on when we first met, Russell used to do that to me. And I kept turning him away. "No, I'm busy." I'd never tell him why; I'd just make it sound effortless. "I wish I could go, it sounds like fun! You should've called me sooner!" "Oh dear, I accepted an invitation to go someplace else two days ago. I really want to go; I'm kicking myself but I can't change this, I'm sorry." And eventually don't you know those Friday night phone calls turned into Wednesday night phone calls and then eventually Monday phone calls because now I was the *first* one on the list. Of course you have to have the disci-

pline to suffer through the weekend while everyone else is out having fun at the Hamptons or South Beach. It's definitely the excruciating route to take, and it gets very hot in a little studio apartment in Manhattan in July, let me tell you. But hey, it got me a husband. And those other chicks who did accept the last-minute booty-trip calls, they are no better off today. All they got was some fun over the weekend and maybe a free dress to go to some Saturday-night party.

I never wanted the free dress. I could buy my own dress thank you very much! Even though Russell has been known to buy an Hervé Leger or two, I had much better dresses from Paris already! That kind of cornball, macho, "Hey baby" behavior just never worked on me. I've always felt like women are worth so much, and we are so valuable and a lot of men don't get it. And it's up to each woman to show a man exactly how valuable we are. As in, "calling at least five days before the weekend" kind of valuable. Or, "not assuming he'll get action on the first date, second date, or 'til whatever date the woman wants it to be" kind of valuable. I mean, given how much emotional energy a woman ends up giving to her man, supporting him, caring for him, telling him, "You can do it, honey"—damn, they better appreciate just what prizes we are.

Or maybe it's like they do get our value, but they're intimidated by it. I think men are very thrown off by a woman with self-confidence and power. If you're independent, you have a good job, you make good money, you're headstrong, you have your little apartment. Hell, even if you're struggling through a job but are confident about your future, a lot of men are freaked out by that. Period. It's like they don't know where they fit into your picture. They think, "Does she even need me?" I guess it taps into some part of low self-worth on their end though they'd never, ever, in a million trillion years admit it. (I don't think I've ever heard a man even say the words "low self-esteem," let alone apply it to himself.)

Kimora's Romance Rule #3: Ignore his craziness. We as women analyze every little thing that comes out of mens' mouths, but sometimes you've got to just pay their craziness no heed. Just pretend it's their "time of the month" and think about the dry-

THE NO SUCCESS WITHOUT EFFORT APPROACH

When I was farther along in dating Russell, each time that I'd spend the night at his apartment, I'd leave before he woke up. Like clockwork! I'd be out before he got up, and I'd take every personal item with me, not even leave a toothbrush. No matter how tired I was. I'm talking long into the game, when we were already boyfriend and girlfriend! The opposite is the girl who puts her toothbrush in the bathroom right away and tucks her panties under the bed as a reminder of herself. Well, I don't want you to have my panties, and if you want to see me again, call me up and maybe we'll make a date! Again, more effort than just swimming along in the sunshine, but it turned out better in the long run.

cleaning you've got to pick up. And girls, I'm sorry to say their craziness gets more pronounced the more of a catch you are—the more empowered, self-reliant, and confident you become! It's a weird dynamic: Men are intimidated by power but also attracted to it. You think they want a dumb somebody to be the mother of their children? No. But sometimes they can't take the whole package, they can't take beauty and brains, so they act totally nuts, like little kids who can't make up their minds. I think that basically men need to be needed. That's their nature. They need to be needed much more than women do, so give them an unneedy woman, and they don't know what to do! But they can be taught.

Kimora's Romance Rule #4: Set yourself apart. Back when we first started dating, I was modeling all over the place, doing my rounds, and never around that much because I'd be working or I'd be out of town. Meanwhile he was doing all the really epic stuff—sending me huge baskets of flowers, giant Calla lilies and white roses like right out of a movie. It was enough to make any St. Louis girl swoon. But at the same time I had this streak of pragmatism and common sense underneath. I knew he sent flowers to lots of

DRESSING ON DATES

If you dress sexy all the time, go a little less sexy on a date! I don't know about how girls out there dating feel, but when I dress sexy, it's sexy for myself, first, not *you*. Even though obviously I'm generating responses from other people, the fulfillment for me comes from the fact that I'm doing it for myself! So I would think about wearing something that was just a tad more difficult to take off, with more buttons, a bit longer . . . sound bizarre? I'm a little reverse of the tradition. Super sexy outfits on early dates is just too obvious—and why rush it?

girls; I'd hear stuff about him giving amazing gifts to other models, like floor-length fur coats and stuff. He was a bachelor with money to blow at that time—this was before he got all Deepak Chopra; he was more like Run DMC back then—and he was having fun with it. That's why I say I've always felt like maybe I was older inside than him; I just saw it all with an old wisdom. I didn't really care who he was and what he was; I wasn't impressed by the fancy lifestyle and all the people he knew. I was the one he talked to when his mother died, and he was really knocked off his feet; the fact that he knew the VIP-room guys at Moomba was no big deal to me. And I think that's what got him.

By the time I decided that I really liked Russell, I knew that I had to carve out my own spot. There were plenty of other chicks vying for his affections. So I made conscious decisions to behave differently from other women. It's about doing little things that make yourself individual and special. That includes keeping your legs closed! I think waiting time is something each woman figures out on her own. In this whole age of liberation and independence, a girl can go either way. She can have a one-night-stand or hold out for six months, and it's up to her to feel it out. But I've always kind of been in the slow lane in that respect, and it's what worked for me. I can't tell you how to live your life, but I will say it meant my husband and I were at a much deeper level of friendship than most people are before they get that intimate.

Kimora's Romance Rule #5: Be prepared to walk away. There were times before I got married that I was not with Russell. There were periods when I was just over it, the whole confirmed bachelor thing, where he loved me but still kept his options open for other women. He was a player back then, and at heart I've got pretty old-fashioned values. I told him straight-up, "You know what? This isn't me. I don't party. I don't go out clubbing. I don't know every nightclub doorman in Manhattan and don't want to. Maybe you should just go do your thing, and I'll do mine." And I got on a plane to Milan without saying good-bye, found an apartment, and didn't call him for a year. I got really into Italian life and just expanded this whole other side of my personality.

The only reason Russell found me was that he called my mom up in Missouri. He tracked her down and phoned her like a little wet puppy trying to come in from the cold: "Mrs. Perkins? I'm looking for Kimora?" And my mom goes, "You lost her, did you?" And he says, all sad and forlorn, "I did, and I'm looking for her." My mom felt so sorry for him she did some research and called around and asked what kind of guy he was. (Can you tell she worked for the government?) People told her that, yes, he was a good man and not completely psycho—and p.s., he's really successful and considered Manhattan's top bachelor—so of course like any mother would, she gave him my number in Italy. As soon as he got it, he hung up on her and dialed it. A few minutes later my mom got another call. "She hung up on me, Mrs. Perkins! Can you help me please?" I was so mad at my mom! I called her a few minutes later and said, "Why'd you give him my number?" But he persisted in calling and eventually we reestablished communication and started talking again. When I came back to New York, we began dating again.

Until I actually walked down the aisle with Russell, I was always willing to walk away. Not because I didn't love him—I was totally ga-ga, dewey-eyed, crazily crushed-out on him, and he was on me. But I knew what I wanted and was evaluating whether it was the right fit. I refused to play the "foxy girlfriend" role to a powerful man, and he knew it. I was too young to be looking to get married, and in any case, I had more to do with my life, places I

wanted to go, things to achieve, so I wanted everything under my feet to feel solid and real. Being in limbo, being the girlfriend to a guy who's got other girlfriends and won't commit one way or another? Nope. No can do. The heartache and doubt that comes from wondering, "Does he love me?" is just not worth it. I wanted to build my life on rocks, not soil or sand, and I had to know if he was going to be part of it or not.

We got married after I told Russell exactly how I felt. I said, "I'm going to split for good." I pushed him to an ultimatum; and it had effect. He stepped up and soon after we were married. Russell actually called my mom and told her, "I promise I will take care of Kimora"—after all, she was the one who gave him my number. And now we take care of each other.

The crazy thing is that ultimately, after all the strategies are played and commitments made, it is the woman who always has the upper hand. I really believe it. I guess women are so much more in tune with our emotions, we can just get over the bumps faster. But the guys—they're not nearly as strong. So I do think that pretty much in every way, women are the backbone of the family. We keep it all together.

The BREs (basic rules of engagement) for romance

1. *Put yourself first.* I think every woman should feel self-reliant, self-fulfilled, and self-confident 100 percent of the time, whether she's single or married! If she carries that attitude into a relationship, it gives both sides room to breathe. Don't be the woman who *needs* that man; want him, work for him, love his corny sense of humor . . . but know you'll survive just fine without him, too. Focus on protecting and securing yourself with or without a man, so that anything you get is just a bonus to an already solid life.

DO-IT-YOURSELF #12: KINDLE (OR RE-KINDLE) THE FIRE.

Romantic dinners for two, a little strip dance now and again, some roses for no reason, some poetry . . . I know how to do it all to get the love going and to keep it going years down the line! My favorite and most simple thing to do when I was first dating my husband was to make hand-made cards with some kind of poem inside. If you can't write poetry, go find someone else's work and copy it! Then on the back of the card you write their initials so it's not plagiarism. Find some work that moves you, turn it into a card or letter, and mail it. It costs nothing, and it's so romantic. It's a goddess thing: Nurture the love you've got.

2. *Don't expect fairy tales.* Love is great! Love is what we all should share more of! But love isn't a fantasy. Don't sit there expecting Prince Charming to take all your cares away. Are you Snow White? No. Would you even want to be Snow White, asleep in that glass casket for a century? Of course not. When dealing with men, I think women need to get *less* dreamy not more. They should use their smarts and make sound choices about how much of their time, emotion, and money they give out. Wake up, Sleeping Beauty!

3. *Believe your cheat-meter.* I see women all the time who just don't get the obvious. Their man is fooling around on them, and they probably know it inside but refuse to see it. Ladies, God gave us instinct for a reason. Maybe my eyes are more wide-open than most because I've never worn pink-tinted spectacles when it comes to men. But I'll just tell you that I see married men who are very respectful to me because of my husband and my position but who then walk across the room and get some chick's phone number right as I'm watching. And I know their wives! So if you're picking up a feeling that something's up, trust your own instinct and have it out with your man.

4. *Be clear about what you will and will not stand for.* Before I was married, I had to learn how to handle the sharks. They were his old girlfriends or women who wanted to be his girlfriend—and in New York, honey, this breed of shark has got sharp teeth. I started out so sweet and nice, you know doing the *My Best Friend's Wedding* kind of thing. And actually it drove them crazy because I was really happy and on top of my game. They thought I must be ditzy: I was that smiley and effervescent, and they used to tell Russell, "Come on, she's a fool! She's a kid!" But underneath I was learning and studying: who was who and which one was a friend, which was a foe. I was very self-confident and very self-assured, and in my mind, though I was nine, ten, or twelve years younger than those other women, I felt like I was always more powerful than any of them, like I had way more going on than just a pretty face.

So I worked my way on and I sat in my little corner and did my little thing, observing and figuring out the whole story, and eventually one day I was able to say to Russell, "You know what? I don't like them! Now that I know them, I don't want to be around them! And if you want to be around them, fine. I don't control them; I only control me. But know that I won't hang out in this scene, and if you want to be with me, it'll have to be elsewhere." And that's how I operate my life right now, to this day. *I can't control you, but I can control me, and I'm not going to socialize with people I don't respect. I'm not sitting next to that person who is rude and unkind and jealous.* I take a stand for myself. And either my husband understands and he doesn't go, or he makes his own choice and goes without me. We are two adults with two opinions, and we don't get complacent or just let things slide.

5. *Communication is the key to everything.* Go into a relationship with a set of expectations that you both agree on, and keep talking about them and adjusting them as you go. You have to talk! Figure out, who's going to pay for what? Who wants kids and who doesn't? Who's keeping ownership of what, and are we both cool with that? True, you definitely have to pick your battles and let

some things go, but if something's bothering you, you should speak up about it or you'll blow like a pressure cooker. I recommend scheduling times to meet and have an open forum, just the two of you, maybe a couple of hours a week where you know you're going to just have a proper talk. Because the opposite is where you start to get naggy and just constantly say negative things rather than having one positive conversation.

6. *Treat marriage like a job.* I think you have to work on your marriage and work on your relationship like you would work on your career. You can't just take for granted that it will always be there! You could get fired; you could fire your partner in a fit of anger—it takes some effort to keep it all on track. It demands the same kind of attitude: pulling late nights, coming in early and leaving late, shining those shoes and doing extra work to get that promotion, dressing your best to make a good impression. That sort of goes against my feminist outlook—why would I dress for you, a man? I want to wear my sweatpants today! But by the same token I go to the office and work very hard and put my best foot forward in public—I don't think you can just coast and not try to pull it together in private.

It's not true that you have to find the person who wants to do every little thing with you. More important is to have great communication, talk to one another, maintain honesty, and laugh a lot. My husband and I always have a great time together—and now that we have kids, it's given us this whole other area to play in. At the end of the day, that's what keeps the glue tight. Do you have fun together, or not, and under your differences, do you share similar goals and visions for the future?

And of course you start to influence each other as you grow. My man's changed so much from being with me, and I've changed so much from being with him, and we've grown together. We really are a great balance for each other in a lot of ways.

"I think men are afraid to be with a successful woman because we are terribly strong, we know what we want, and we are not fragile enough."

—WHITNEY HOUSTON

"Love makes your soul crawl out from its hiding place."

—ZORA NEALE HURSTON

"Real love requires a lot of respect and a lot of space. It requires a lot of giving of you and not always thinking of yourself only. You might be having a bad day, and he might be having a bad day. But who will put on a smile so that the other person can have a good day? There's a lot of giving."

—MARY J. BLIGE

"Being deeply loved by someone gives you strength; loving someone deeply gives you courage."

—LAO TZU

"Most women set out to change a man, and when they have changed him, they do not like him."

—MARLENE DIETRICH

Strive for fabalance *

BREATHE SLOWLY. *In-two-three, out-two-three, repeat.* Deep belly breaths that fill the lungs with oxygen and flush out all the anxiety that's accumulated inside. Picture a bright globe of light warming your stomach and dissolving all the tension. Now *whoosh*, let it all go.

That's what I *should* be doing all day long. But I don't. Because everything's busy and rushed, and there seems to be too much going on every minute to remember to breathe, let alone picture little golden globes shining on my stomach. My lifestyle has become one of high-velocity fabulosity! It's got its own relentless schedule of babies, meetings, appearances, interviews, travel, and sometimes, late-night stress sessions, too. There are *a lot* of human beings in my orbit both at home and at work; there are constant streams of information to process and problems to solve. I bring it on myself, of course, piling more onto my plate because there always seems like so much to do with the opportunities that are given—so why not shoot for the moon?

*def: (n.) the state of utmost Fabulosity in harmony with balance and peace of mind

It's a maximalist approach to life. Great efforts breed great re-wards. When faced with a new challenge, some inner voice goes, "I can do that. Sign me up!" It's a woman thing: Because we *can* do lots of things, we tend to take on the full load—caring for the kids, the parents, and half the community too. (For a lot of women, ob-viously, there's no choice in the matter.) What's behind this con-stant urge to be active? Maybe we're addicted to action or scared of slowing down. Maybe we fear that if we let the train stop, it might not start up again. In my case, all the little engineers I've got on board would go on strike and say, "Sorry lady, but you have maxed us out. We quit." And I'd have to get checked into the train yard for a thorough mental and emotional overhaul! So rather than break down, I choose to power through and keep everyone in-spired, all chugging forward together.

I remember once seeing an Albert Einstein quote tacked up on somebody's inspiration board at the office: "Life is like a bicycle. To keep your balance, you must keep moving." It was my mantra for a while, but now I'm not so sure, because half the time it's ridiculously hard to find the balance between family, career, and "me" time. (Who am I kidding? There isn't much "me" time.) Working moms know the feeling: It's as if you've got eight arms and legs, just like one of those Indian goddess statues, and all of them are getting pulled at once.

Life is a struggle for all of us. And as we set our expectations and aspirations even higher, keeping a cool and steady state of mind gets harder, too. Every woman has something to worry about in her life; definitely, every young mother has major things to worry about (and if she's doing it all on her own—times those con-cerns by ten.) I'm blessed with material effects. But those things are irrelevant when it comes to lying awake at night with my brain whirring around. Just like pretty much any other woman, I worry about my husband and what he's doing; I worry about my kids and their development and well-being; I worry about my mom, and if she's okay living a plane ride away. And I stress about business and show reviews and sales figures, too!

I guess when you're in the public eye, you're not supposed to

say things like this! You're supposed to be blissed out from all the wheatgrass shots and Zen gardening you do—at least that's what it seems like from reading about celebrities in *In Style*. But since I like to keep it real, I'll tell it to you real: Finding the time for and actually having an interest in all the maintenance that comes with finding a New Age balanced lifestyle does not come easily to me. When I'm tired and stressed, I want to do what any tired and stressed person does: sleep, watch *The Little Mermaid* for the six-tieth time with my daughters, stay up 'til midnight organizing my T-shirts according to color and sleeve length.

But from my position in the eye of the whirlwind, I can say that finding a balanced way of being is an absolutely critical component of Fabulosity. Success, wealth, and even philanthropic achievements mean little if the person doing them is staggering around dizzy from riding the teeter-totter. How can a girl be of any help to anyone if she can't first get to some level spot inside where she's present, focused, energized, and not constantly distracted by *what else*—"What else needs to be done? What other one hundred things need to be set up before next week? What else could I have done better *last* week?"

We are hardwired for drama and irritation and pessimism and doubt, and our egos take over our entire lives, ping-ponging us between extremes. "I'm great! I suck! I can do this! I'm gonna fail and shame myself!" Then magnify that by the egos of other people clashing with yours ("He said that she said that everyone says you really suck!"), and *yuck*, what a mess. It takes stepping back from all those mind games and making a few deliberate changes of behavior to shift the circuit board around and just get to the point of knowing there's only one part of those phrases that is true: "I am." The other stuff—the value judgments, self-criticism, and mood swings—they're tidal. They come, and they go. Our job is to just sit through the high tides and low tides and not fall over and get too wet.

It's weird to say happiness is work, but it's true! As parents, think how hard we work to make sure our kids' lives are well-rounded and balanced. Do they have the right mix of learning and

fun? Do they have enough social time with other little kids versus time with their parents? Do they run around outside enough but also get their rest? But we totally forgot to apply those same parameters to ourselves. Now that the pace of my life has picked up so much, I've had to learn some lessons in humility to keep my sanity. And hopefully . . . to achieve serenity.

—— LESSON I ——

Accept help from others.

WHEN I WAS YOUNGER, I definitely thought I could do everything myself. And I could, because my life wasn't nearly as complicated as it is today. The only person I had to look out for was me. But now? Forget about it. There is no way I could handle all the different demands of being a working mom at this level of business insanity if I were doing it alone! I have acquired a multi-faceted, diverse group of people to help and gotten much better at delegating. They're my Glam Squad—and they extend far beyond the hair and makeup artists in most celebrity retinues (though I value hair and makeup experts like diamonds). The Glam Squad comprises lawyers and nannies, a chef and PR guy, personal and professional assistants, a driver—they're not officially a team, but somehow they work in conjunction to keep everything on track. They help me get it all done on a daily basis.

Success so often comes down to the team around you; people who are either specialists in things you don't know about or good at what they do, who can focus on those things when you can't. Because you really can't focus on everything. There's no such thing as a one-man show. There's always someone producing and lighting and opening up the curtains and taking the tickets at the door. I live with positivity that it's a one-man show—meaning I have that pep in my step that personally I need, the mantra: "I can do it, I can!"—but I also live with the humility that nobody can do

BALANCE TIP #1: As you get more experienced in anything—from child-rearing to brand-building—you'll be able to get the same results with less effort. Everything eventually gets easier. Maximize that: Get things done quickly and efficiently, but don't take on more work to compensate for the hours you free up. Suddenly you have a life again!

it all by herself. I've always been a good manager of my own finances, work, and responsibilities; now I'm trying to manage my own time and energy better.

The ability to delegate must be a sign of maturity because I definitely didn't have it at eighteen or twenty. I thought I was Wonder Woman. Now I'm better attuned to what's possible and what's just not going to happen, and I'm getting better at not committing to stuff that can't be done, so that I can tape a talk show, attend business meetings, *and* take Ming to school in the morning. The goal is to move to a place where I can oversee the projects and chose the ones my company gets into, so we can keep building.

How this applies to you: No matter what your goals are, *you've got to bring other people onto your team.* For one thing, if you surround yourself with people who want to be successful, you become successful. It's like you all charge each other up and magnify each other, which is something that just can't happen when you isolate and try and do everything alone. Secondly, every single successful person I know has an inner circle of confidantes and collaborators who help them make good decisions, in both work and life. Usually there are some senior figures within that group who are more like mentors—you might not talk to them every day, but the relationship's tight enough that they'll take your call 24/7.

And wherever you are in your career, learn to split the workload. Holding tight to your power at all costs and never collaborating with people or thinking you can never give up any prime jobs to others if you're self-employed, will only take you to a dead-end. Learn to hand off work to people in your inner circle or to be a manager who delegates duties instead of trying to do everything herself. The important thing is to get the job done on time—you never have to tell a client or a boss exactly how you pulled it off! They don't want to know! They just want the right work in, on deadline, on budget. You have to think broadly to survive. Ask yourself, "Who do I trust, who can I ally with, who can share the workload when things get tough and won't take advantage if I bring her in on some of my best work?" It's about picking people who complement you and add strengths that you don't have.

—— LESSON 2 ——

Don't let technology take
over your life.

WE'VE ALL LET TECHNOLOGY GET TOO INTRUSIVE. What is it with everyone Blackberrying away while I'm trying to have a decent conversation with them—my husband included? Maybe I'm just not a techno-addict, so I don't get it. I only recently got a Blackberry, and before I even turned it on, I sent it to be studded in rhinestones. That may be the most attention it ever gets from me!

It's hard to fight the torrent of technology. E-mail floods in, text messages pop up, and the cell phone plays its Usher ringtone 100 times a day—not to mention everyone's always getting out their matchbox-sized, chrome-plated cameras to document every single thing that happens. But unless you want your whole life to turn digital, you've got to prioritize. I've set up a system of checks and balances to help me filter out the unnecessary stuff and avoid too much time at computers. I don't do much e-mailing and avoid giving my cell number out—a land line at home and work is sufficient! There was a time before instant messaging and Nokia picture phones, and no one was suffering from not checking in on each other eight times an hour!

How this applies to you: First of all, try living without a cell-phone for a week. Horror of horrors! I know, it's a gruesome concept. But see how much more connected you are to the reality around you. Suddenly you're talking to strangers at Starbucks or making plans with your friends in advance and keeping them because you can't flake out ten minutes before, and you're feeling more connected to what's happening right now because you're not on the phone talking about where you might go for dinner later. Got it? Now turn that into a new technique: Don't answer every

call even when you do have your phone. That's what voicemail is for! Use it or lose it! I think too many people are half-absent all the time, communicating virtually and missing out on opportunities unfolding in real time. I see it in young kids a lot. They are hiding behind their technology, not stepping up and participating in what we're all doing here together. Pay attention; put away that pager.

—— LESSON 3 ——

Take time to organize.

MY EXPERT LIST-MAKING is almost a joke in my house: I make lists for everything. Every little thing! From "What I want to accomplish by the year 2010" to "What I need from the drugstore tomorrow." They're all in my journal or on post-its everywhere. I have to have things straight in my mind because a lot of my business set-up is chaotic. The GS (Glam Squad) and I travel at the drop of the hat or will decide to sponsor an event two hours before it starts, or we'll change an ad concept the day before the shoot. I need to find order in whatever places I can so that the spontaneous crazy stuff doesn't freak me out!

How this applies to you: When you write things down, they're more likely to happen. It's about your intention—even by putting something on paper you're making it more real than just a fleeting thought in your head. You have to keep looking at it, and you feel guilty if you ignore it. Plus, there's something incredibly empowering and confidence-building about crossing things off the list after you're done (even if it's just, "Go to the Post Office"). I make so many lists; I don't think I ever go back and check them all off! Nor do they all ever come to fruition, but it doesn't matter. Lists are an essential first in the process of organizing your life.

BALANCE TIP #3: Spend time on things that celebrate your home and family. The possessions that I get most pleasure from are not jewels or sexy stilettos. No way! My photo albums are prized possessions. I'm really careful to chronicle all the big events in our family life and shoot pictures of everyone who comes to our parties. It's another way of slowing down the rush—a way of creating your own private history.

THE FRIENDSHIP INVENTORY

I learned this from a girlfriend a while back who called to tell me, "You have fallen off my friendship inventory. You never call me any more." I remember I was like "Friendship inventory? What? Wait a minute, I don't call you all the time, but I love you! You can't mark me off the list with the other chicks! You can't think I'm like them, I really love you!"

But the idea of the friendship inventory stuck in my mind. The idea is that you should pay attention to which people give you their love, call to check in on you, and remembered you on your birthday. Which person from way back in your life surprised you with a phone call out of the blue to say he was thinking of you—not asking for money or a hand-out, just saying "Happy Birthday!" That's a gift! So you write their name down, along with every other time a friend leaves you a kind message or calls to invite you to dinner. Life rushes along at such a fast pace these days that often these small gestures get steamrolled over.

(continued)

I'm also a fan of just tinkering around the house. Meaning, doing little jobs—watering the plants, alphabeticizing the spice rack, putting the *Vogues* in chronological order from 1985 onward. Okay—so we've established by now that I have slightly obsessive-compulsive habits when it comes to organizing. But basically, it's nesting. I'm constantly making my house a home. Putting photo albums together, arranging vases in new groups, purging filing cabinets of old papers. I just find it super calming! When the whole world is kind of spinning out of control, I am putting order into my personal world.

I think it's really important to close the doors and float around doing your thing at home—your heart rate lowers, you start daydreaming because you're on autopilot, and you get in this tranquil relaxed-but-busy zone. If you're not single or living alone, it's maybe a bit harder to achieve, but most families naturally end up with areas where each person is left to his or her own. Mine is my clothing closet (how did you guess?), and my husband's is his meditation room or movie theater. The meditation room is kind of like Russell's version of Al Bundy's Lay-Z-Boy—like, don't touch my beer or my auto magazine, this is my spot. In his case, it'd be don't touch me in my headstand or move my copy of the Bhagavad-Gita! Likewise, no one can go through my stuff in my room.

And of course there's tinkering together, which at my house may or may not involve cooking (I cook for fun, but people know better than to rely on me for their nutrition), watching movies, swimming, and playing with the kids. Then when no one's looking, I'll go check things around the house and replace light bulbs. I can't help it! I obsess over things.

Stop trying to be supermom.

LEARNING HOW TO NURTURE a family is definitely the most fulfilling part of my life. Being a mother is the ultimate goddess act! More than anything I think it tests how balanced you are as a woman. Can you switch off your thoughts and worries and be present for your kids? Do you have the energy to give them your best self? That's why I am so adamant about taking care of yourself and staying well because motherhood, no matter how you do it, is taxing. By the way, when I speak of having "family," I mean it in the broadest terms. It's open to anybody. You can be single, married, divorced, whatever. Define family any way you want—if there's love there, it's all good.

What I've learned in the five years since becoming a mom is that parents shouldn't enforce their perfectionism on their kids. Everyone's so worried about Baby Einstein this, Infant Mozart that, what grades did your three-year-old make at kindergarten . . . enough! Yes, kids do need discipline and structure, and they need to feel safely supported within a world built around rules. It's good to be a hardass in that sense. My children don't get to call the shots: I do. They don't always pick out their clothes or say what they want to eat. All of their routine is decided for them; they're kids! And they respond way better to authority than if they have to make up their own rules all day long, because they feel secure. But you can't obsess. I want my daughters to do everything, from karate and swimming to ballet, French, and baby yoga. I want them to have the best opportunities they can have and be competitive with their peers. But I had to relearn the obvious: They're little kids who like to wear sheets and play princess. They shouldn't grow up too fast! The world is competitive enough, and they'll learn soon enough that you've got to work to get ahead.

Sometimes they have to do nothing but just chase the dogs

(continued from page 216)
You instantly forget about that message when you delete it; that nice postcard gets thrown in the recycler. And that's how relationships disintegrate. I've had to learn a lot about friendship in my adult life. That I need to check in on my friends. And that friends have to be free to tell each other, "Hey, you let me down." That wake-up call from my girlfriend made me think of the people I care about and remember to never take them for granted. Every day, I try my best.

What's my idea of comfort? I love great sheets! I think nice sheets are like nice lingerie. You should own nice sheets because you sleep in them—not to make your bedroom great for someone else. It's not an outward motion to the world. Same with lingerie: indulge in great lacy bras and panties, something you enjoy. It's a personal gesture of valuing yourself. I'm into personal bits of goodness. A great box of chocolate, a nice cup of tea, and a storybook curled up with your cat. Small moments. Little things. A secret sexy pair of underwear you buy for yourself! A great masque for your face, deep conditioning hair treatment over the weekend, spending time with your kids . . . I'm into quality of life, of living, of being!

around the house or get dirty in the yard. That's something my generation of parents have almost forgotten, so I try to always have goof-off time with the girls, dressing up, playing make believe together, and just being silly. The serious education stuff often comes naturally because they're exposed to so much stuff through my life. Traveling, meeting all kinds of people, eating all kinds of food. So they're developing skills in so many ways on their own, I figured, my babies don't always need to feel the force of mama's bronze ambition—not just yet. My older daughter is so brainy that the school suggested she skip two grades: I managed to hold my achieving streak back and just let her do one.

How this applies to you: The best gift you can give to kids is exposure to different cultures, people, and places. You can do it without leaving your own town! Take them to the museum or to the zoo or take trips in nature. If you're in New York, take the subway to the end of the line and explore the beach. I've seen my kids grow from hanging out in grown-up spots, too. Eating out in restaurants occasionally teaches them how to be good and quiet, and they feel pleased that their mom trusts them to be well-behaved. If we never take our kids to any adult locations when they're five

or six, they won't know how to behave, and they'll be out of control. My motherhood balance comes down to a mixture of exposure and discipline—and a healthy dose of chilling out and having fun.

—— LESSON 5 ——

Combat stress before it starts.

IF YOU LOSE IT, YOU'VE LOST. That's what I try to remember on a daily basis. "Kimora, don't lose your cool." If women are going to endure in the workplace or stay happy as a student or mother or whatever we're doing, we've got to be mindful of daily stress levels and notice when they elevate. Those moments when we feel our bodies tightening and irritation rising—that's the moment to go take a moment, slip into a quiet spot, and just breathe, get a big glass of water and drink it slowly. Rather than let all those little stress-hits accumulate throughout the day so that by the time we go home we've become a she-monster. It's all about proactive, preventative measures, like taking quiet time outs, talking about issues before they blow up, or going to a yoga class in the middle of the day, rather than letting small stresses build up until you explode!

—— LESSON 6 ——

Party like it's 1999
(at least once a year).

GUILTY SECRET: My python boots and suede-fringed mini skirts almost never see an all-night rager any more. I'm not exactly the pass-the-Courvoisier girl, buckwhylin' in the clubs—the sound-

Given that I'm married to a yogi who makes yoga DVDs and is trying to start a yoga revolution for the masses, you might think I'm some buffed-out yogini who can do sideways crow position with her eyes closed. Wrong! I'm only just starting now, after birthing two kids and having never really worked out in my life. And I'm seeing results. Meaning: It's never too late, people!

I confess that when my husband got me into yoga, I was pretty skeptical. I thought it was probably too out-there for me. All that chanting and bowing and Darth Vader breathing through your throat. But I was finding it hard to deal with stress, and my energy levels were shot, so after years of Russell badgering me, I caved in and gave yoga class a shot. Although it was the super-beginner's level, I was really shocked. I felt better! Freer! More grounded. And taller. I hadn't realized how tight my back and neck had gotten from all the tension 'til I really worked it out. I've had back problems all my life, and it was like, Phew, relief!

So far, that's what yoga is for me: Something that helps me on a physical and mental level. It's not a part of a larger spiritual practice—and frankly, all yoga asanas (postures) really are at the end of the day are different ways of opening and oxygenating your body. Keeping you young, fabulous, and sweating out those waste products, honey! Getting that glowing goddess skin going! It's about helping the body take care of itself. I like it because I stretch out all the kinks, get oxygen flowing through my organs and muscles, flush out all the toxins, and of course strengthen and tone my muscles. I do it at a moderate level, a couple of times a week at most, and sometimes just once a week, and I already see the difference in my strength. Once you learn a few poses and how to put them together in a few sequences, it's free. You don't have to go to an expensive class—just roll out a mat and do it on your living room floor.

I think it makes me a calmer and happier person too. My mind slows down and stops skipping around different thoughts, and I feel mentally clearer and more capable. When I bend and twist and sweat the frustration and fears out, I'm much less quick to jump to angry reactions afterward. The nastiness of the world doesn't poke and prick at me so much

because my stress level goes down. I'm never going to be a blissed-out yogini, but my goal is to get a lot of things done with my life—and if yoga helps me avoid high blood pressure, I'm in. Because if I ever did get hypertension, I'd be really pissed. I'd know I brought it on myself by just not letting go. So I'm taking proactive measures now.

As for the meditation part? Well, I know that's also supposed to make you live forever. Studies of people who meditate show their longevity skyrockets and that major health problems like heart attacks and even cancer go way down. I don't officially practice it, but I take a nice warm bath, let myself have a nap when I'm tired, or go sit outside and take a break from everything. I'll just sit and focus my mind on the noise the breeze is making as opposed to listening to the busy drama running over and over in all of my brain, the soundtrack-loop of business concerns, children's needs, money issues. It's the same song played over and over anyway! So I make my own kind of meditation.

track that plays in my ears is more like "Mommy, can I have some applesauce?" I love being at home with my kids and choose it over most everything else! (With baby number one, there was still some time left for dancing, but baby number two? Forget it.) When I do socialize, it's usually got some work element or philanthropic purpose; even Ming's giant second birthday was basically a big industry mixer for the moms and dads. I've realized that a key to balance is play. Maybe not throwing wreck-the-discotheque type party in my living room, but at least giving the twenty-person dinner table some use. Entertaining keeps the energy going in your life when you invite friends to celebrate what you've been blessed with. Throwing open the doors to your house is like saying to the universe, "I'm thankful for what I've got, so come on in and share it with me!"

How this applies to you: Throw a fabulous soiree from time to time; it won't kill you! A party doesn't have to mean everyone sippin' on the Cris and a soundsystem the size of a bus (though that'd

BALANCE TIP 4: I burn lavender candles on my desk at work to calm me down during the day. Lavender tea also works super well if you can find it. There's just something about that herb that changes your body chemistry and nudges the anxiety out of your system.

Since yoga's really all about getting your breath flowing, you can start doing it even while stuck at work. Try this simple series to relax and rejuvenate; it'll only take about five minutes.

Begin by sitting on the edge of a chair with your feet placed squarely on the floor about hip distance apart. Place your palms flat on your thighs, and feel the length in your spine from your pelvis all the way up to the crown of your head. Inhale and exhale evenly through the nose for five counts each. Repeat and just breathe for a couple of minutes.

Inhale and lift your arms overhead, taking hold of your right wrist with your left hand. On an exhalation, bend to the left. Stay there for four breaths. As you inhale, come back up to vertical and change wrists. Exhale, and bend to the other side, for the same number of breaths. As you breathe in, curl back up as straight as you can, then release your arms as you breathe out. Inhale and tip your head left, so the left ear tries to touch the left shoulder and stretches the right side of the neck, eyes gazing softly down. Three breaths. Repeat on the other side. Now circle your shoulders a few times, slowly rolling them up, back, and down. On the fifth roll, interlace your fingers behind your back with your arms out straight behind you. (Hold onto the outside edges of the back of your chair if space is tight.) Take a deep breath in expanding and arching your chest, lengthening the neck. Stay here and draw three full, rich breaths into your body. As you exhale, release your hands, place them on your knees, and round your spine. Tuck your pelvis and pull your navel away from your knees, coming into a seated cat pose. Breathe deeply and feel the broadness of the back body. Let your head dangle to open the back of the neck.

From that pose, begin to fold forward, letting your upper body fall through your thighs. Lay palms flat on the floor if you can, or simply hold onto your ankles or shins. You want your head to drop lower than your hips. Breathe for a moment and let the spine go long and soft.

Slowly roll up and sit up tall from your pelvis. On an exhalation, twist to the right. You can place your left hand on the outside of your right thigh and your right hand on the back of your chair. Check to

make sure that your right armpit-chest area is lifted. Remember to in-
clude your head in the twist as well. As you look over your right shoulder,
move your eyes to the upper right corner of your eyes and then the lower
right corner. Repeat this eye exercise two times. Then close your eyes as
you untwist back to center. Repeat to the othe side.

be great, so invite me if it happens). Entertaining can just as well
mean watching *Desperate Housewives* with a plate of carrot sticks
and blue cheese dip or a picnic in the park. (Although try to make
each one just a little fabulous: a dress code, perhaps?) The point is
to make an effort to bring friends together, share your space, and
invite people into your little universe! Modern life can be so isolat-
ing, and without realizing it, we are knocked off balance because
we haven't reached out to friends. I forget this all the time because
I feel I've been an adult all my life, but grown-ups need to play.

Despite all my efforts to slow down, I'm always on the go. But
I hope I'm incorporating things into my life that make it more sus-
tainable and easier to achieve my goals. A fabulous life and a bal-
anced life can—and must—go hand in hand; try to have them
both, and you're closer to attaining Fabulosity. I'm trying to
smooth things out so that I have a steady flow and am not zig-
zagging all over the place in terms of energy and mood. I'm trying
to be on time, to be on schedule, to be a better person inside and
out. In my own way I'm trying to "Stop the Insanity!" So far it
seems to be working. What are you doing to bring some balance
into your life?

"By the cultivation of feelings of friendship and fellowship toward those that are happy, by great compassion and love toward those that are unhappy and suffering, by joy and entertainment toward those who are meritorious and virtuous, by neutrality and indifference toward those who are demeritorious and evil natured, a yogi shall attain undisturbed peace and happiness of mind—Patanjali, Yoga Sutras." This is right next to the number for J. Sisters Brazilian bikini wax salon. Balance and Fabulosity, all wrapped up in one.

"Be still for a moment. Look inside. Happiness is inside; nothing on the outside can make you feel happier or sadder."

—RUSSELL SIMMONS

"Working with great people makes you great, you learn a lot, and it also gives you the experience and confidence to move on with your own career. You know?"

—NAS

"Yoga is the method by which the restless mind is calmed and the energy directed into constructive channels. As a mighty river which, when properly harnessed by dams, creates a vast reservoir of water, so also the mind, when controlled, provides a reservoir of peace and generates abundant energy for human uplift."

—BK IYENGAR

"When you stand with your two feet on the ground, you will always keep your balance."

—TAO TE CHING

"Women need real moments of solitude and self-reflection to balance out how much of ourselves we give away."

—BARBARA DE ANGELIS (SOCIOLOGIST)

Positivity
&
Sustainability

LAW
#14

Defy the haters

PEOPLE SAY I HAVE BEAUTIFUL CARAMEL SKIN. What most of them don't know is that it's thick skin, too. It has to be; as I learned at an early age, Fabulosity isn't always popular.

It started with the BMW convertible that I bought myself at age sixteen. I never told you the whole story. It wasn't just the cause of conflict with my mom; that car was my first exposure to an important truth: *The bigger your bling, the harder they come.* It's like some kind of sick mathematics formula. The brighter a woman shines, the bolder she stands, and the more fabulous she looks, the more haters will try to topple her right off her steel-heeled Jimmy Choos. Ridiculous, but if you want to carve your own different path, you got to learn to deal.

What happened with the car was this. I took it to school the first week I had it and parked it in the lot right alongside all the other cars. I loved my BMW so much; I'd cleaned the rims with a toothbrush, and I'd buffed the interiors with a Ferragamo suede shammy. I was so proud to have earned that car on my own; I just wanted it to sing! Apparently some of my classmates didn't agree. They thought it was a little too much of tooting my own horn. On the third day of class, I came out of extra-credit English and prac-

tically choked on my Milky Way. My prized automobile was sprayed with neon-green party paint and smeared with egg yolks! Right there in the middle of the lot, looking like a hot green-and-yellow mess. It was a cruel and vicious act on the part of a group of punk chicks—and the egg yolk ended up totally corroding the paint job, so it was a criminal act too. But it delivered a tough reality check that's served me for years: When you make big gestures, no matter how fabulous you may think they are, you automatically become a big target for haters. (Years later, I discovered the exact same thing had happened to a famous female singer as well, only her car was a black Mercedes.)

That's when I developed an outlook I call the "Glamazon Attitude to Haters." It means being out-of-the-box and proud of it. It means never letting the threat of criticism stop you from dressing the way you want to dress and behaving the way you want to behave—not to mention driving the cars you love! That kind of petty and spiteful egg-throwing happens all through life; it's high-schoolish behavior, and it runs rampant in the entertainment, fashion, and media fields. If you're always thrown off your game by other peoples' negative opinions, you're going to have a problem! You've got to imagine yourself clad in a suit of silver-plate armor, and each time some fiery missile gets shot your way, think, "I'm far too fabulous and shiny for that to affect me! Take your little catapult back to the playground!"

In the case of the car, I got it cleaned up and who knows where those punk girls are now? But as an adult there are no teacher-parent meetings to punish the bullies. I am bigger than life, over-the-top, I speak my mind, and therefore from time to time, I provoke controversial reactions. I'm not talking about constructive criticism here—the kind that may hurt but steers you in the right direction. I mean the real down and dirty bitch stuff. The verbal equivalent of the mean girls' paint and eggs: words intended to humiliate and take a girl down a peg or two for daring to stand out. Although, "Sticks and stones will break my bones, but words will never hurt me"—come on, we all know that's not true! Words are toxic, they're corrosive, they can sink into the most confident mind and set off all kinds of doubt. *They have this way of getting in*

> **YOUR HOMEWORK: LEARN HOW TO
> DEAL WITH BEEF OF ALL KINDS**
>
> **1.** How to take criticism from an employer silently and graciously: Don't answer back and wag your finger in their face, and don't tell them they're wrong unless you have clear facts and figures to back it up.
>
> **2.** How to respond to unjust criticism from a friend, lover, or the press: Put down the phone! Do not dial their number. You will get emotional and lose your cool. Consider writing a calm and collected e-mail, and get a friend to read it over before you send. Keep it brief and to the point, and only respond to their comments; avoid ranting about all their faults. It's messy, not classy.
>
> **3.** How to offer constructive criticism to others: Start with a positive, *then* offer the advice. "I love the way you styled the hat, but the outfit, shoes, and accessories need a bit of work."

there and staying in there for years! That's why I think the way you face haters is like the final, crucial touch to your whole personality. It's like waterproofing a building. You've got to seal up the cracks so that bad weather doesn't do any damage. What good is it to courageously put yourself out there if you let other people crumble you down?

Here are my survival strategies for dealing with the haters and coming out on top (while trying to succeed in this game called life).

1. *Don't Wallow.* This is true in any situation, be it a corporate job, college sorority, or the celebrity circuit. You simply can't let yourself get highly emotional about criticism and wallow in hurt feelings. Be detached about it. Recognize that this is where you are on the mountain, and you could get knocked down at any time. People want to throw things at you and make you fall off *because* you're at a certain enviable height. So be proud of that, and then keep it moving or get off the hill! Or to put it another way, get out of the kitchen if you can't stand the heat!

I know it doesn't come naturally to women to lock their emotions away—I have to work at not having emotional reactions because I tend to wear my heart on my sleeve—but the reality is that everyone is not at the same place in life to deliver great things and kindness. So I've learned to expect great things from myself and to expect great things from God and that's the only way to make it through. That's what toughens you up! You can be (and should always try to be) sweet-natured, but don't ever be naive—naive is for little girls, not for grown women. Why expect other people to do well by you for no reason? I know it sounds harsh, but it's a self-protective measure. Having no expectations also means that sometimes you're pleasantly surprised. Better that then slit your own throat because it wasn't what you expected! There's room to be surprised and that's a much better feeling than to be heartbroken.

2. *Know that for people to be talking about you, you must be fabulous.* You've got to take this attitude toward gossip. For your name to be a bold-faced headline or the subject of the day around the water cooler at work—come on! It says something about your status! It says something that your name would be bigger than the writer's name or bigger than the column's name and on the top of the page above all the other gossiped-about people. In my situation, I always figure the newspaper is making money off me, so obviously I've got some kind of cultural currency. In fact I've asked the gossip writers about it, and they've told me so! They say, "We don't hate you, we don't really think bad of you, but you're hot, you're newsworthy, you sell our paper. Without you where would we be? We love ya!" They'll spin whatever tidbit they have into a juicy story, regardless of whether it's totally unsubstantiated or plain-out wrong. They do that to everyone, but it's most fun to do it to me—to push me a bit and see if I'll fall to the ground. Newsflash: I won't, ever!

Hearing or seeing mean things written about yourself is a quick flash of searing pain—ouch! It happens to all of us, whether the negativity's coming from office coworkers or a national newspaper because when a woman reaches for what she wants and has confidence and style, somewhere, someone's going to say she

"thinks she's too cool" or is "getting too big for her boots." I always tell people, "Choke back the tears and consider it a tribal rite of toughening up." You get burned a couple of times, you get less vulnerable to the pain. Emotional survival all comes back to flipping negatives into positives. Just like when I persuaded myself that the mean runway model made herself look foolish by ditching me at the end of the catwalk, I can choose to believe that all press is good press. Any woman can do the same, whether it's in school or work or just a vicious social crowd. If she catches wind that people are bitching and whispering about her, she has to mentally polish up her platinum diva armor and realize that it must say something about the effect she has on them that they can't stop talking about her. Come on now, if you were half as interesting, half as fascinating, would they even bother to say your name?

3. *Take Ownership of the Gossip.* Haters only have power over you if you let them have it. I had this idea recently to Xerox every negative gossipy thing written about me and blow it up huge and paste it over my front door. It'd be a way of telling them "Thanks, because your criticism only has the effect of pushing me to do bigger and better!" It definitely takes having a sense of humor about the whole situation and refusing to even hear the stuff that isn't true. A magazine article once called me the "Queen of Conspicuous Consumption." Well, I read that and just didn't see it as a snarky title; I thought it was funny and fabulous even if the writer was trying to get a little dig in. Who cares? It just doesn't register in a bad way to me because it's not true, that's not how I live my life. I didn't perceive it in the negative way that maybe others did, so it will never have a power over me.

You'll survive all kinds of scorn if you're fully confident about your choices. If you're insecure about your style or persona, then of course, snide comments will rock you more. I express my style the way I do because I love it—because that's me! There are people who criticized me for getting a Rolls Royce—they think it's tacky because they roll in Lincoln Town Cars and have the car service drop them around the city. Great for you! But I'm happy to have my beautiful, cream-colored Rolls. My mama didn't have a

What to do the morning after something bad breaks (be it on the network news or the high-school grapevine).

1. Dress up, up, up. Now is the time to look better than ever. Ladylike and powerful. Wear heels, tailored jackets, or tops that pull you up straight and pull your shoulders back, and flawless accessories—jewels if you have them. Think classic Liz Taylor.

2. Now's the time to dial up the beauty routine. No neutral beige: Go for red lipstick, and use a double coating of mascara. Clean, crisp hair, matte complexion, groomed brows. No one but your cat needs to know you were crying all night.

3. Make all your gestures stronger than ever: bold eye contact, firm handshakes, elegant posture. Let people subliminally know that *you know what they're thinking*, and you're not thrown off your game. No crossed arms, hands in pockets, or eyes to the floor.

4. Unless you're going to pull off a dramatic coup (like printing your mug shot on a T-shirt for the world to see) avoid bringing the scandal up in conversation. It usually looks defensive. Never use self-deprecating humor. Pretend you've forgotten already even when it's obvious the world hasn't.

5. Run any public statements through a trusted adviser first: PR person, mom, or the smartest kid in English class. One great line is sometimes all you need.

Rolls Royce; I didn't grow up with one! In fact knocking me for it makes me want to be double fabulous—it's the opposite reaction from what you wanted; you thought I'd shrink down and hide? To the contrary. I'll stand taller and more proud of myself; now I have two!

In times of scandal, this tactic is even more critical, though it takes a lot of guts. In fact, it might only apply to those well

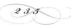
schooled in deflecting verbal bullets. I had one incident where things got really hot, due to an unfortunate run-in with the traffic cops near my home. The short version is this: They took me down to the station for a mug-shot that then made its way onto the Internet. (Note: Because I was following my own Style Law about dressing like you're about to run into your worst enemy, many news items referred to the cuteness of the mug shot! You never know what's going to happen.) The gossip columnists had a field day with it, 'til I one-upped them. I printed that mug shot on thirty white tank tops and had the models wear them for the finale of my Spring 2005 Baby Phat fashion show. It was perfect! It was a way of saying, "Yeah, I screwed up; I take ownership of it rather than let you gossip about it at my expense." I went for a larger-than-life approach and broadcasted it myself in a tongue-in-cheek way—that's what I mean by owning it. The crazy thing is that it *won* me support. When you take ownership of a scandal, you are often empowered, not disempowered. My point is if you have the courage to grab the spotlight and speak out about what happened, you often win way more respect than you (temporarily) might have lost.

4. *Understand the Psychology.* I remember a write-up about a Baby Phat show that said, "What's with all the glitz and glamour? Kimora's a denim designer, and her price point is $75—where'd she get the nerve?" And I was thinking, *It's a stage production! Do you really want to see a runway show with nothing but jeans?* I'm giving you vitality and life! I mix the denim with outrageous runway pieces and jewels! I couldn't believe a critic would come to a runway show and say, "She sells to Macy's; how dare she make it fabulous?" This is what a fashion show is all about! Big girls, big Kabuki hair, big diamonds, big music. And I saw you, the critic, smiling and tapping your foot to the deejay—you were having fun! So where do you get off, writing that I'm overstepping my mark?

It's hypocritical. Why can't all women have fun with rocking over-the-top style and diamonds and furs? In Hollywood it's always about the Oscars; so-and-so has on the 500-and-something carat

necklace, and that actress's gown cost $25,000. So why hate on other women for being ostentatious and pairing denims with diamonds—do you say Elton John is ostentatious? Do you say Donatella is over-the-top? The media might hint at it, but it's usually with warmth or admiration, whereas fly girls in their cute jeans and designer accessories always attract this high-school bitchiness, as if to say, "That's not *real* fashion."

The psychology of it is obvious. Our generation and culture are rocking the boat. We represent a change in the status quo. Suddenly regular women vamp it up and feel free to go browse in Cartier just for the heck of it. Fabulousness is not only for the establishment any more! The larger-than-life attitude is inclusive not exclusive; it's saying to the girls from Brooklyn or backwoods Tennessee, "Come to Bulgari and try on some bracelets you may not ever buy—women do it all the time, and you can do it too if it makes you feel good!" I love saying that! Why not? But I'm not a European fashion designer from Milan and not talking to those customers, so I'm not supposed to say it.

Just like with the paint-and-eggs situation, most of the time people say mean stuff it comes out of jealousy. Once you recognize that, you're freed from being affected by it. In a way, it has nothing to do with you and much more to do with the hater's own insecurities. Because if we hooked up everyone who says that the hip-hop luxury style is "too much" to a polygraph test and asked them, "Would you fly First Class if you could? Would you prefer to fly private if you could? Would you turn down matching Louis Vuitton luggage if someone gave it to you?" I think we'd all know what many of the answers would be. So maybe it's their own dissatisfaction that makes them hate on those who do have that lifestyle or aspire to have it.

At the end of the day, bullying and meanness all comes back to the basic schoolyard rules. Just like I tell every little girl, "You know why that boy keeps pulling your hair? 'Cause he really likes you. He just feels weird about liking you, and unfortunately it's coming out in hair pulling." Hopefully we'll all grow up, and one day it'll come out in the form of a love letter.

5. *Take the Good Stuff to Heart.* There's a difference between being self-assured and stubborn. You have to be able to accept constructive criticism and learn from it. You can stay true to your big vision and sail toward the goals you believe in, but you have to let other people nudge you back on course when you stray from it or make bad decisions. Knowing the difference is easy if you've surrounded yourself with advisers you trust: When you trust the critic, you can take their words to heart and adjust your behavior a bit. I've even gotten a lot better at admitting when I'm wrong. But if the critic barely knows you or your business and is making vague attacks about your character, style, or attitude instead of specific events and activities, then chances are their "advice" is more about them than you. Learn to drown out their angry buzz.

6. *Focus on Your Own Audience.* Sometimes you have to have faith that certain people are going to dig you and certain people aren't, and if they don't, then who cares? One time, a well-known TV interviewer challenged me: "What are you teaching the kids in the inner-city and the kids working minimum wage jobs in the sub- urbs? That Rolls Royces are okay; that furs are okay? What kind of values do you think you're showing them?"

I like and respect that particular interviewer enormously, but when it came to this, he just didn't get it! My message is not that "You *need* a Rolls and that fur." Mine is a message of luxury and opulence in the broadest sense. It's about the feeling you have when you're being as fabulous and sexy as you can—whichever way you want to achieve it. I told him "Mine is an inclusive mes- sage not an exclusive one like most fashion houses! Look at the logo on the ads; it's Baby Phat! So I'm saying, 'You can have my jeans and still be super fly.'" I mean really! Women know what it's about. We don't see ads and think they're oppressive or that we have to have everything in them. We use them as inspiration for a look and then make it happen on our budget; we mix and match H&M tops with maybe one little pair of Chanel designer earrings. It's really about a feeling. And that's what's so funny about me. It's not about the Bentleys and stuff. You can take it all away. You can

shove it up your you-know-what! Have it, take it, I don't care! It's about aspiring to that feeling of total luxury and fabulousness, however you choose to express it. Be fabulous on a skateboard if you want to be. Be a fabulous cowgirl on a mustang! To each her own. But just make the effort to recognize what makes you fabulous, own it, and share it with the world—turn it out and express it! To me, that's luxury. The freedom to express your spirit.

I've learned that the people who would think I'm too much tend to be the people I'm not interested in pleasing—the old-guard media or the old-school "straight" fashion establishment. The very reason they don't like my style or my persona is the very reason I like it. And it's liberating to realize that. I come from another place in terms of heritage and ethnicity and the way I understand culture, it's hip-hop culture, and it's youth culture. So why would their criticism have anything to do with me? I don't seek the acceptance of those people; I don't really know them. I see them with their sour faces, and I just think, "Are you happy? Are you smiling? You look like you ate a lemon!" When you're focused on the audience you care about, you have to also have the discipline not to take the input of other groups outside that audience too seriously. Use your energy wisely and respond to the people you actually care about. Everyone has an opinion; the question is which opinions are actually relevant to your journey, and which are just static in the air?

7. *Get Immunized.* Write this Nietzsche quote somewhere you will see it every day: "That which does not kill me makes me stronger." It's a good maxim (even if you're sweet as sugar pie and no one ever gives you grief, you'll need it someday). There are people who live at others' expense in a negative way, whose entire occupation is to circulate gossip and rumors and sometimes vicious lies. But these days I see criticism as a shot in the arm that makes me stronger. It's like a vaccination, when they give you a bit of the virus to build up immunity against a disease: Exposure to the bad stuff ends up making you healthier in the long run.

Should you ever fight back? Probably not. If you're busy doing your thing, why would you waste the time? That's the whole point!

The person criticizing has all this time to focus on you . . . and you shouldn't have two seconds to give to them because you should be building something much bigger and much more positive. Try not to get caught up in tit-for-tat exchanges and saying things back. Your focus should be on avoiding conflict and conserving your energy. Why give the energy to anger when you need it to get through your day? It's the woman warrior mentality: flex in the wind rather than snap. That said, there will always be people who push you to the edge. For example, there's one male gossip writer in particular who just keeps coming at me. Again, and again, and again with the petty attacks and absurd claims! Like I've said, I don't condone violence, but every woman should have a bit of fighting instinct in her. Grace gets you to a point, but then sheer self-respect should force you to stand up for yourself in dire straits—confront the bully head-on and without fear.

Attacks like that only serve to make me certain of how strong my shield is. It makes me feel like one of the damn Incredibles: *You cannot penetrate my field.* You try, you throw stones at me all the time, and it's just not working. In fact it's helping because every little stab, every time you think it hurts, helps me get more of a backbone, to get it together and be strong. And it helps me search for those few people who really are my friends instead of being ambivalent and thinking everyone is my friend, because they're definitely not. It's like "In case you thought they were, here's the kick in the butt to wake you up!" So I take the good with the bad, and I take the perceived bad and turn it into good, and I treat the people closest to me well and sleep easy every night. There are definitely haters out there, it's a fact of life. And I do think you need the good, the bad, and the ugly to have a balanced life and not be complacent. They're all part of your Rubik's Cube. The key is how do you respond to it? Does it make you change your goals and vision or do you stick firmer to it because of the challenge? Every woman should feel untouchable and know that she can do anything, be anything, and not worry about what the world at large says.

Ultimately, know that *someone saying something bad about* you is not the same as *something bad happening to you.* At least, that's

what keeps me light-hearted in the face of opposition! You can only be responsible for what you give out; you can't control how other people receive it because different people will receive a message in different ways. No woman likes to be criticized, but if you can keep a grounded perspective on it, and remember to focus on the positive energy you're putting out there not the negative vibes that a few bad apples might send back, you'll have a stronger sense of satisfaction and less self-doubt.

Maybe the whole point of negativity and criticism floating around is to be a test of character and self-belief. I recently heard John Travolta say it best, "Shame on you if you get a bit of criticism and think you're crap all of a sudden—shame on you!"

"Everything that happens to you in life shapes you as a person. Every struggle, every challenge, every thing that is placed in front of you is to see how much stronger a person you're gonna become."

—JAY-Z

"You find out who your real friends are when you're involved in a scandal."

—LIZ TAYLOR

"All the hate and animosity between folks, y'all need to kill it with a skillet."

—MISSY ELLIOTT

"I'm just trying to be me/doing what I do/ so why y'all keep hating on me and my crew?"

—LIL' KIM

"While I'm hot to death, I'm gonna say this to all you playa haters/Y'all should hate the game, not the playas."

—50 CENT

"N**gas see you in the street, pretend to be friendly/ but I know any type of success breeds envy."

—JAY-Z

"If you haven't cried, your eyes can't be beautiful."

—SOPHIA LOREN

Live large, give large

NOW FOR THE MOST IMPORTANT Fabulosity law of all. Ready? It's the final step to achieving a fabulous life. *Once you got it, you've got to start giving back.* Take some of the money, some of the objects, and all of the influence you've earned and sow them back into the ground you came up from. It's all part of the balance we were talking about earlier, people! Keep the flow moving, keep the river moving in and out, don't hoard up the good stuff in your corner and then come running to me in twenty years with a midlife crisis, going, "But what was the point of doing all that work? Why aren't I happy?"

Here's what I'm learning after seventeen years in the business. The bling, the shoes, the bags, the cars, these things all add up to three letters: F-U-N. Sometimes they add up to very, very F-U-N. They are fabulous tools: life-enhancers that make you walk taller, project yourself louder, and carry yourself like a queen. They are shiny goal posts that motivate you to work harder and perform better and to aspire to a much bigger existence, which as you know by now is something I consider very healthy. But are they important to your whole life's journey? Satisfying to your soul? Do they make you sleep better at night? No. And I'd never suggest otherwise.

Material possessions, at the end of the day, are not what make your life rich.

It's what gets left out of every interview; the part where I say, "If I lost everything tomorrow, the only objects I'd miss would be my photo albums and my teddy bear from when I was two." It's true! Maybe the way my husband, Russell, says it is more succinct. "We've got all these fancy chairs all over the house, but a man can only sit his ass in one chair at a time." In other words, nice possessions are beautiful, they're sexy, sometimes they're notorious; but they're not *important*. They're great for expressing your style and building a fabulous persona that gets you recognition and authority. But they're *decor*. They don't define who you are as a person or define what your life journey is about! And if you hold on to them too tightly, they'll drag you down like rocks in a river.

You see that kind of thing happen all the time in the entertainment world, especially in hip-hop where young people can get rich really fast. Kids have one hit song, and they get blinded by the glittering ice and high-beamed cars they can now afford. And all of a sudden, they start turning their posses against each other and stirring up grief, even though if they stepped back for a second, they'd realize they should be be celebrating because they've arrived at a position where they have as much as they ever wanted in life! But because they're holding on to the material stuff too tightly and they're so set on protecting their turf against the other guy, things sometimes turn ugly.

I guess I just don't see possessions as a life or death deal. I own them—a lot of them—but they don't own me. I just happen to think that bright orange ostrich-skin bags and emerald-green satin sandals make the world a more colorful place for everyone! And if a girl can't have Hermès ostrich skin, then orange-colored fabric or fake leather will do; the point is not to accumulate expensive things but to turn on the bright lights the best way you can, instead of letting things get too gray and repetitive. Use beautiful things strategically to make yourself and other people smile! (Or make them drop their jaws in shock at your pink ultra-mini skirt, whatever turns you on.) It's about not taking any of it too seriously.

For me, part of that mentality is also to let things circulate. When you're done playing with whatever great clothes or accessories you have, you pack some of it up and give it to someone else. That's what I've got my daughters doing even at their young age; every so often we go through all their stuff together, box up the clothes they've grown out of or toys they're too old for, and send them to charity. So they're learning that nice things pass into their hands and eventually pass out of their hands, and they aren't the be-all, end-all of life. They're learning the simple truth. That happiness is inside; nothing on the outside can make you feel happier or sadder. Okay, that's what their dad says. I say the outside stuff can give a girl a great little sparkly rush now and then—come on now, who are we kidding! But it quickly fades like a candy high if there aren't more substantial reasons underneath for what you're doing with your life.

There's a reason I've put this Fabulosity law at the end of the book. Because it's what I'm learning the most about right now: how to give back in a smart, efficient and effective way and how to use the persona and the power I've gotten to do some good. Partly it's what I'm learning from Russell; he's already been through the cycle of owning lots of toys and not finding deep satisfaction in them. But partly it's what I'm discovering for myself because I'm my own person and I don't have exactly the same approach to spirituality and religion that he does. What he and I definitely agree on is that as part of doing business, you have to do good. Call it what you will—he says it's burning karma, I say it's plain common sense—but we both see it as an obligation of success. Putting water back into the well that you drank from coming up! Sowing some nutrients back into the ground for the next generation. We all have to do it, no matter if we're rich and famous or not. It's just a natural law: *You drink from the well, you refill the well.* Who helped you along the way, and how can you play the same role for somebody else now that you've got solid earth beneath your feet?

The Fabulosity credo

Around my house you'll hear this phrase repeated a lot: "To be a good leader, you must be a good servant." My husband has said it so many times that now I find myself telling it to the girls too. Because I've learned what it means, and I'll give Russell props—it's true! It means that whatever your vocation or whatever goals you pursue, if you want to have some impact on society, you should be driven in your heart by the part of the job that contributes something to society and serves other people, not by greed or ego. I think it's a really good thing for any of us to ask ourselves when we embark on something new in our lives; it's like a filter to keep us on the right track. Most of us start off with the right intentions . . . and then wake up a few years down the road having to do a serious self-check. For instance, if you're making clothes, are you motivated to go to work each day by the prospect of big profit numbers on the spreadsheet or are you motivated by the reaction of the women who wear them, who come up to you in the street and say, "I feel like a million bucks in this outfit! I feel like a goddess! Watch out world, here I come!" If you make music, are you motivated by the idea of buying another Lexus, or are you motivated by the desire to put your story out into the world and hope that someone, somewhere connects with it emotionally and is affected by your effort?

I'm not saying you have to choose between money and virtue, not at all! I think if you follow a personal mission to put something positive out there, you will get rewarded, and you will prosper. Good intentions breed great rewards because people respond to what seems genuine. In any field, accolades and praise depend on whether people are made happy by what you do, whether they feel like they've received something from you. In my case, my mission is for all women to feel fabulous and empowered and diva-like in my clothes, no matter what their life situation may be. It's a pretty universal sentiment—who doesn't feel that way?—and success has

come because the audience and I have connected around some-thing real. The "good leader/good servant" quote also means that if you work solely for the motivation of money, it won't hold up all the way through. At some point down the line, you will almost certainly lose heart. The key is to figure out: "How can I use my potential to do something that will add to the world? What's miss-ing that I can fill?"

I'm sure that if I hadn't had a few encouraging adults to build up my self-esteem and push me and my giraffe legs out onto the stage (my mom, my first model scout, and my early mentors in fashion), I might have tried to shrink into the woodwork and hide because I saw no place out there for me as a pre-teen. Somebody had to look me in the eye and tell me "I see your potential." That was the match to the fire that I needed; I had the courage to step out and speak out and claim my space, no matter how much other kids scorned me. I've heard the same things from many successful people who weren't handed opportunities on a plate when they were young. They had to discover their own potential any way they could by finding people and activities that could help them shape their own identities, develop their talents, and make meaningful contributions to the world. If they hadn't found ways to express themselves through art and music or through sports programs or leadership programs who knows what their lives would be like to-day. We all benefited from mentors and guides and beneficiaries; Now it's our turn to play that role.

I don't stray too far from my own history when I refill the well. For one thing, I started a foundation at my school, Lutheran North in Missouri, to give scholarships to deserving girls who can't afford private education. I also support programs that give kids outside the margins a chance to develop a voice and a sense of self-esteem. It's a case of "do what you know." I guess you could say I started as the underdog—it wasn't that long ago that I was getting chased down the halls with lighter fluid sprayed after me—and now I use my position to champion other underdogs through sub-sidizing institutions and programs aimed at disadvantaged youth. (One of my favorite causes is an alternative high school in New

York that provides a home for at-risk teens, many of whom have harassment and abuse due to their sexuality or who are just too "out there" to thrive in regular schools.)

My mission with philanthropy is to see more underdogs becoming top dogs! I want the underdogs to start to feel ownership of something—to see that they have unique talents or attributes that other people don't have. And I want to give them safe environments where they can express themselves creatively and get encouragement for it. A lot of the kids that my company's charity projects support have been stuck with screwed-up labels, from "drop-out" to "teenage mom" to "criminal." Because I overcame my own "Chinky Giraffe" label to make it in business, kids and I can connect. We talk about the way it is. They tell me what's really going on in their lives, the uncensored version; I'm upfront with how I got from St. Louis to Seventh Avenue and what choices I think they need to make, and we have a good time.

These days I have a broader perspective on things; I've seen how glamour and fashion is like magic dust—you sprinkle it around pretty much anything, and people want to be part of it and get on board. It's incredible how powerful it is. Russell and I throw huge benefit parties every year to raise money for kids' art charities, and the tickets sell out immediately because it's bees to honey: Fabulosity draws a crowd. I tell the society ladies and the celebrities who come "Giving keeps you young! It makes you feel joyful, your skin glows, you shed all this heavy stuff you don't need—it's better than going to a spa retreat. Here's a pen; now write us a check." Since I'm a fashion girl, I'm trying to make it fashionable to give.

The way I see success and social responsibility is that it's as if I've been given this mighty pair of shoes that I'm going to wear for the rest of my life and that I will pass on to my children someday. As my business gets bigger and bigger, I'm growing into these shoes and realizing just how major they are. Because when you have money plus a certain level of fame, it's a double whammy. You can give a certain amount away financially, and you can also persuade other people to give. Fame gives instant access to other celebrities and to the people you never hear about who have the fi-

> ## YOUR HOMEWORK:
> ## PRACTICE GRATITUDE
>
> One of the many lists and charts I doodle into my journal during car rides is my gratitude list. I make a Top Five List of what I most appreciate, on that day, at that very minute. And I update it on different days, so there's a little private history there in all my lists. From the tiny things like a kiss on the cheek from my kid in the morning to the TV commercial that cracked me up to the complex business problem my lawyer solved, yet again. Just like writing out my intentions for my life, writing my thankfulness makes it concrete and real. I go back and look at the list if I get stressed and remember, "I've got everything I need, so just chill out!"

nancial power to make a difference to a cause. If I can get an introduction to basically anyone important on the planet, my thinking is together we can do something worthwhile to benefit society. When I recently went to Asia to support a benefit concert for the tsunami relief, I was able, through the people I met there, to donate money to build a new home for a local orphanage. Being able to take advantage of global connectivity and having an effect on kids halfway around the world, as well as kids who are blocks away from my office, is one of the most exciting parts of my job.

There's a way to live large and to give large that makes everyone happy, if you're always putting back into the well. It really is just common sense at a certain point! At home we say our goal should eventually be to live on between 1 and 10 percent of what we have and give the rest away. For a lot of people we know—for very wealthy people—that's doable. What can you do with so much money, when you get into the millions and billions? What are you going to do with it? You only need so much to live. Even to live very well! And that will become our children's' job too: to give it away.

I'm not just talking about what a person should do if she strikes gold and makes it rich or famous. By giving back I don't

1. Try new foods: Indonesian, Malaysian, Scandinavian—I'll try any-thing, and I'll get my kids to try it too. We'll talk about how it tastes, why it tastes that way, and who we imagine eats this food. It's a way of feed-ing the imagination along with the tummy.

2. Practice foreign languages. The French and Italian I learned when I was young gets a little rusty with time, but I stay up on it with my French and Italian *Vogue* and *Elle*, thank you! My older daughter learns French and I practice with her, so she keeps me fresh. But if Spanish is what your grandma speaks or it's what you hear all around your neighborhood, why not get into it, with a few books or tapes? Your brain is a muscle; it needs a workout too.

3. I get all those travel magazines and read them in the bath; then I cut out articles, make notes in my journal, and write down where I want to go in the world even if I know that realistically there's no time or chance to get there. Because becoming conscious of all the opportunities some-times means you're more likely to seize it if a great one does come along.

necessarily mean she has to give back money—most people have a tough enough time dealing with taxes. I mean giving back of your energy and your attention. Noticing what's going on in your com-munity and being involved when you see injustices. Participating in something bigger than your immediate family's life. Are your schools having their budgets slashed; are all the local kids getting asthma from the air? I happen to live with someone who's an involvement-addict—my husband has the number of every politi-cian, activist, and media person this side of the Mississippi speed-dialed into his phone. And personally, I've never been one for keeping too quiet if I think a situation is screwed up—I'm the one who wants to adopt the unwanted kids and start the animal shel-

ter! So our household might be kind of an extreme example of a community action center sometimes. But the point is that every single one of us has a voice and using it is free. It doesn't cost anything to express an opinion, to vote, to protest. It just takes some time and some effort. Living Large, Giving Large means never being complacent and just accepting what's handed to you or writing off things as "not my problem." It means getting involved. Showing up to the PTA session, the town hall meeting, or volunteer day to clean up the park. What you see around you is happening *to* you, no matter what you think.

Living Large, Giving Large also means giving to yourself. The aim of life should be to prosper as a whole woman—as a multidimensional human being!—not just to prosper as a worker-bee with a great résumé. Women *should* give large to themselves to nurture their own intelligence and creative spirits, but way too often we don't. Not long ago, I saw part of a daytime TV show about teenage pregnancy. One of the subjects was a girl who'd had two babies very young and had to work like crazy to support them alone while getting her nursing degree at the same time—an amazing girl who'd not had it easy. The host asked her, "What would have made a difference in your life when you were younger? What might have led to a different outcome for you than two babies as a teen?" And the girl replied, "Maybe if I'd had some kind of hobby. Something I loved to do and was excited about when I came home from school. But there was nothing I cared for, and I started doing stuff I probably shouldn't have." As simple as that! "If I'd had some kind of hobby." Sounds kind of trite and too obvious, doesn't it? But it's not. Just like we should refill the common well for people after us, we have to refill our own private wells too by doing things that enrich our minds and spirits. That's why, even though I've written a lot about finding success on a public level in your career, I think it's just as crucial to give time to doing whatever moves your heart on a personal level as well.

It's Grandma's advice, isn't it? "Stay busy." "Idle hands make for the devil's work." I don't see it from quite that doom-and-gloom point of view, but I do get reminded of what we adults tend

to miss out on when I look at my kids. They are constantly trying new things, playing new ways, and doing new activities, and they're constantly excited. They always have something to talk about! So even if as adults we only have a tiny bit of time to ourselves, I say pick something that adds to your experience! Fill up your life as much as you can. Expand it. Turn off that DVD, get off the couch, and learn to bake, take an African-dance class, join Greenpeace, read every book by Charles Dickens for a year—whatever it is, stay curious.

It comes back to self-reliance. Who are you going to rely on for your feelings of fulfillment and satisfaction? Are you waiting around for some guy to come complete you like that scene in *Jerry Maguire*? Do you think having kids is going to make you suddenly be overwhelmingly fulfilled? Is that job you're after going to finally make you feel utterly content? Don't bank on any of those things because, sure, all of them are elements of a fulfilled life, but in any of those scenarios, unless you keep moving and keep growing on your own terms, separate from your identity as a girlfriend, wife, mom, or employee-of-the-month, you'll eventually end up in a rut, frustrated and stuck.

That's why I'm so big on travel. If there's one piece of advice I could give anyone starting out in their life, it's probably this: *Take advantage of any single chance you have to see something new, to experience the way other people live, and to get inspired by the world outside your neighborhood.* I have a lot of friends, and this includes models, hip-hop artists, and executives, who are so resistant to change and so suspicious of foreign things. I think it comes from fear or just not understanding. They have all that money and all that fame, and they get to travel the globe to exotic places . . . but they still want chicken fingers and French fries wherever they go! They don't want to leave the hotel and see the sights and countryside nearby. They don't get it. To them, anything "other" is weird and just disrupts their schedule. But take it from me—traveling and getting exposure to the world is just as valuable as any education you can get at home.

Sure, there were times when I was living by myself in France or Italy that I missed out on certain things at school, on movie

GIVING BACK

To see more about some of the charity work we do and find links to volunteer organizations, check out our site www.rushphilanthropic.org.

nights with my girlfriends, the usual teenage stuff. My nights were lonely. And I know that it's pretty intimidating to just jump on a plane and voyage out. Even now I have hesitations when I have to leave on a big trip, wondering if something will go wrong, and what the heck will I do if no one speaks English? It's natural; but the only answer is just to go. Turn around with your woman-warrior shoulders held back and walk right toward that fear. Because it makes your brain exercise to be in a place where you don't understand the language and can't read the signs. Navigating around strange cities sharpens your senses and hones your survival skills. And it's such an enriching thing to understand new cultures and meet different people; you feel more awake and more vital as a person when you explore the world.

That's not to say that if you cannot ever do it, you're doomed. But it's to say that if you can find a way to do it, you must. It doesn't even have to be expensive (get on the Internet, and you'll see). And if it is a little pricey, ask yourself, which will impact you more—getting those rims on your car or spending that same amount of money to buy an air ticket, go backpacking around Brazil, and learning to surf with a hottie from Rio? Which will you remember when you breathe your last breath? (If you say the rims, I guess I can't help you!) Life is supposed to be an adventure, guys. You've only got one, so make it rich and full! Stretch yourself outside your comfort zone—and when you make it to Paris, order the escargots, not the chicken McNuggets!

I really try to hold on to that experimental mentality that came so easily to me as a teenager. If it's hard for me, with kids and employees and a huge company rumbling along, I know it's even harder for women who don't have support teams. But it's so impor-

tant to never stop exploring in all aspects of daily life. Keep looking for opportunities that will offer new ways to learn. Do that maintenance of yourself as a person—stay interested and interesting. Be willing to sometimes walk away from jobs and sensible options that will serve no other purpose than to pay the rent. I still do it because I want my brain to keep active! I take jobs in film or TV that don't pay me a lot because I really want the experience and exposure and want to learn things that will be useful to me in ways other than the money. I want to finish getting my college credits too—another thing that will take away from my time in business, but will make me a more well-rounded person. It's to fulfill my own personal mantra: *Do the most you can do in this lifetime, and be the most giving with your time that you can be.*

"Service to others is the rent you pay for your room here on earth."

—MUHAMMED ALI

"We are responsible for our own fate, we reap what we sow, we get what we give, we pull in what we pull out. I know these things for sure."

—MADONNA

"Be the change you want to see in the world."

—GANDHI

"Life is a process of becoming, a combination of states we have to go through. Where people fail is that they wish to elect a state and remain in it. This is a kind of death."

—ANAÏS NIN

"We are never alone. We are all aspects of one great being. No matter how far apart we are, the air links us."

—YOKO ONO

"Develop interest in life as you see it; in people, things, literature, music—the world is so rich, simply throbbing with rich treasures, beautiful souls, and interesting people. Forget yourself."

—HENRY MILLER

Write your own script

AND NOW IT'S OVER to you. I've shared everything I know, my complete fifteen-part Manifesto of Fabulousness, my Philosophy of Fabulosity. But like I said at the jump-off, this is just one person's life, and one person's tips on what worked, and you may want something completely different from yours. Since I'm always encouraging women to think for themselves and challenge the status quo, you're welcome to challenge or disagree with my way of living—I'm not saying you have to follow the exact same path, want to dress the same way, or have the same beliefs about what to do with your success. Be different! Be daring! Create yourself in complete opposition to my style if you want! What I hope is that most of all, you're inspired to *be your own woman and claim the most power you can claim*—no matter if you're an out-there artist, a stressed-out student, or a busy mom, I want *you* to be directing your destiny, not some other forces out of your control.

As you've no doubt gathered by now, the aim of Fabulosity is not necessarily to rocket to the top of the music charts or become a top model. It's not about being a celebrity or becoming an overnight-millionaire. It's much broader, and I hope, much deeper,

than that! The aim is for every single woman to have a fulfilling and self-sufficient life, free of debt, and free of doubt, and as far from struggle as possible. To have the confidence to shift her situation around to some extent: to dream a little, push the barriers, and obtain things people said she couldn't obtain. And to feel part of something bigger than herself. Women are natural caregivers and nourishers: I think we should maximize that by putting back as much as we can into the well and contributing to the world at large and to the lives of other people.

The theme of this book, above all, is *do it yourself*. I don't want you to feel like that's a burden, as if there's nobody around to help and nobody cares what happens to you (I care! Or I wouldn't have written this book). I want you to feel like doing it yourself is the best blessing and the best freedom a woman could have! There are so many places in the world where doing it yourself—in other words, creating your own destiny, choosing your own career, life partner, and even whether and when to have kids—is not an option for a woman. So don't get complacent and don't waste the opportunity for creating or even reinventing yourself. Enjoy the power of self-definition—don't fear it! First, be free to dream, then put some energy into getting yourself into first gear (which might be as simple as writing down your intentions), and then move forward by making the best decisions you can at each moment. I'm talking baby steps, people. There's no grade-scoring system here; it's a Pass/Fail situation! And when Prof. Kimora's at the lectern, everyone who makes even one solid move toward her dream—anyone who participates—automatically gets a Pass.

So let's do a quick recap. A pop quiz to see who read all the assigned chapters. What are you going to do from now on to build Fabulosity for yourself? Anyone?

You're going to:

LAW #1: Work yourself into a frenzy of high hopes and aspirations.

LAW #2: Embrace and exhibit the qualities that make you different.

LAW #3: Speak out, ask questions, and make your presence felt.

LAW #4: Assert your way into the field you aspire to work in.

LAW #5: Persist through the times of disillusionment and disappointment.

LAW #6: Activate your incredible female power to deal with adversity.

LAW #7: Control any money you make to the last dime.

LAW #8: Claim ownership of your best work and ensure you reap rewards.

LAW #9: Develop a memorable, unmistakable persona.

LAW #10: Express your fabulous, feminine, sexy self through fashion.

LAW #11: Celebrate and take care of your inner goddess and outer diva.

LAW #12: Take the reigns in relationships and ask for what you want.

LAW #13: Bring balance and softness into your successful life.

LAW #14: Love yourself enough to rise above criticism.

LAW #15: Contribute your best energy and attention to those around you.

And while you're doing it, bring a little luxury and goddess-like beauty into your life, in whatever small or large ways you can. This process is supposed to be fun! So adorn yourself, express yourself,

get your shine on—and radiate some of that hot female-power to the world!

At the beginning of this book, I said I wanted to "inspire you to aspire." What and who you aspire to be is not my business—as long as you know your value and hold yourself to high standards. As long as you keep feeding the hunger that makes you want *to do more and be more than the status quo suggests you should be.* It might seem like there's a road paved out for you in life—that you'll inevitably do what your mom did or your sister did or become what the other girls in your school or neighborhood have become. But I hope my story of being the one-time misfit from Missouri has proven otherwise. Not to repeat myself—okay, I will repeat myself, because it's my book and I can! *I didn't know exactly what I wanted, I just knew I wanted something different.* And that's enough for anyone to start the journey. Keep every one of your six senses alert, scanning your environment for possibilities—then take a risk and jump toward one of them. If it doesn't work out, take a breath and make another move. Life is a series of adjustments.

Just look at so many people out there who've made it. Sure, there are a ton of folks who followed the straight-arrow path, went to the right schools, got the right grades, made the right connections, and checked every single perfect little box along the way. But there are just as many who didn't do any of that. People who came out of left field with a good idea and a lot of confidence, and eventually, after shedding some sweat and probably some tears, they won the prize too. By prize I mean they *won the trophy*: the fulfilling and satisfying and, sometimes, utterly fabulous life they wanted—even when nobody expected it of them! I like those stories best.

If they can do it, if I can do it, so can you. But if you get caught up thinking that there are too many hurdles in your way— baby, do us all a favor and stop thinking! Just keep taking the hurdles, one at a time. Because I can tell you from my own experience that it's the difficulties you face that define you. Get past your teens, make it through your twenties (which are about twenty

times tougher than anyone ever told us!), and suddenly it all be-comes clear: It's the hurdles and the obstacles that help carve a girl into an interesting, strong, complex woman. Thank God for the challenges! Difficulties are not interruptions to our journey; they are part of it, as if they're part of the weave of the cloth of our lives. They weave in and become an essential part of the whole. Because the more challenges we face, the more capable we realize we are, and the less there is to fear.

Like I said at the start: This is no here-are-all-the-answers, happiness-guaranteed, self-help book. But I hope it's psyched you up to help yourself to everything you deserve. I hope it's demon-strated that success so often comes when a person prevails in times or areas they're not supposed to, when they push against convention and behave the way they want to behave. My goal in my career has been about pushing that unconventional quality to the forefront, being applauded for it, and changing the status quo a little, so that a different look and a different lifestyle gets cele-brated in our society.

Today, that desire to push the boundaries a little is where my strength comes from. And it's a powerful reserve because I've put in effort, proven I can do it, and now have total faith in myself. That's what I want you to feel—that solid foundation under your feet! Not necessarily that nothing bad is ever going to happen but that *"No matter what, I know that I'm going to be okay."*

I don't know what your goals are, but I know you've got some in there. I want to start hearing and seeing that you're acting on them and moving toward claiming that trophy you deserve. Women have always come up to me in the street and at in-store events to tell me what they think about Baby Phat. So I'm ready; I'm listening. Come on, show me what *you* got!

"Don't be afraid to close your eyes and dream. Then wake up and see where you are."

—SEAN COMBS

"I think that young men and women are so caught by the way they see themselves. Now mind you. When a larger society sees them as unattractive, as threats, as too black or too white or too poor or too fat or too thin or too sexual or too asexual, that's rough. But you can overcome that. The real difficulty is to overcome how you think about yourself. If we don't have that, we never grow, we never learn, and sure as hell, we should never teach."

—MAYA ANGELOU

"The more you praise and celebrate your life, the more there is in life to celebrate."

—OPRAH WINFREY

"You learn by failures and mistakes but don't take them to heart; if you do it takes the spirit out of you, you die a little. Bad news is everywhere, tragedy is everywhere, but you have to keep it in perspective. Ask, "Where is the joy? Where is the fun?"

—JOHN TRAVOLTA

"What we really want to do is what we are really meant to do. When we do what we are meant to do, money comes to us, doors open for us, we feel useful, and the work we do feels like play to us."

—JULIA CAMERON

Acknowledgments

THANK YOU TO EVERYONE who made this dream a reality for me.

First and foremost, thanks to God, for all of his blessings. "I can do all things in the name of Him who gives me strength."

To my mommy and daddy: Thanks for the great genes! Mommy, thanks for sharing my vision and always believing in me, for your unconditional love and support, and for being a great role model for me. You're the best! I love you always, no matter what.

To my husband, Russell: You are the best! Thanks for all your love, wisdom, and inspiration. I admire you.

My babies, Ming Lee and Aoki Lee: Mommy loves you so much. You are perfect. Always be strong and smart!

To Raye, Kim, and Vernon: I love you tremendously and forever.

To my manager Jack McCue: Thanks for believing in me. I believe in you too. You are so handsome and smart! I luv u.

To my glam squad: My sister Misa, Cristopher, Danielle, and Q. Thank you, thank you, thank you! I love you and your visions. You are all so fabulous. Thanks for the *illusions*!

To the KLS team: Tina Lee, Toya Reli Lee, and Sandra Faye Lee. Thank you so much. I couldn't do it without you lovely ladies. I love you!

To everyone at Baby Phat: BJ, Tina, James, Lee, Patricia, Marcie, Josh, Shaun, and Tamisha: Thank you for all your hard work. I love you!

ACKNOWLEDGMENTS

264

To everyone at Phat Farm: Myorr, Kevin, Kevin L., Rasheed, Karim, Nikki D.: Whass up!

To everyone at Rush: Simone, Christina, Ellen, Brother Gary, and Rich: You're fabulous!

To Karl Lagerfeld: Thank you so much for planting the seed of fabulosity.

To Zoe, Max, Hollis, Mickey, Beluga, Midnight, Miyake, and Manu: Mommy loves you!

To everyone at ReganBooks: Thanks for all your hard work and vision.

To Amely: Thank you for your commitment and dedication to this project. You are talented and fly!

A special thanks to BJ Coleman for all of the long hours and helping to make this book happen. You're the best.

To Marcus Klinko and Indirani: Thanks for making me look fabulous!

To all my fans and everyone that believes in me, women everywhere, you inspire me to be better and greater. Thank you for your kindness, good energy, and positive vibes. I feel you—believe me I do!